PAGE LAYOUT

PAGE LAYOUT

ISPIRATION • INNOVATION • INFORMATION

GENERAL EDITOR: ROGER WALTON

PAGE LAYOUT

First paperback edition published in 2002 by: HBI, an imprint of HarperCollins Publishers 10 East 53rd Street New York, NY 10022-5299 United States of America

Distributed in the United States and Canada by: North Light Books, an imprint of F & W Publications, Inc. 4700 East Galbraith Road Cincinnati, Ohio 45236 1-800-289-0963

Distributed throughout the rest of the world by:
HarperCollins International
10 East 53rd Street
New York, NY 10022-5299
Fax: (212) 207-7654

ISBN 0-06-050609-1

Copyright © HBI and
Duncan Baird Publishers 2000
Text copyright © Duncan Baird Publishers 2000

All rights reserved. No part of this book may be reproduced in any form or by any electronic or mechanical means, including information storage and retrieval systems, without permission in writing from the copyright owners, except by a reviewer who may quote brief passages in a review.

Conceived, created, and designed by: Duncan Baird Publishers 6th Floor, Castle House 75–76 Wells Street, London W1P 3RE

Designer: Sonya Merali Editor: Simon Ryder

Project Co-ordinator: Tara Solesbury

10987654321

Typeset in MetaPlus Color reproduction by Scanhouse, Malaysia Manufactured in China

NOTE

All measurements listed in this book are for width followed by height.

CONTENTS

SECTION ONE	56 74		
DESIGN FOR DESIGN SECTION TWO DESIGN FOR BUSINESS SECTION THREE DESIGN FOR EDUCATION AND THE ARTS			
		GLOSSARY OF USEFUL TERMS	140
		INDEX	142

FOREWORD

The job of the graphic designer is to communicate; after that there probably aren't any hard-and-fast rules. You can refine this a little by asking what it is that needs to be communicated and to whom but essentially the remit of the designer in the pursuit of effective communication is as wide and deep as the designer's imagination and that of the client.

The foundation of any design job includes the brief (information, materials, and thoughts provided by the client), the schedule (how much time you have overall and how much of your client's time within that), and the budget. These are the parameters and ingredients within and upon which you must bring your imagination to bear. As the work shown in this book demonstrates again and again, of these three elements what ultimately makes a design successful is the designer's imagination—not the source material, the amount of money available, or the production process. Be it an item of stationery, a website, or a calendar to promote manufacturers of machinery used in the production of paperboard, what gives the designs in this book their

edge is the way in which individual designers have analyzed the requirements and constraints of the job and responded with exceptional imagination and flair.

The title *Page Layout* has been interpreted in the widest sense possible. It is intended to be an expression more of the design process than of the format in which the final design is realized. Increasingly, among the questions under consideration by the designer is what form the communication should take—a book, leaflet, brochure, press announcement, website, series of billboard posters, television advertisement—or a sidewalk performance? I would say there are circumstances in which each of the above might be appropriate, along with many other possibilities.

Page Layout comprises a wide range of designs drawn from all over the world that show imagination working at the highest level. This work can be seen as a stepping-off point from which your imagination can roam freely and creatively—an inspiration for future designs.

DESIGN FOR DESIGN

This opening section shows designers promoting themselves, the company they work for, or another company within the design sphere. The work ranges from the intensely personal—a book exploring the impact of new media on graphic design, for example—to more obviously commercial projects, such as posters to advertise typefaces, sets of stationery, and furniture-design brochures.

BECTION ONE

the values involved in the items and the company's the red line of the elastic binding techniques. This suggests a link between making of handmade the cover close to the spine, combined with The different color of of traditional leather band, is reminiscent own philosophy.

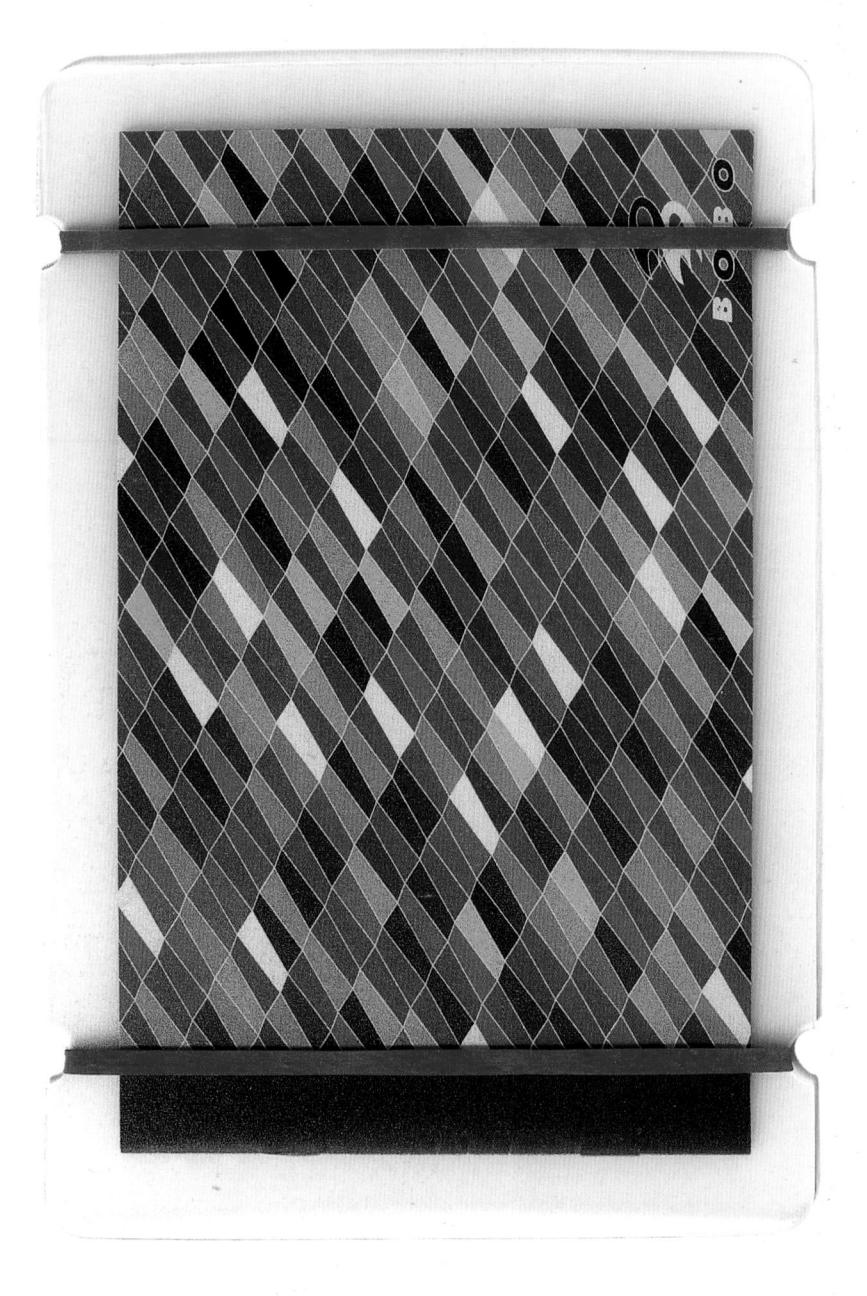

Bo Bo Brochure

almost monochrome, tones of the photographs, while on some lefthand pages piece of translucent polyurethane, a reference to the types of material used in a prismatic abstract background is suggestive of the way light passes through of furniture under construction are brought together under different headings a translucent material. Shots of personnel, conceptual drawings, and images the company's products. Inside, strong colors are used to set off the muted, This stylish publication for a furniture design company comes attached to a to give a very full picture of the company philosophy and practice.

Designers Red Design

Design Company Red Design

Country of Origin

8-page promotional brochure for the product design company Bo Bo. **Description of Artwork Page Dimensions** 210 x 135 mm 8¹/₄ x 5¹/₄ in

Format Brochure

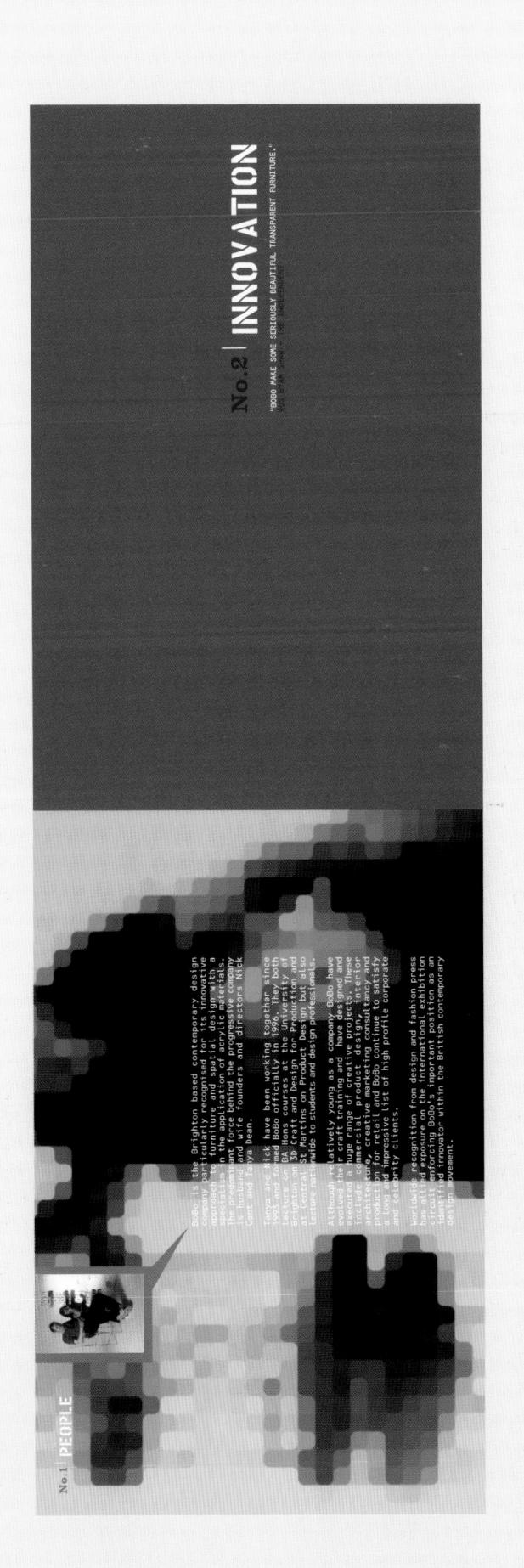

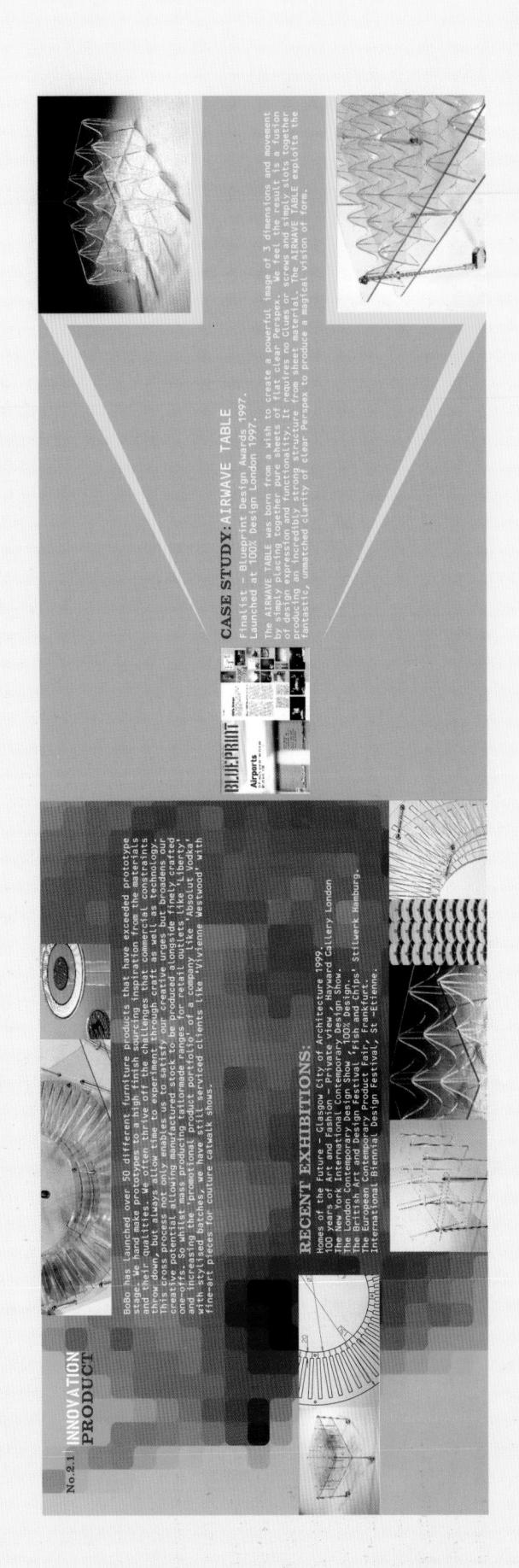

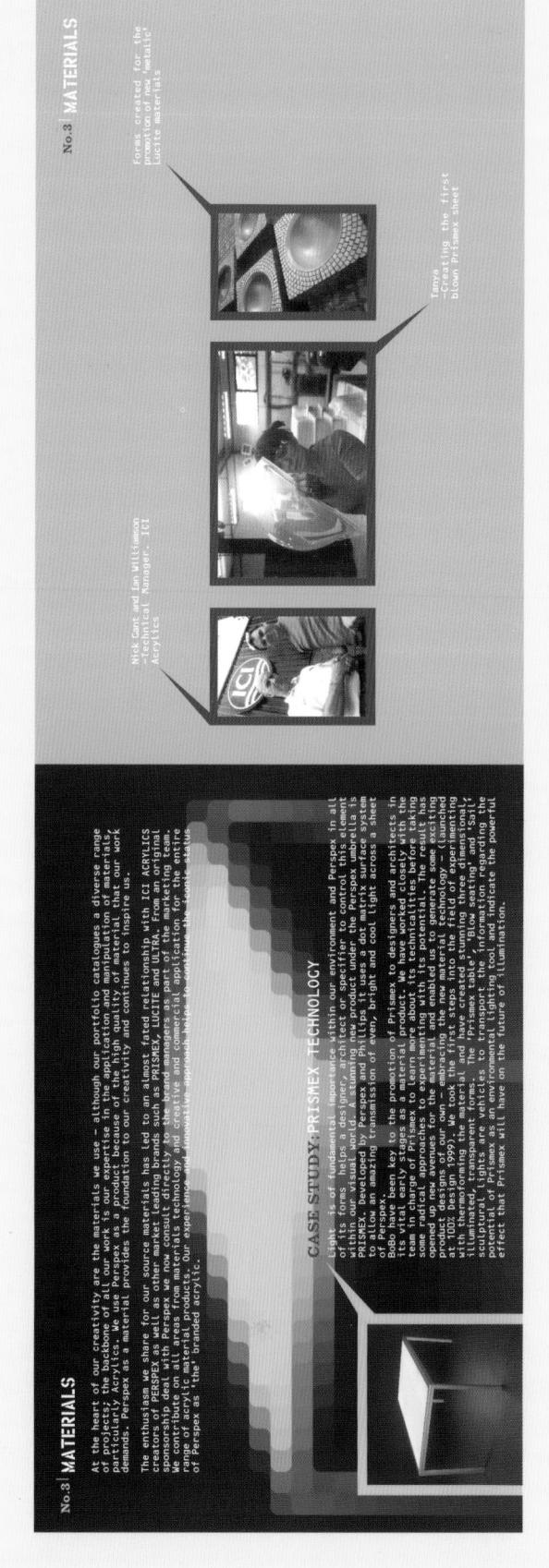

In a nice reversal of the way text bubbles are used in cartoon strips, here the images (photographs) are surrounded by a border and connected to the text with a tapering leader line.

Designers

Mark Allen, Dave Bravenec, Adrianne De Loia, Armando Llenado, Chris Martinez

Art Director

Dave Bravenec

Illustrators

Dave Bravenec, Adrianne De Loia, Alejandra Jarabo

Photographer

Dave Bravenec

Design Company Kick Media

Country of Origin USA

Description of Artwork

Stationery for C14 Design, the creative laboratory of Kick Media.

Dimensions

Sticker (below left), Business card (below right, top & bottom): 115 x 51 mm, 4½ x 2 in Postcards (opposite): 153 x 102 mm, 6 x 4 in

Format

Corporate identity

C14 Design

The strong graphic identity of this design group has two simple elements: a black C14 logo-type and the second-color hippopotamus. Two-color printing is used to maximum effect (*below*), with the second color appearing in three different percentage tints, and text reversed white-out-of-green in contrast to the black text used elsewhere. The postcards (*opposite*) immediately identify the company through its name and the hippopotamus, showing that consistent use of a word or symbol can identify, even when their connection to the activity of a company is not immediately obvious.

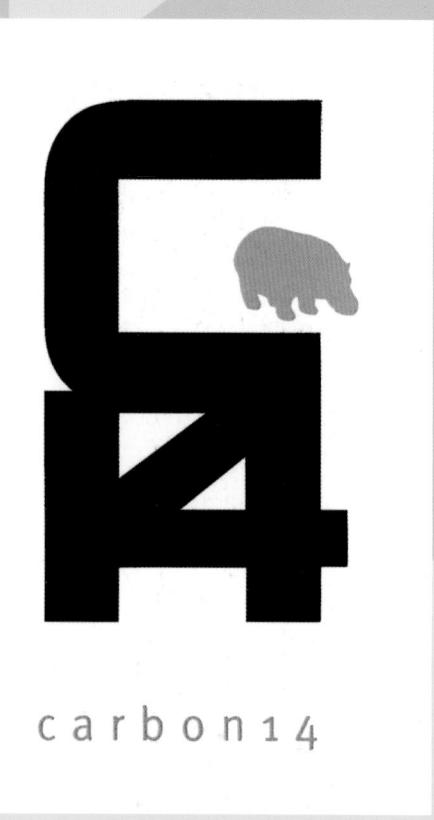

Dave Bravenec
Creative Director
dbravenec@carbon14.net
310.314.6713

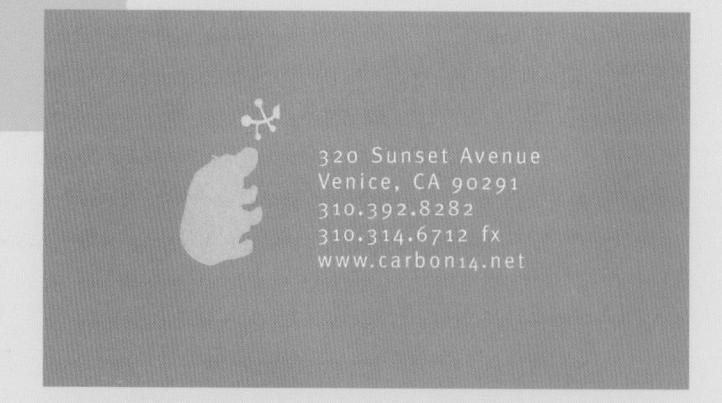

This side of the business card reveals how the varied use of the second color can produce a degree of subtlety within a bold design.

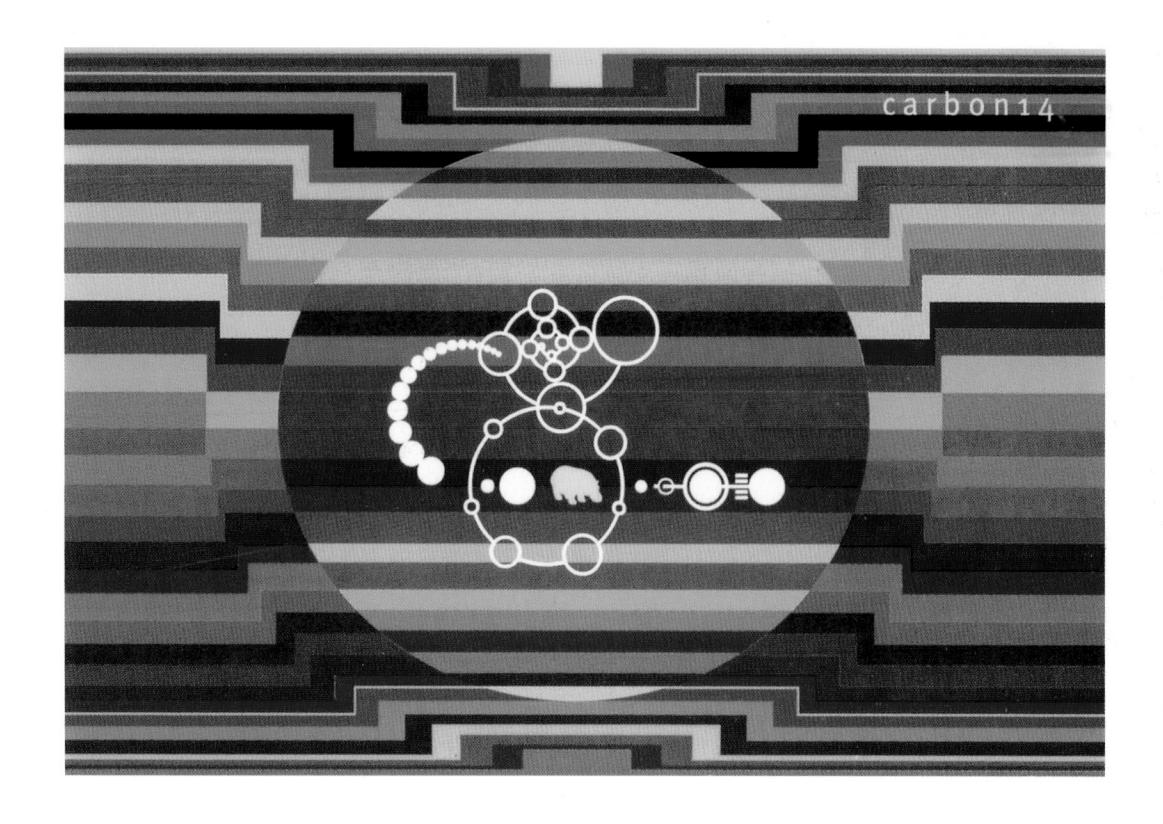

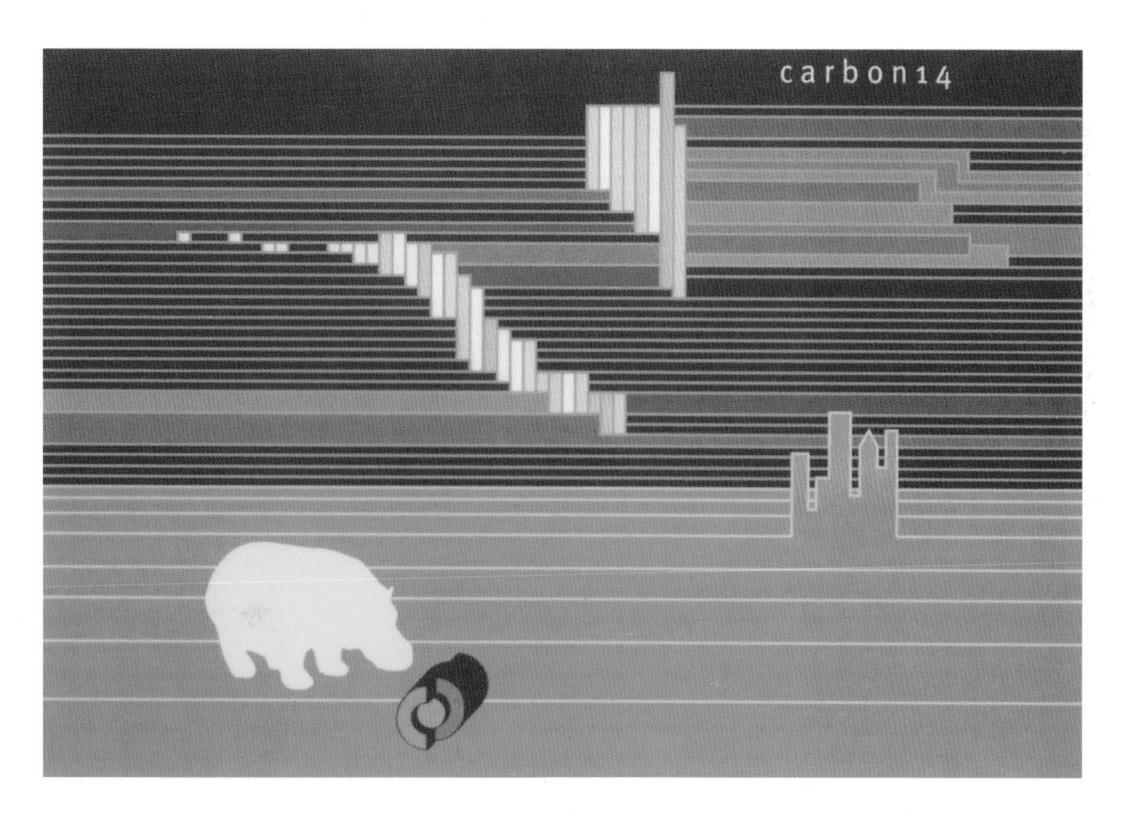

C14 mostly use the hippo symbol in a purely abstract way. However, on this postcard, its use is more directly linked to the design: it seems to be looking at the cylindrical object—which increases its flexibility and adds a touch of humor.

Thomas & Bohannon Stationery

Everything about this range of stationery has been inspired by tools of the printing trade—a simple idea, nicely executed. The centerpiece of the design is an industrial-catalog-style line drawing of a printing press which acts as the company logo. In addition, a number of graphic devices, all part of the printer's lexicon—crop marks, registration marks, density panels, and guide rules—work to produce a distinctive and extensive stationery range. The resulting design communicates a sense of specialist expertise and attention to detail that is a very good promotion of the company to potential clients.

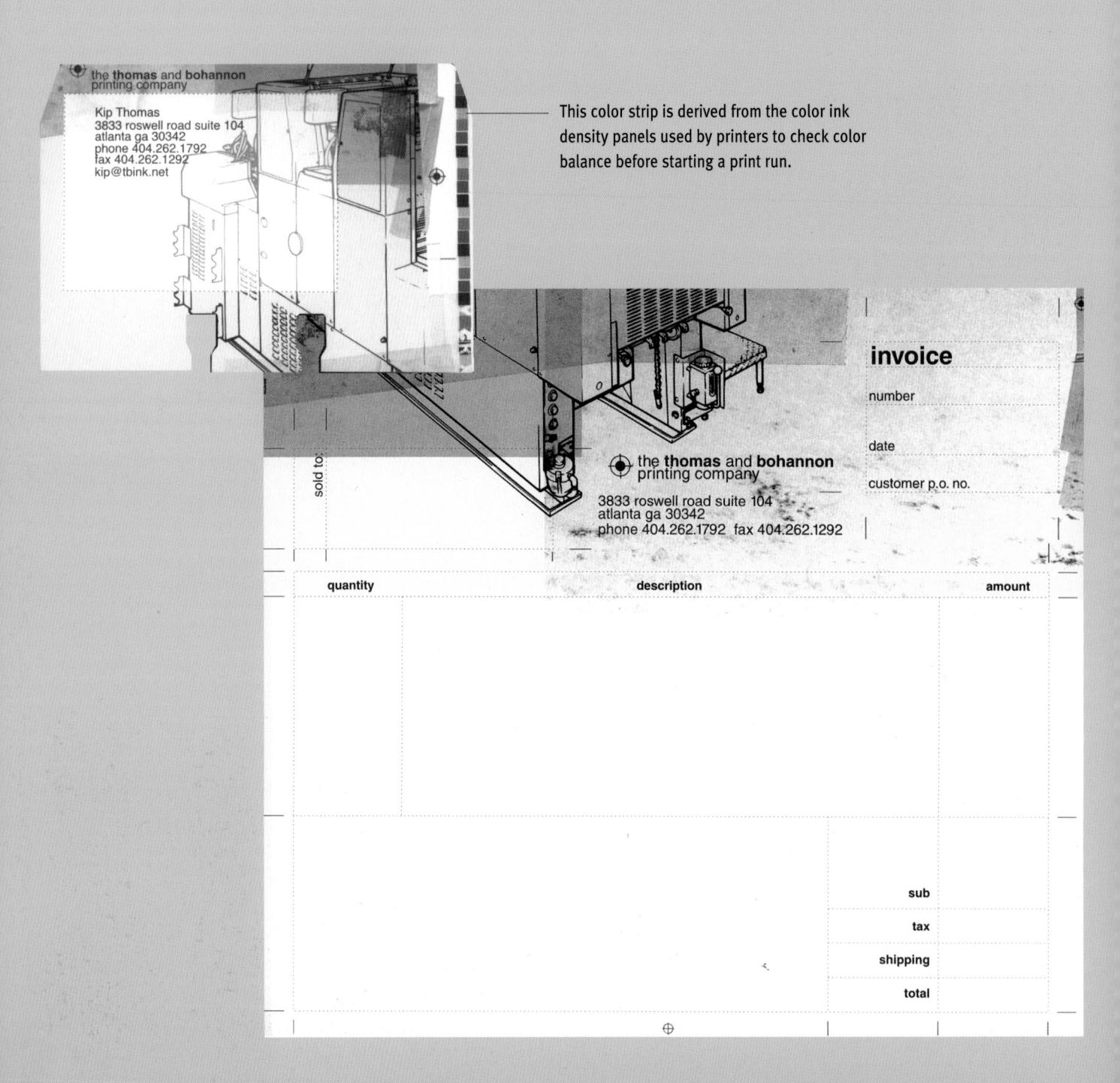

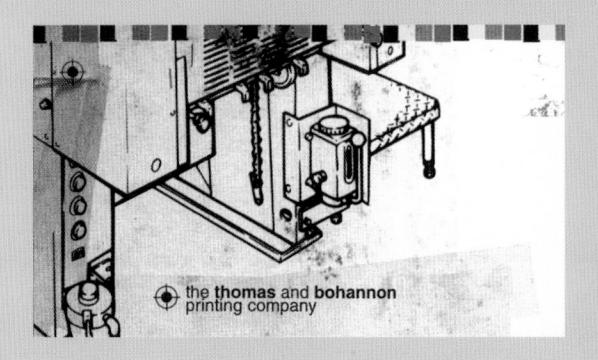

Crop marks, normally used to show where to trim the printed sheet, are used here to play with the space on the page by demarcating the area in which to type or write.

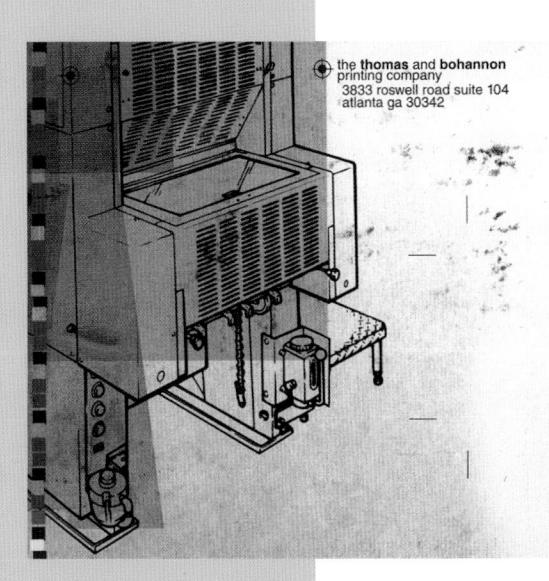

Designers

Graphic Havoc avisualagency

Illustrators

Graphic Havoc avisualagency

Design Company

Graphic Havoc avisualagency

Country of Origin

USA

Description of Artwork
Corporate identity package, including 'logo,' stationery, and website, for an offset lithography printing company.

Dimensions

Various

Corporate identity

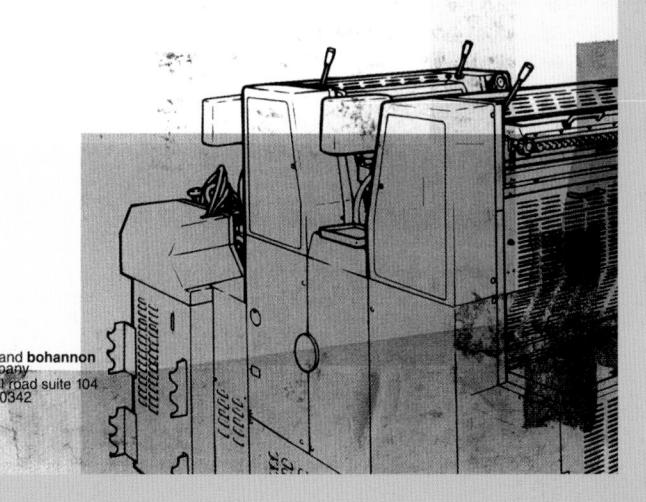

Designers

David Hand (below, left)
Seel Garside (below, center)
Hitch (below, right)
lan Mitchell (opposite)

Design Company

Beaufonts

Country of Origin

Description of Artwork

A set of posters featuring fonts created by Beaufonts.

Dimensions

297 x 420 mm 11³/₄ x 16¹/₂ in

Format

Poster

Don't Panic-This is Beaufonts

Advertising typefaces is not easy, as they are often required to be the unobtrusive building blocks of design. Here, Beaufonts' simple but witty posters serve their purpose very well, not only to promote their type library but also the company and its website. They succeed in promoting very different font styles by using disparate but always intriguing images together with recurring areas of flat color that give visual cohesion to the promotion.

Special Production Techniques

Designed specifically to be downloaded from their website, these posters have never been traditionally printed.

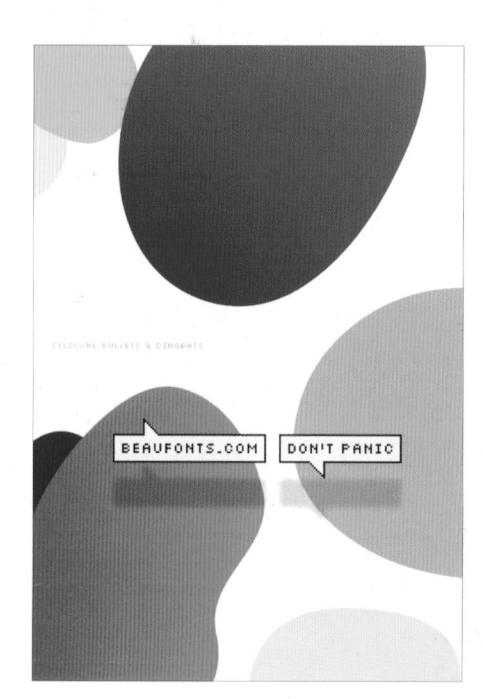

DON'T PANIC

BEAUFONTS.COM

Chercher/Trouver (Looking For/Finding)

Interesting self-promotion is achieved here without showing any of the designer's work. Instead, the activities of the group are presented conceptually. This book has been created alongside their website and therefore has been strongly influenced by it. The use of geometric line imagery creates a background texture upon which the text is overlaid. The central information bar acts as a stable backbone against which the other elements are varied and contrasted.

Opposite, *center*: the fluid background design successfully evokes movement, which is a key element of the accompanying interactive website.

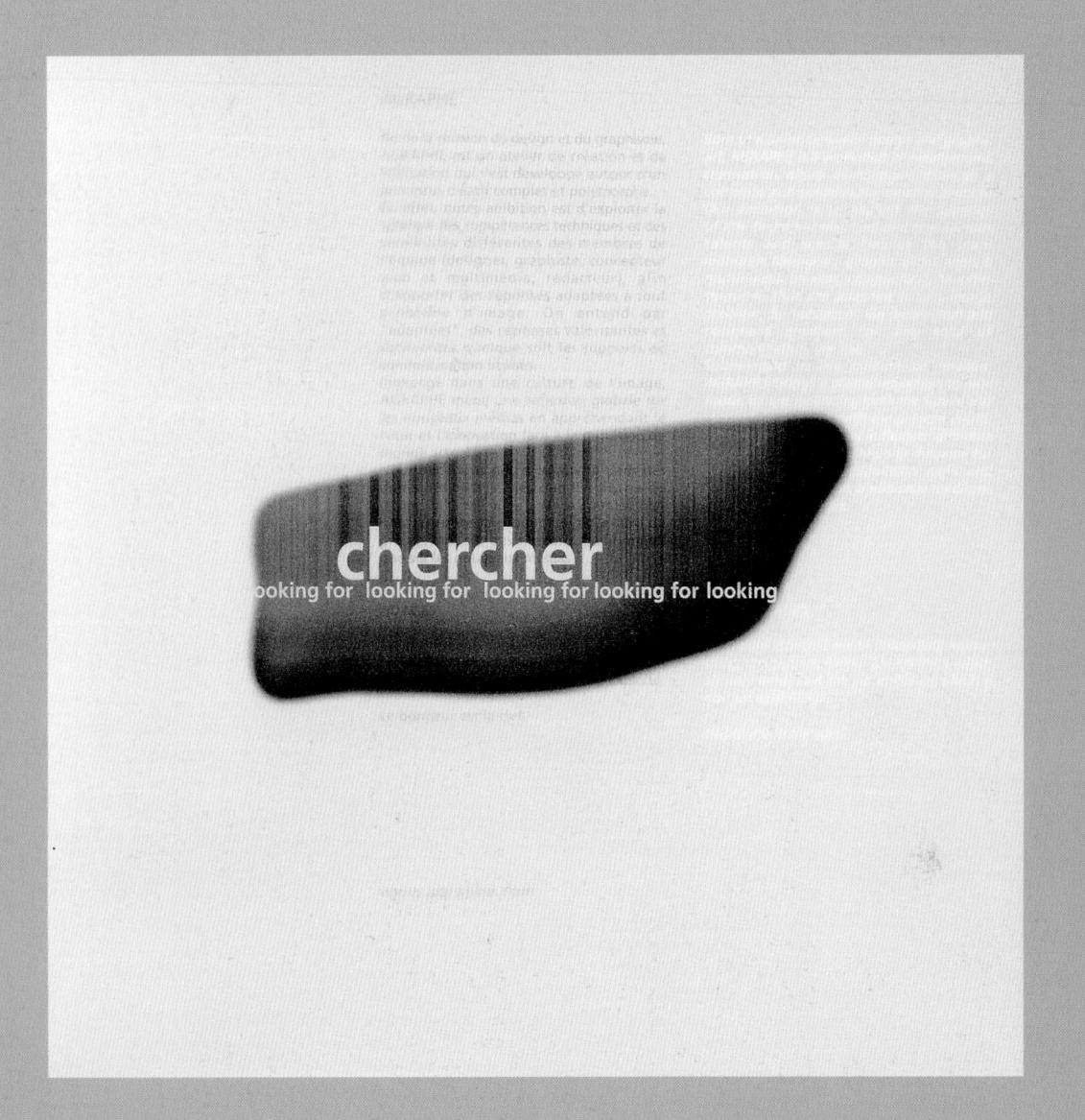

Designer Agraphe

Art Director Thomas Erhel

Copywriters Laetitia Campana, Thomas Erhel, Luis Mizon

Illustrator Ludovic Erhel

Photographer Computer images and photographs by Agraphe

Design Company Agraphe

Country of Origin France

Description of Artwork 28-page self-promotional book

Page Dimensions 210 X 210 mm 81/4 X 81/4 in

Format Book

Fuel Printed Matter

(See following spread for description)

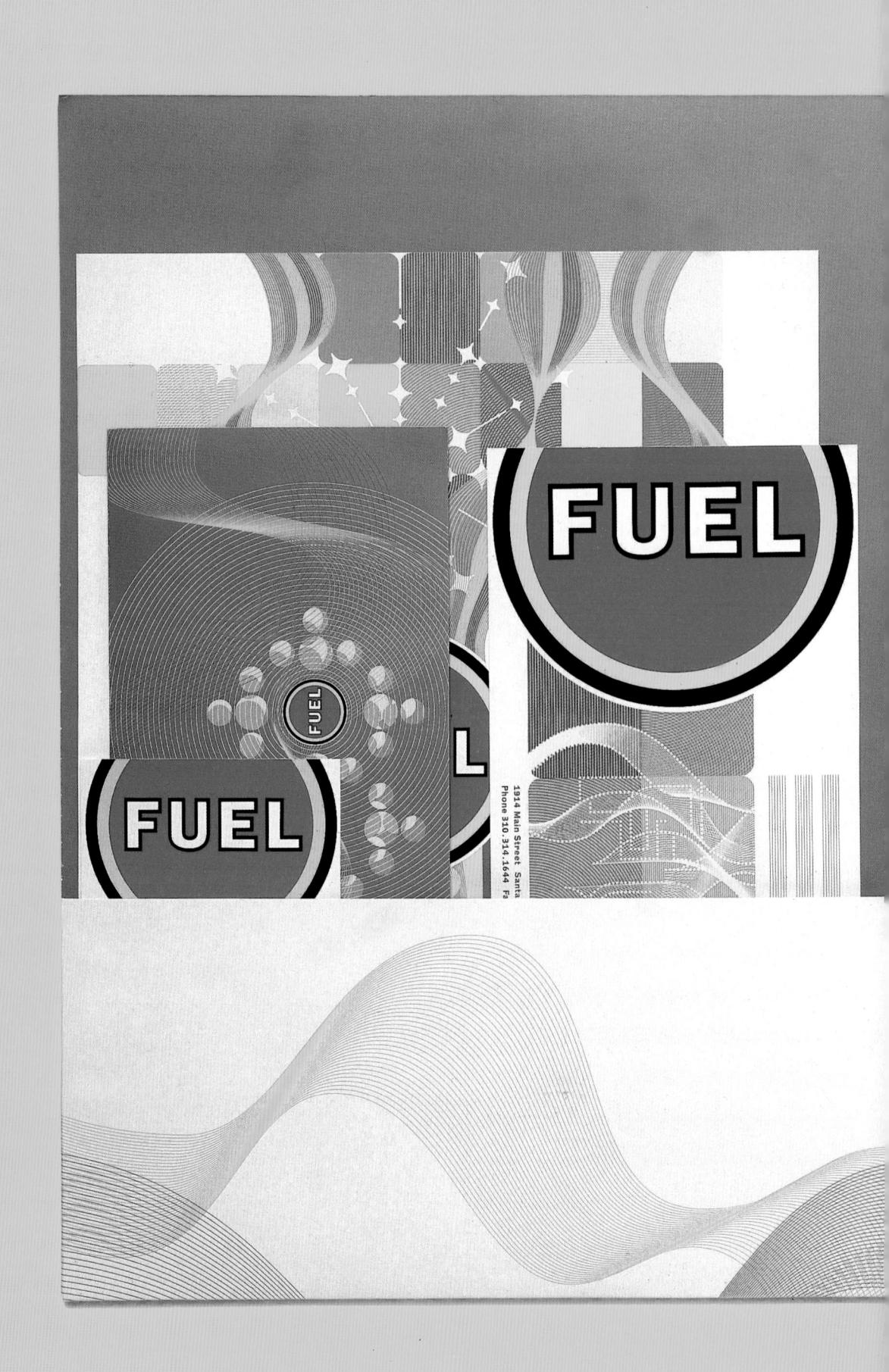

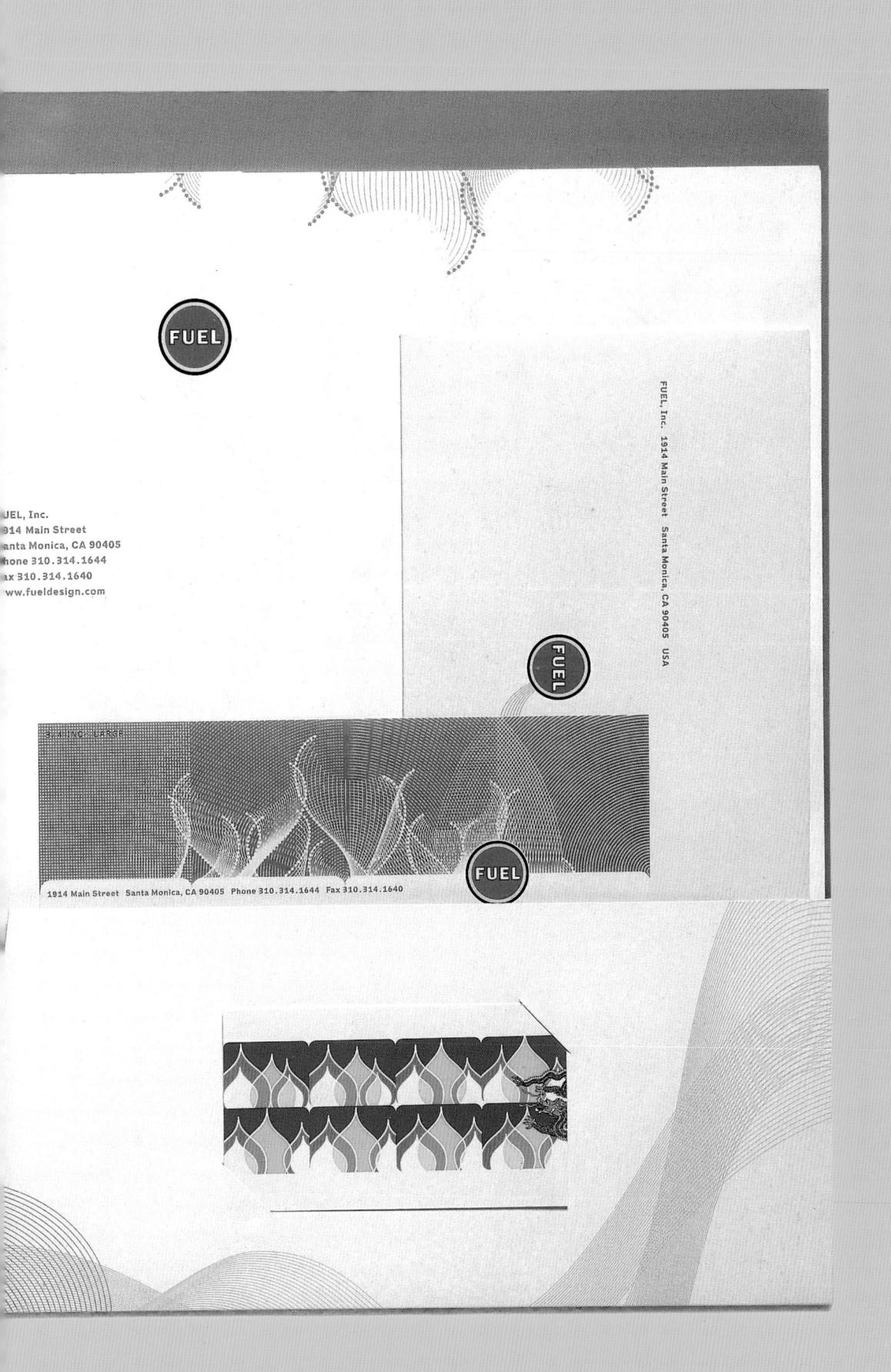

Designer Jens Gehlhaar

Creative Director Seth Epstein

Illustrator Jens Gehlhaar

Design Company

Country of Origin USA

Description of Artwork A range of stationery and packaging, including video labels and inserts, for the Santa Monica based motion graphics studio Fuel.

Dimensions Various

Formats

Stationery, packaging

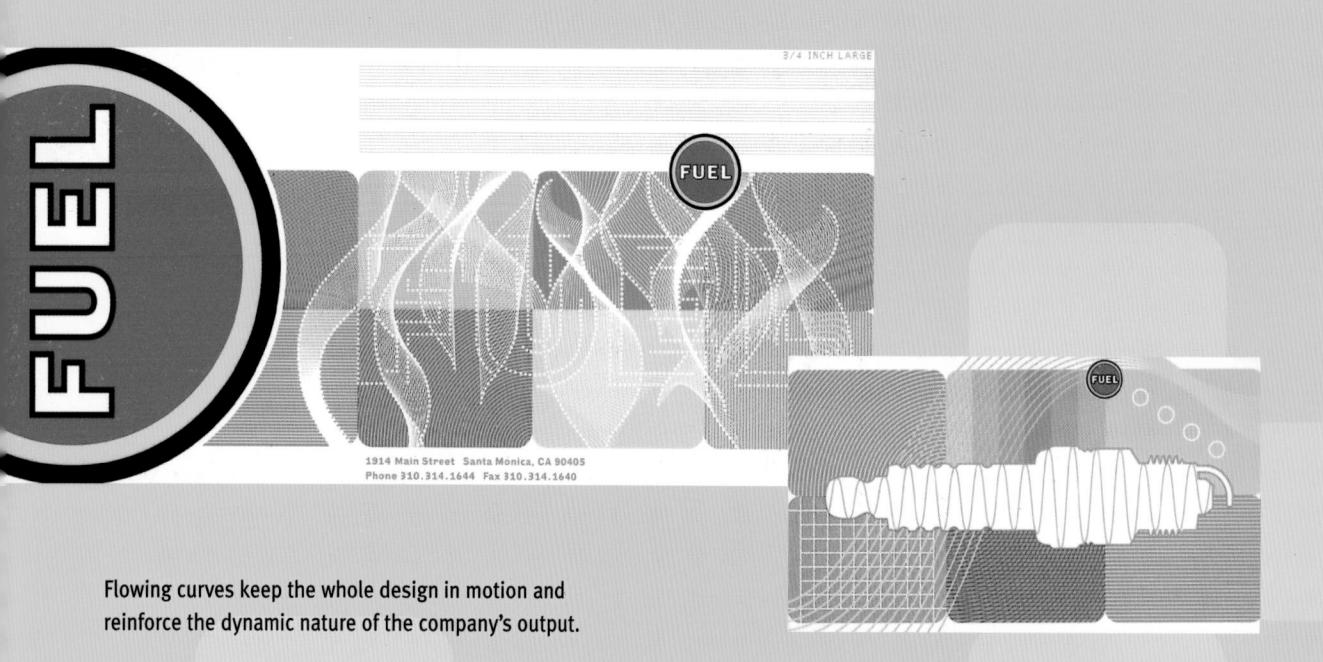

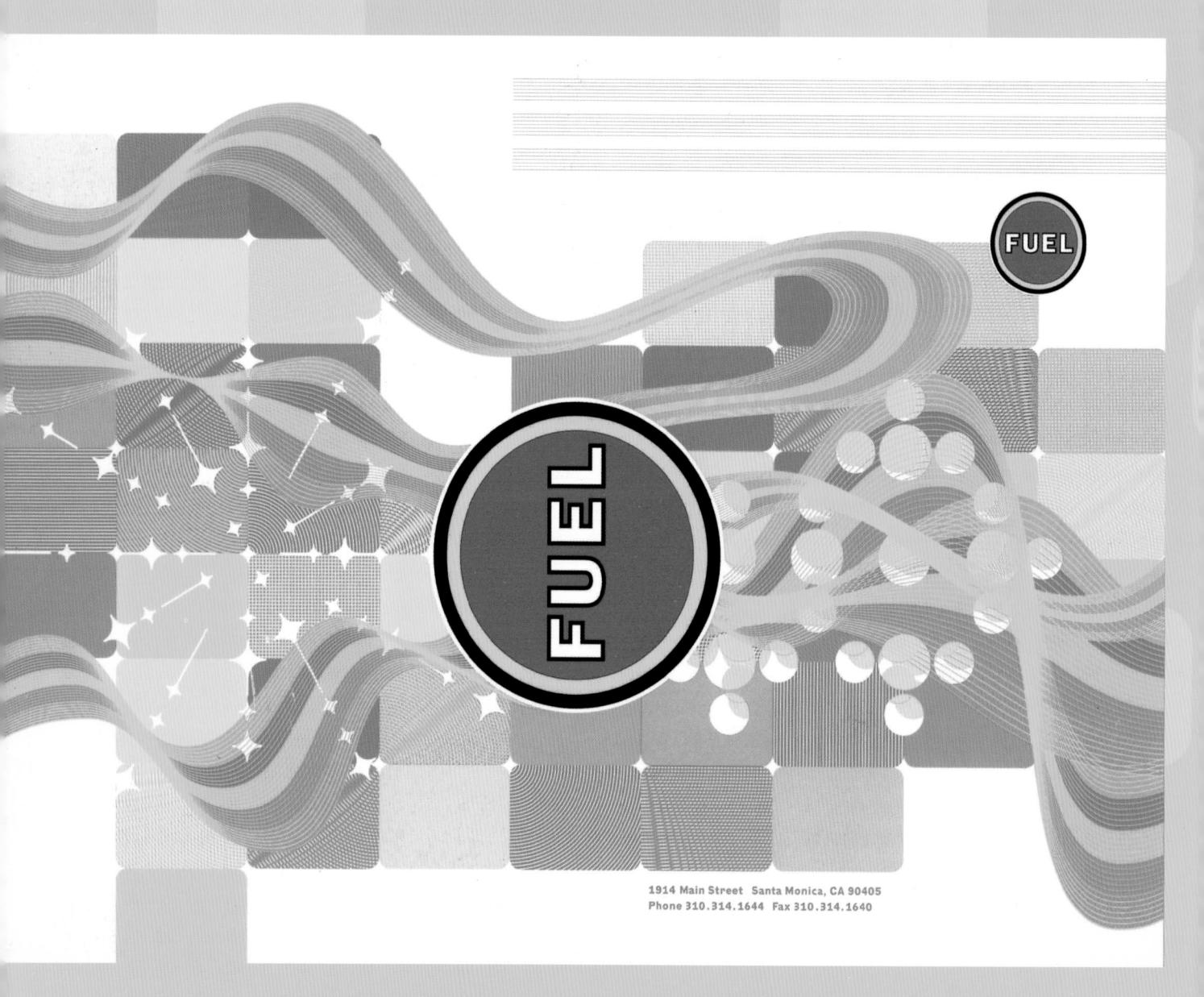

Fuel Printed Matter

Taking its inspiration from the company's name, the designer's intention was to 'express very television-specific ideas, such as energy and motion, with very print-specific means, such as metallic inks and intaglio vector art.' The simple boldness of the logo and consistent use of color gives a strong and instantly recognizable visual identity to a wide range of stationery. The use of metallic ink enhances the visual feel by contrasting bright colors against flat metallic gray, while the 'intaglio vector art,' which hints at bank-note currency, adds a subliminal value.

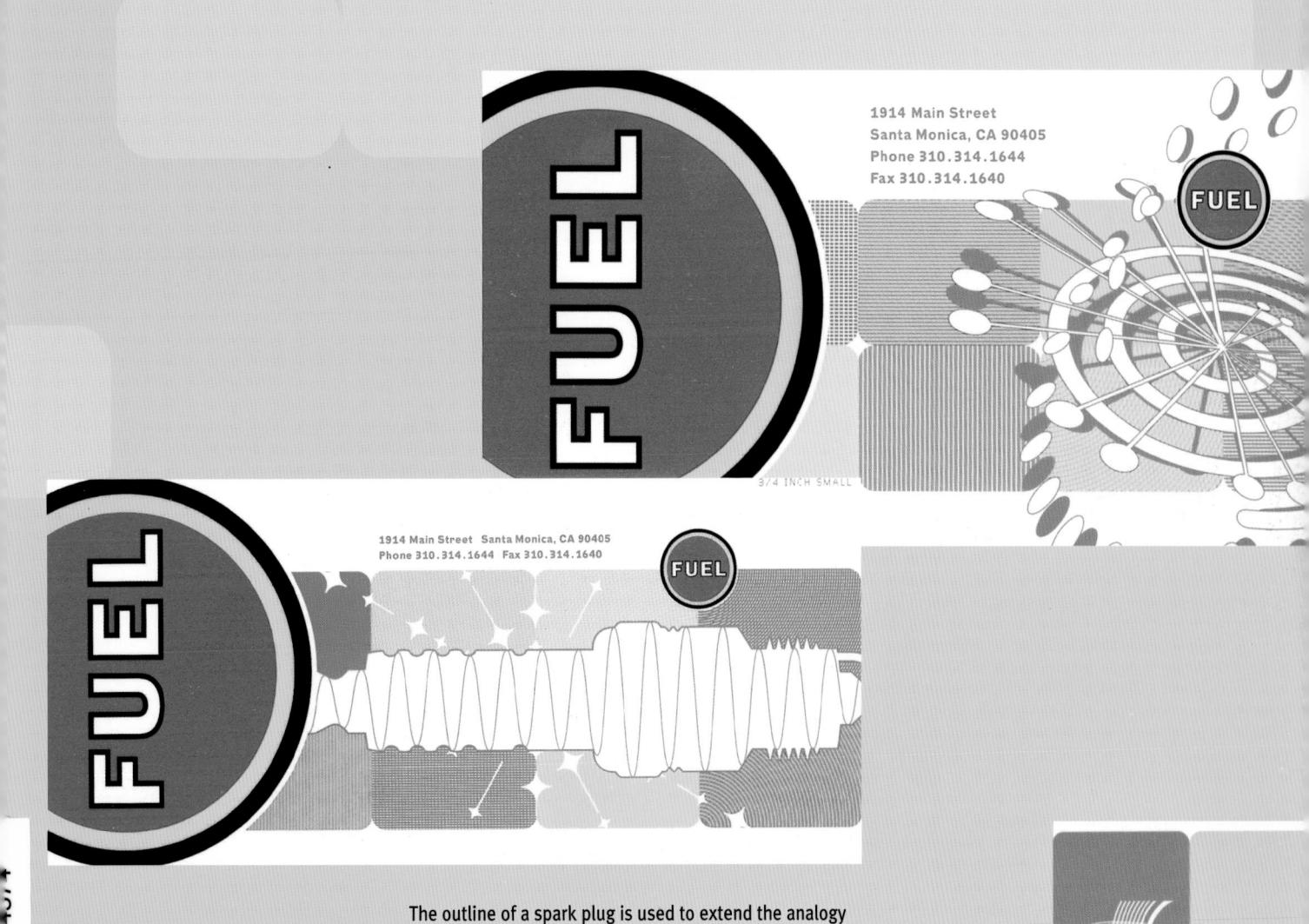

with engine technology and to suggest creative inspiration.

25

The play of forms within a space is central to this furniture designer's thinking and this is reflected in the way that the page area has been divided and intersected by areas of white.

Christophe Delcourt

show-room

Invitations to view the work of furniture and lighting designer **Description of Artwork** Christophe Delcourt

> Philippe Savoir Art Director

Designer

Page Dimensions 180 x 215 mm 7'/s x 8'/2 in

Design Company Philippe Savoir

Country of Origin France

Format Invitation

photographic imagery creates a subtle yet sophisticated style that typography on the covers of the folded invitations (left, above & opposite) is developed inside and combined with a narrow color matches that of the furniture and lighting on show. The delicate range that reflects the materials used by the furniture designer. The choice of two-color printing and the layering of abstract 'New Room'—Christophe Delcourt

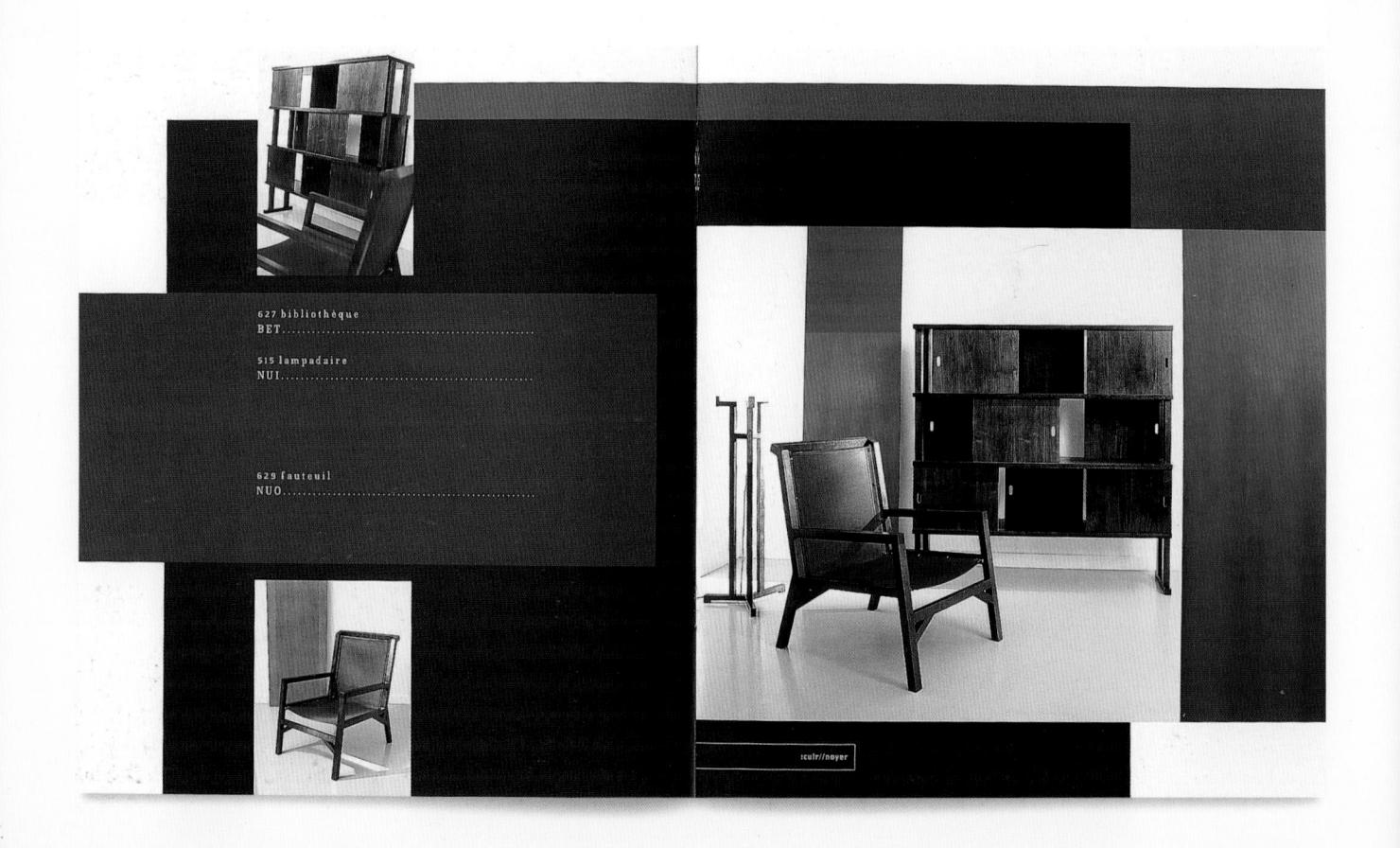

:C1-Christophe Delcourt

The clean lines and style of the furniture and lighting featured in this publication are mirrored in the clear, geometric approach taken to its layout. This aesthetic is extended to the typography which is sparse and tightly controlled. The uncluttered structure of the spreads gives prominence to the elegant richness of the dark wood and leather furniture, strikingly displayed in pristine settings.

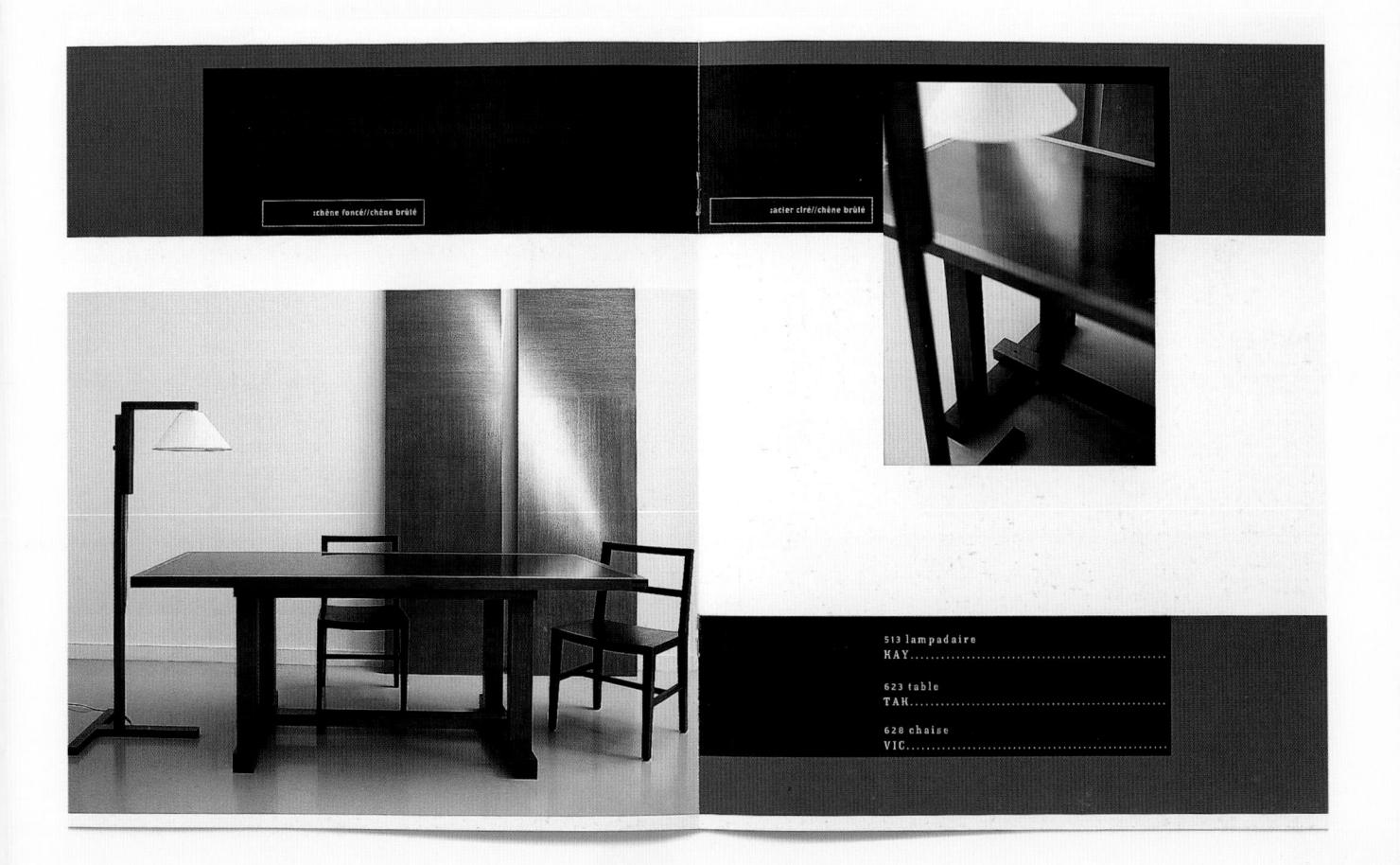

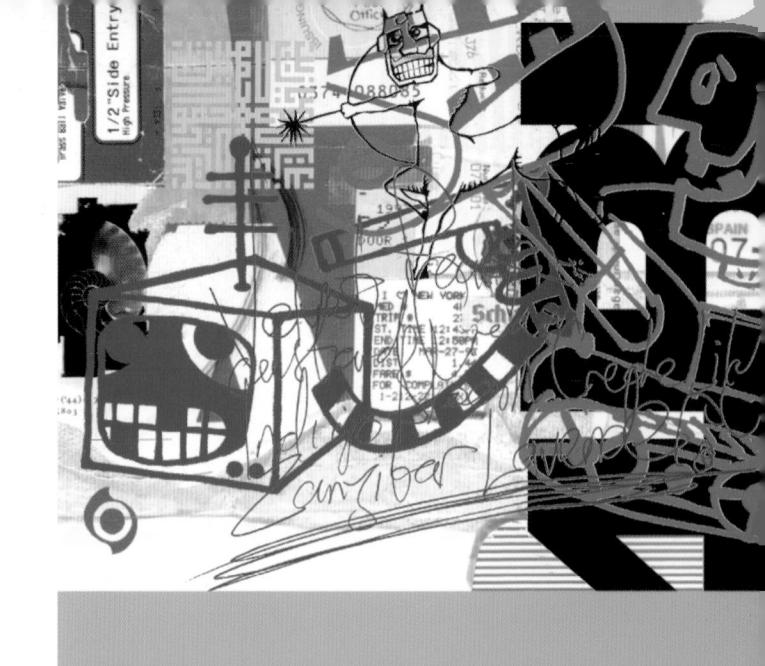

Designer Mark Caylor

Art Directors Rob O'Connor, Mark Caylor

Illustrator Mark Caylor

Design Company Stylorouge

Country of Origin UK

Description of ArtworkCorporate identity for use on a coordinated range of stationery.

Dimensions 210 x 99 mm 81/4 x 41/2 in

Format

Stationery

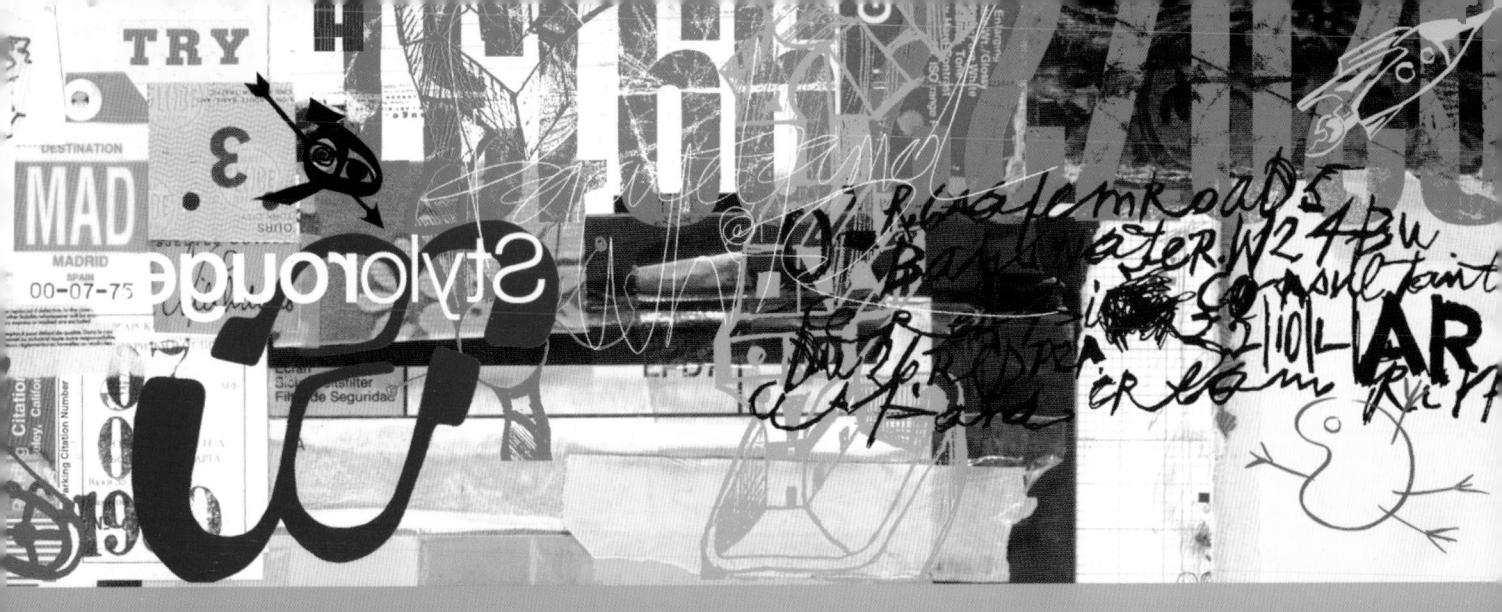

Creative Consultants
6 Salem Road London W2 4BU UK **Tel** +44 (0)20 7229 9131 **Fax** +44 (0)20 7221 9517
E-mail: mail@stylorouge.co.uk Stylorouge on line: http://www.stylorouge.co.uk ISDN (0)20 7221 5803

Stylorouge.

Stylorouge Corporate ID

The diverse nature of Stylorouge's work for the music industry is reflected in the component parts of the image: found typography and pictures, drawings, graffiti, labels, and tickets suggest their eclectic influences. This polyphony of visual languages, reminiscent of a flyposted city wall, stands in stark contrast to the simplicity and clarity of the logo-type and gives this self-promotional work its strong identity.

T) Wideh

Portfolio #1

This bold presentation of design work for the music industry makes no concessions to the viewer. The abstract images are without explanation, and therefore stand or fall by their visual references and integrity. Whether the work is familiar or not, the choice of imagery suggests the theme being promoted.

Designers

Rob Crane, Martin Yates

Art Directors

Rob Crane, Martin Yates

Photographers

Top: Alex Hanson, Lucky Morris Bottom: Stuart Weston

Design Company

Satellite

Country of Origin

Description of Artwork

A collection of design work for the music industry compiled as a promotional portfolio.

Page Dimensions

213 X 155 mm 8³/₈ X 6¹/₈ in

Format

Book

Ogier Stationery

With the type on one side and the image on the other, this slightly costly but engaging twist is an elegant solution to the job. The obscure shapes (parts used in the construction of the lighting sold in Ogier, a contemporary furniture shop) are carefully positioned on the letterhead to be the first thing seen when the envelope is opened. They not only give a feel for the products but also add an enigmatic touch that is in keeping with the whole design approach.

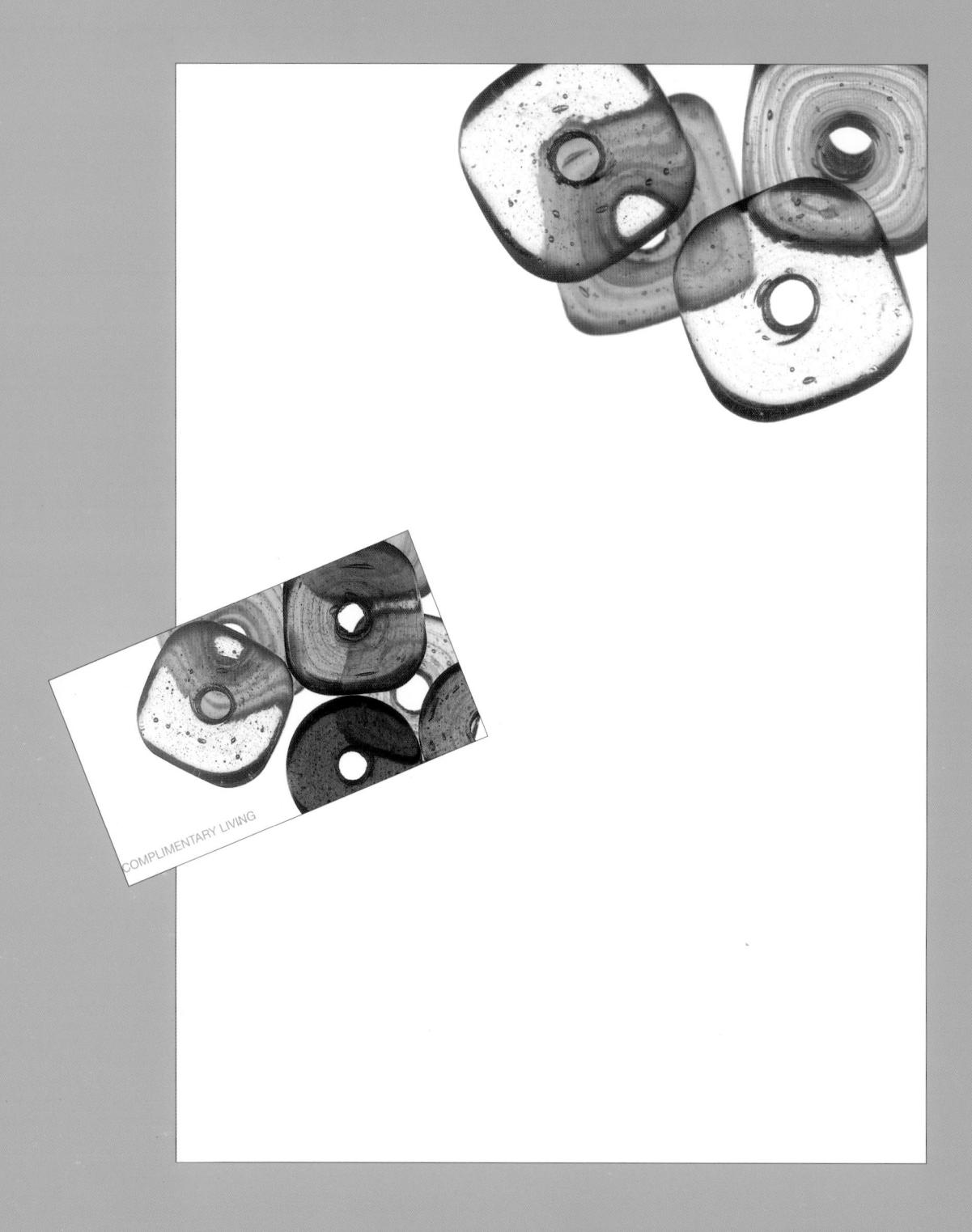

OGIER

Designer Mark Rogerson

Art Director Mark Rogerson

Photographer Jonathan Brade

Design Company Mark Rogerson Associates

Country of Origin

Description of ArtworkStationery designed for Ogier, a contemporary furniture shop.

a contemporary furniture shop.

Dimensions

Letterhead: 210 x 297 mm $8^3/_4$ x $11^3/_4$ in Business Card: 90 x 50 mm $3^3/_2$ x 2 in

Format Stationery 177 WESTBOURNE GROVE. LONDON, W11 2'SB TELEPHONE: 0207 229 0783. FACSIMILE: 0207 221 8276 E-MAIL: OGIER®DIRCON.CO.UK

Scintpreen/Preenscint

(See following spread for description)

Designer Jens Gehlhaar

Illustrator Jens Gehlhaar

Country of Origin

Description of Artwork

36-page book about the changes the graphic design profession faces with the advent of new media. Text by Jens Gehlhaar.

Page Dimensions 203 x 257 mm

203 X 257 m 8 X 10 in

Format

Book
THE VOYAGE

"[...] the process of large group or team projects in multimedia has less to do with the division of labor in print production, and is much more akin to collaborative enterprises, such as theatrical production, TV production, or movie-making in the entertainment industry. And in those enterprises, the identity and independence of individuals responsible for the visual presentation (...) are secondary in both the hierarchy of production and in the point of view of the audience to the vision or authorship of the director (and perhaps the screenwriters).

While the accomplishments of the visual collaborators may be highly celebrated and compensated,

the ability to launch current and future projects rests with the authors—the directors and

screenwriters."

ONO THE HORIZON

the connection between content and its presentation is so tight that there is barely any conceptual space in which to see a separate need for development of the wisual independent from the verbal."

THE PROMISED LAND

A WELCOME CHAILLEINGE

"[...] at Emigre, [...] as we're trying to deal with the new technologies that surround us, communication must appear in the briefest, simplest, most urgent form."

just doesn't seem to have the power that it used to.

We're persuaded much more easily and much more powerfully by a series of moving image empowered with a series of moving image.

SOUND AND

as quoted in: Will Novodselik: "Dumb", Eye, Nº 22, Vol 6, 1996, p 57

We have to understand that these new media are there and plug in."

Scintpreen/Preenscint

Using the metaphor of the discovery of the Americas, this book boldly explores the impact of new digital media on graphic design. Imaginative and complex typography has been used to great effect, overcoming the limitations of the one-color printing. Each spread holds a surprise that keeps the viewer engaged with the text, while the way in which the layout responds to the book's central metaphor sustains this typographic journey through to the end.

THE VOYAGE

PUBLISHING INDUSTRY THE CONSUMER INDUSTRY

coming from backgrounds as diverse as writing, programming, sound design and animation? who will have the ability and the best training to lead a team of professionals Who will design the new media projects?

On the voyage to the new world, graphic designers not alone. Driven by a general cultural mania, almost ev profession in the realm of mass communication feels th need to prepare for the big step. The chase has begun, a

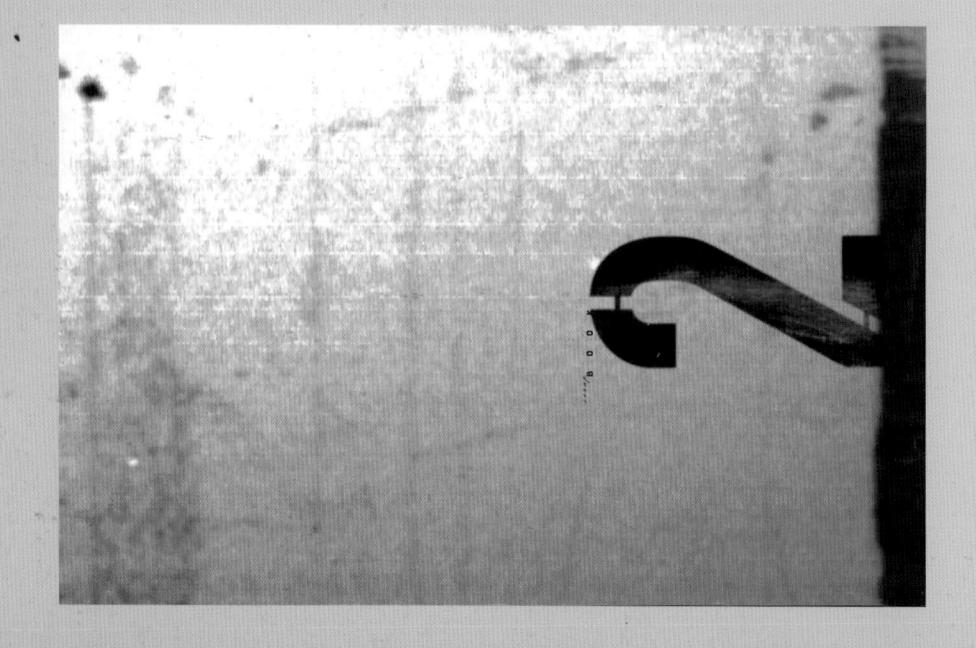

Designers Pol Baril, Denis Dulude

Art Directors Pol Baril, Denis Dulude

Photographers Various

Design Company KO Création

Country of Origin Canada

Description of Artwork Self-promotional brochure for KO Création, a graphic design studio.

Page Dimensions 280 x 435 mm 11 x 17 in

Format Brochure

building. Pleasing and quirky, the combination of informal photography and the space the designers choose to work in, but also shows how they utilize found imagery draws the reader in to this unobtrusively bilingual brochure. obscure, it succeeds in conveying a strong sense of the atmosphere in the space on the page. Although the snapshot style of photography is quite This unashamedly personal piece of work not only gives an insight into

Scrapbook 2

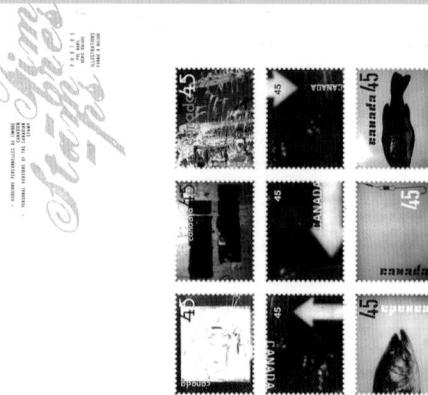

endroit de prédilection c ticuliers pour choisir t 0 th situé au 4e étage d'une imprimerie. Mais il fa

special place to Inspire us nous inspirer jour après jour...

un endroit bien parti

Les nombreuses questions que

notre studio suscite chaque fois new visitors ask about our

qu'un nouveau visiteur y met les studio made us think of letting

pieds nous ont donné l'idée de

vous le faire découvrir you discover it in pictures.

Designer Joseph Eastwood

Art College University of Salford

Country of Origin UK

Description of ArtworkAn experimental typographic reconstruction of the Bible.

Page Dimensions 120 X 170 mm 4³/₄ X 6⁷/₈ in

Format Book

Bible Reconstruction

The Bible must be one of the world's most printed texts, and yet this reconstruction succeeds in drawing the reader in afresh. It is particularly impressive that such an alluring and intriguing treatment should be created out of two colors and pure type—economical and a testament to the power of typography.

thegospelaccording to st. luke.

ST. LUKE.

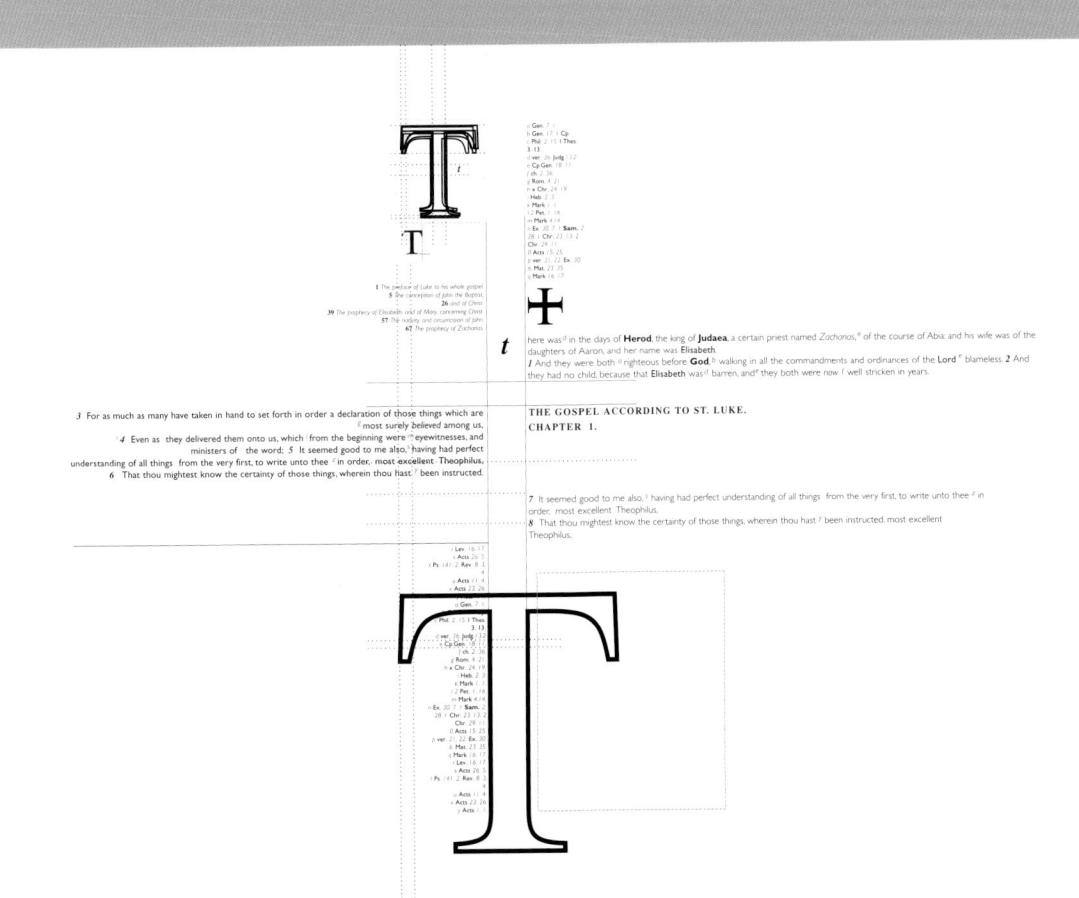

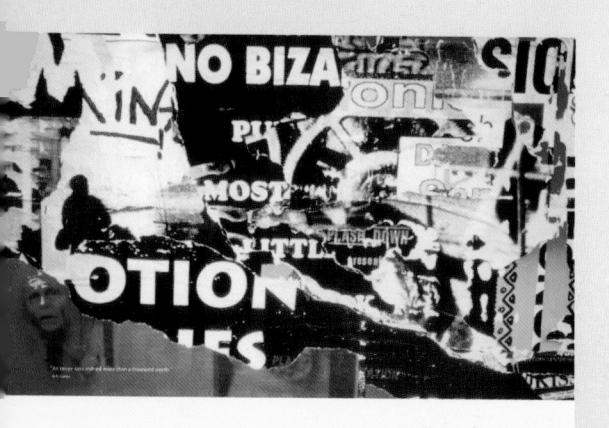

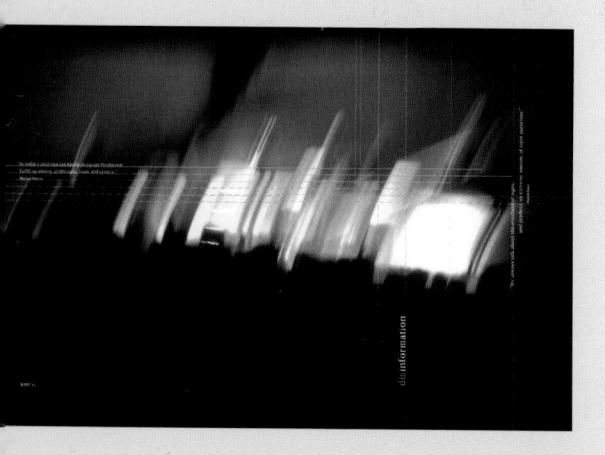

DesignersEsther Mildenberger,
Brian Switzer

Photographers Esther Mildenberger, Brian Switzer

Design Company envision+

Country of Origin Germany

Description of Artwork
A series of three books about
our perception of cities.

Format Book

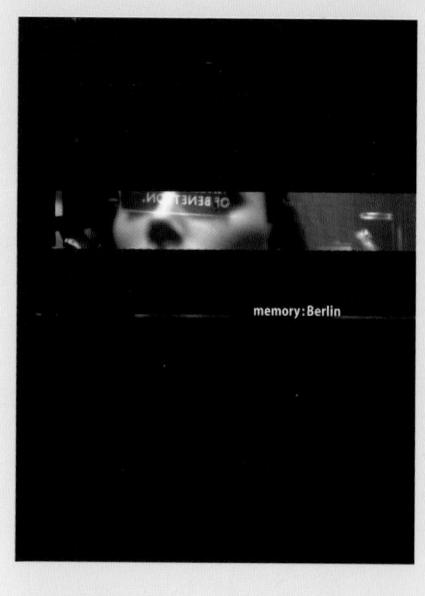

Page Dimensions (memory: Berlin) 150 x 200 mm 5⁷/s x 7⁷/s in Opening to a maximum width of: 300 mm, 11³/s in

city: memory: Berlin, London, Tokyo — Book Projects, 1996-99

Part of an extensive project including videos and interactive concepts, these three books (shown on this and the following two spreads) share the same format and similar covers. Inside, the design of the books is based on a personal interpretation of the cities, and the way in which the pull-out construction and typography have been used adds to the individual flavor of each publication.

memory: Berlin

In many ways the most straightforward in its layout, this book uses abstract imagery and short texts to create a series of discrete impressions. Typography features strongly in the imagery—murals, fly posters, electronic signage—and this has been complemented by keeping the caption texts compact and unobtrusive.

Fümms bó wò tää Uu, pögiff, kwii Ee. Dedesin an rrrrr, Li Ee, mpiff tillff too, tillli, Jüü Kaa? Rinnzekete bee bee nnz krr müü? ziiuu ennze, ziiuu rinnzkrrmüü, rakete bee bee." J RICH AKA LC (SFROM. AS

Beyond the content of what is said or printed, typefaces can express and visualise different atmospheres, and group identities, etc. Today we live with overload and cliches, with the omnipresent application of typefaces.

Where signs no longer have specific meanings and parts can no longer be assigned idiomatic expressions—then the reduction to purely visual ideas is complete. Our perception of signs and sign fragments is always based on the sum of our experience with type and language.

W O R D

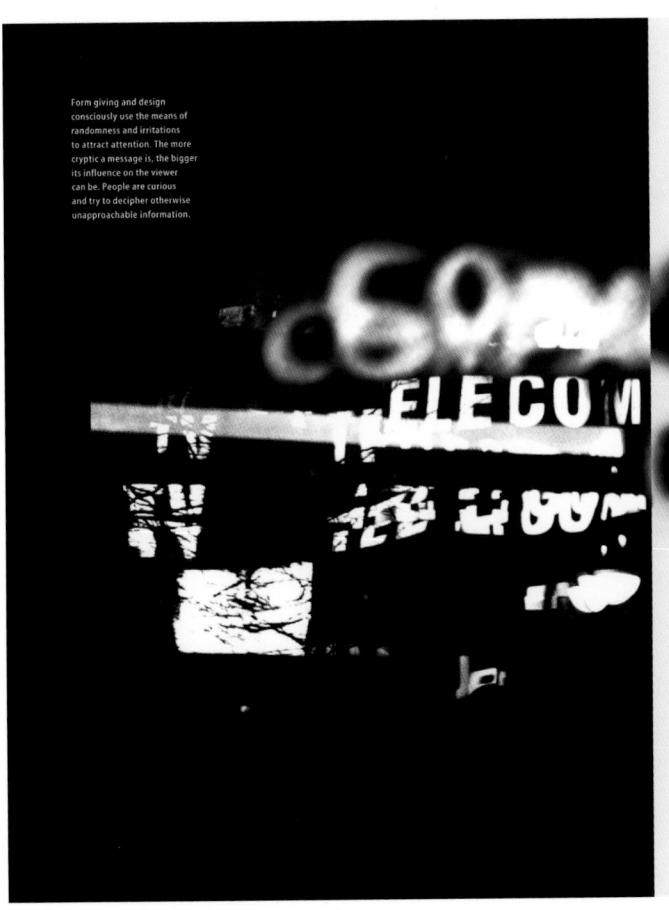

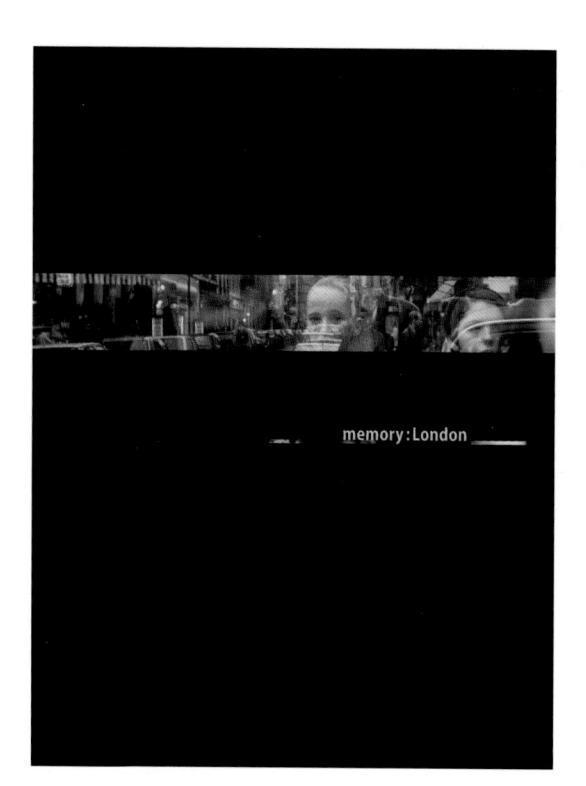

memory: London

The extended pull-out construction of this book has been used to create a sequential narrative of images and texts. Starting in restrained monochrome on the opening spreads, it progresses to the abstract, overlapping, and blurred imagery of the final color pages. The steady increase in the size of the squared-up photographs and the substantial blocks of text have been brought together into a formal yet asymmetric layout that gives a strong sense of this city.

Page Dimensions (memory: London) 150 x 200 mm 5⁷/* x 7⁷/* in Opening to a maximum width of: 2,400 mm, 95 in

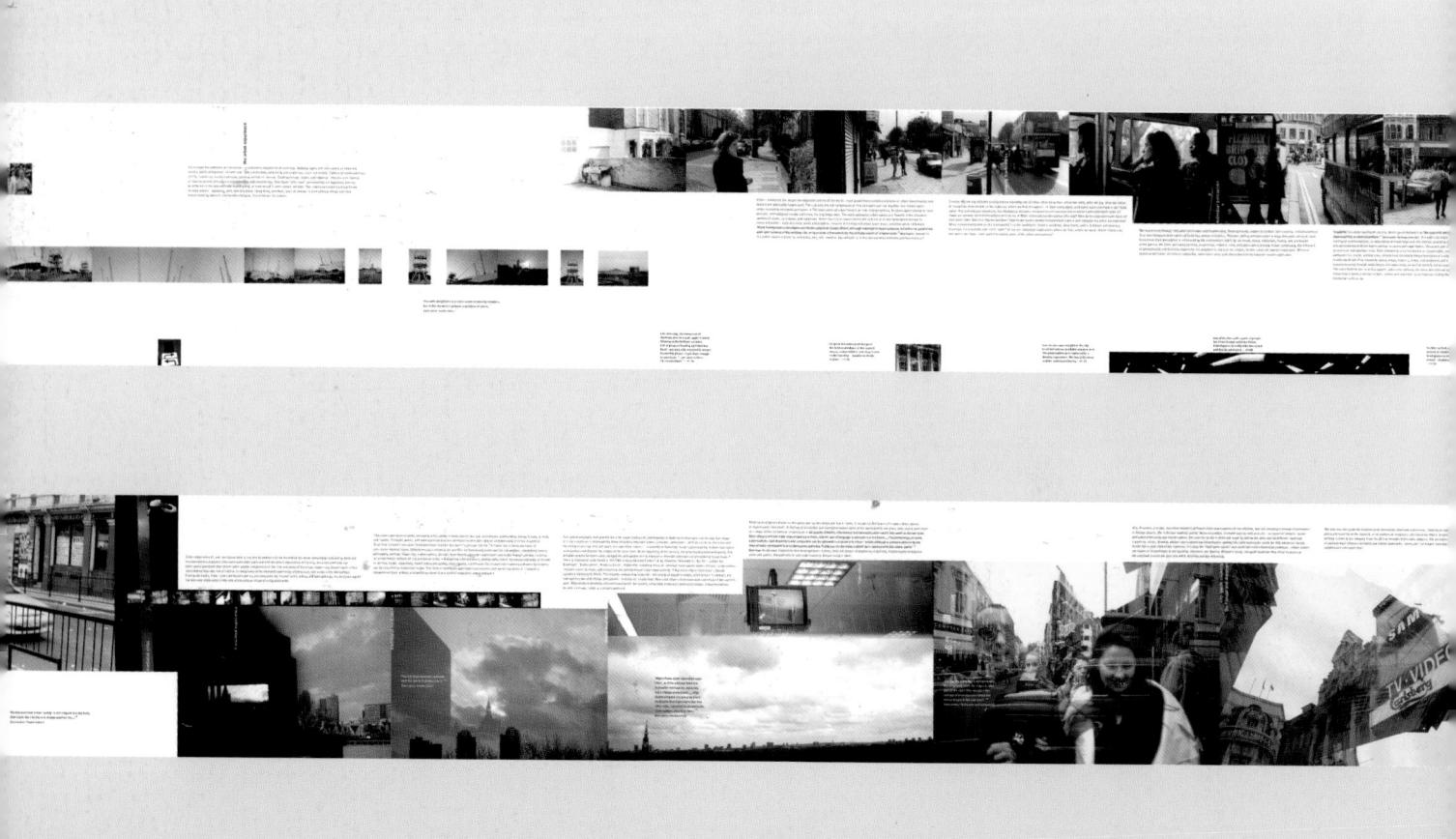

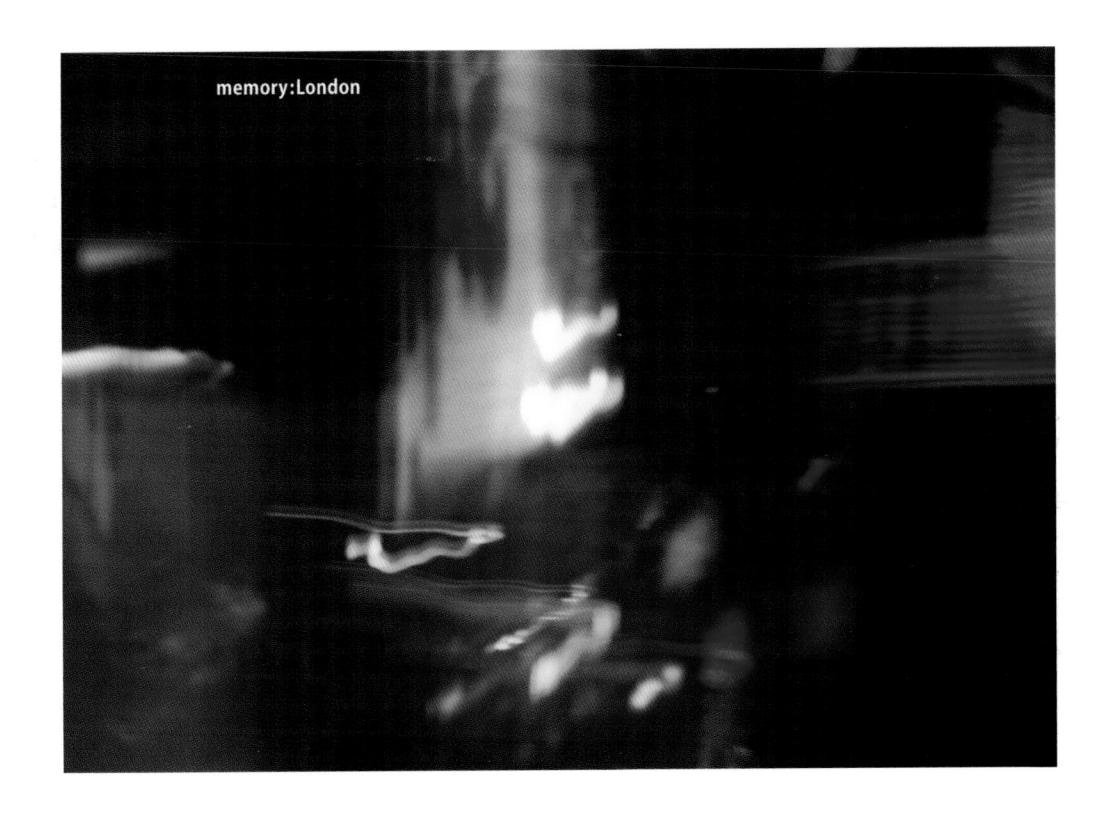

At this stage in the visual narrative, the insertion of small color images within an expanse of monochrome both surprises and hints at what is to come.

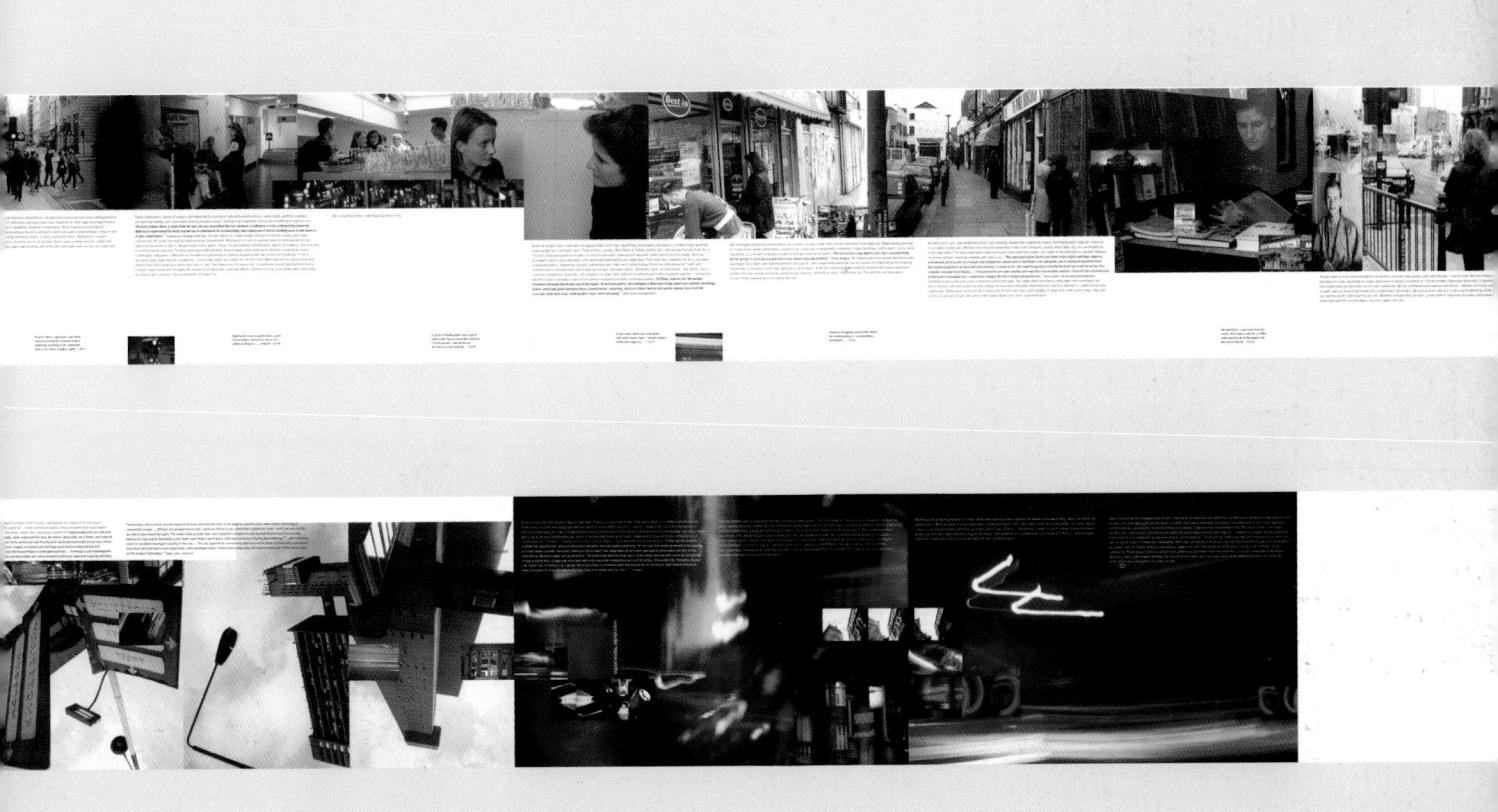

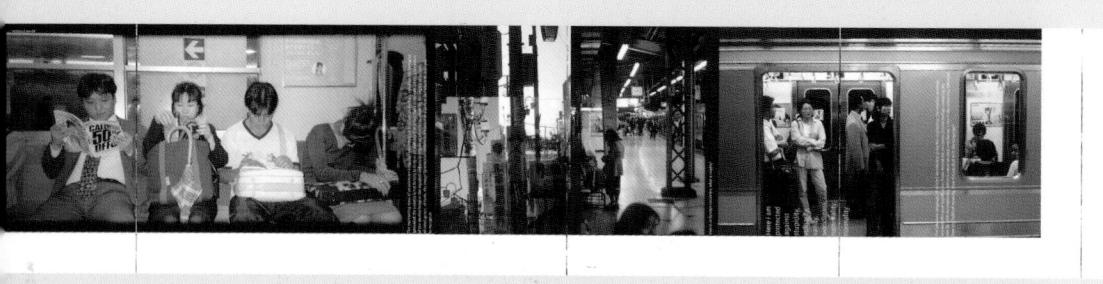

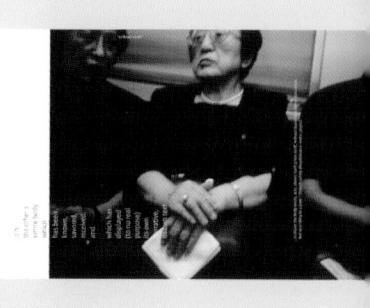

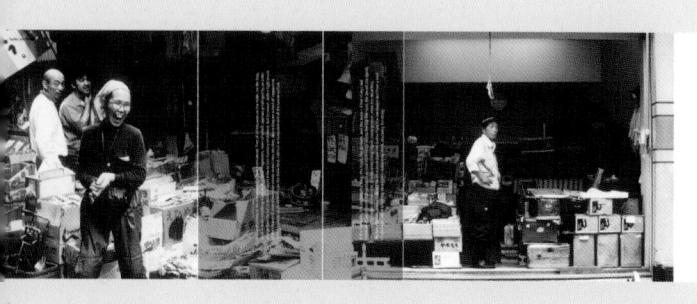

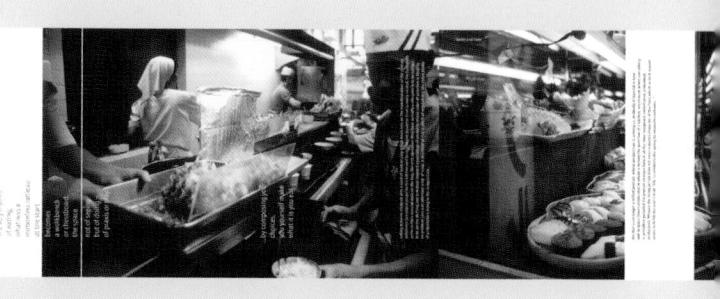

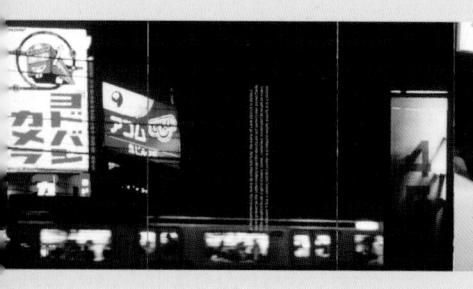

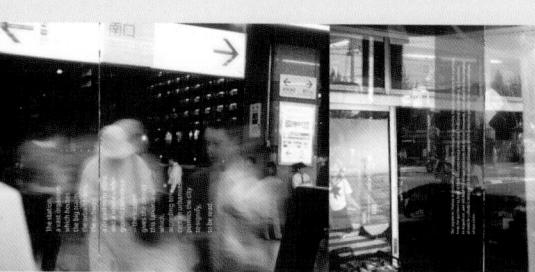

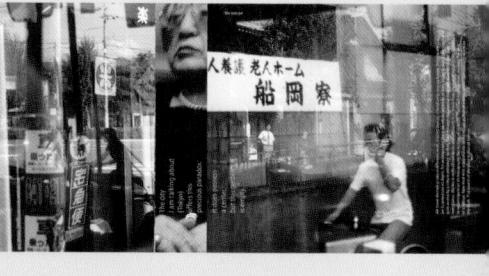

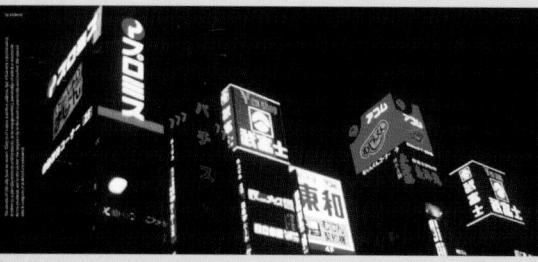

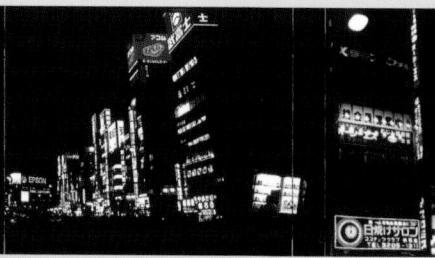

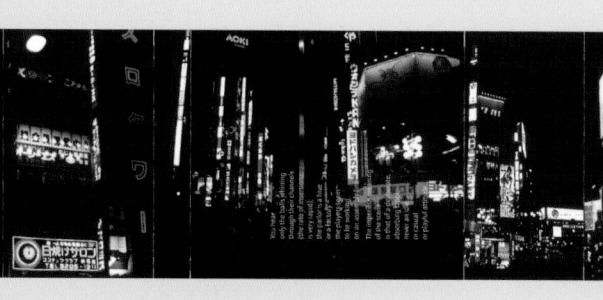

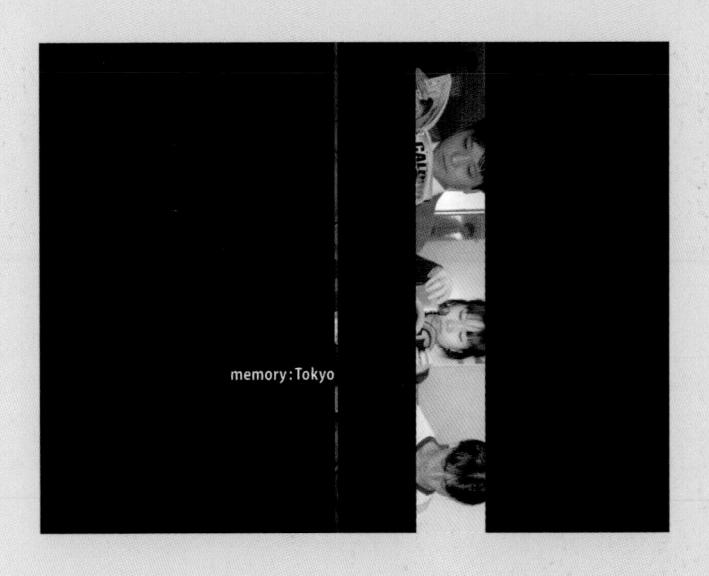

memory: Tokyo

With references to the layout of traditional Japanese calligraphic scrolls the designers have created friezes of imagery—sometimes out of separate images, sometimes one enormous picture—that play with the reader's sense of scale and intimacy. In contrast to this, the bulk of the text has been folded into the book and presented in a more formal way against the plain paper.

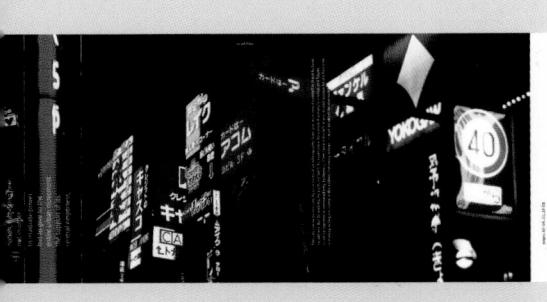

Page Dimensions (memory: Tokyo) 150 x 200 mm 5⁷/s x 7⁷/s in Opening to a maximum width of: 1,760 mm, 69 in

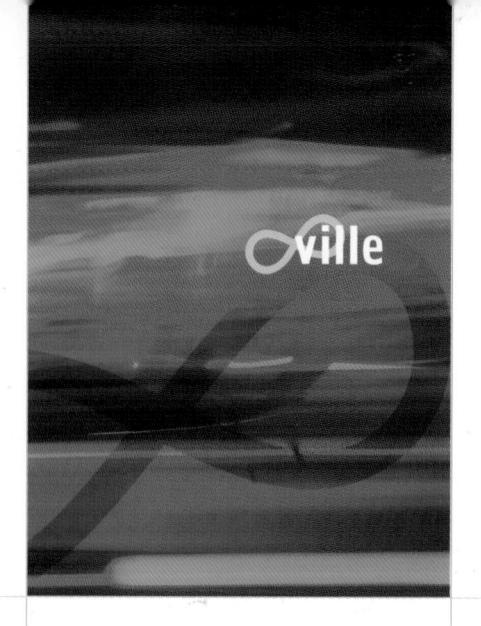

Designers

Esther Mildenberger, Brian Switzer

Photographers

Fran Thurston, Esther Mildenberger, Brian Switzer, students

Design Company envision+

Country of Origin

Germany

Description of Artwork

Catalog for the Architecture & Interiors Department at the Royal College of Art, London.

Page Dimensions

150 x 200 mm 5⁷/₈ x 7⁷/₈ in

Format

Catalog

8th Floor Annual 1998: Infinity-ville

Documenting projects that explore the boundaries of architecture and virtual space, this catalog reflects these concerns in its design by the use of gridlines and a strong structural band across each spread. The bold use of a second color adds real power to the look of the spreads. The cover, on the other hand, takes its cue from the title and uses the two colors to create a more abstract and endless feel.

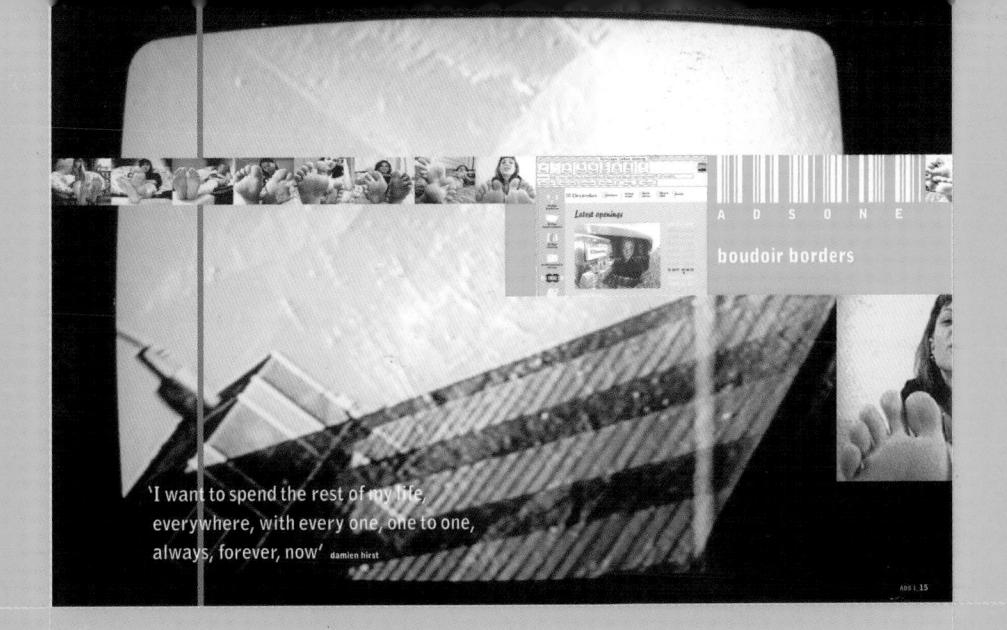

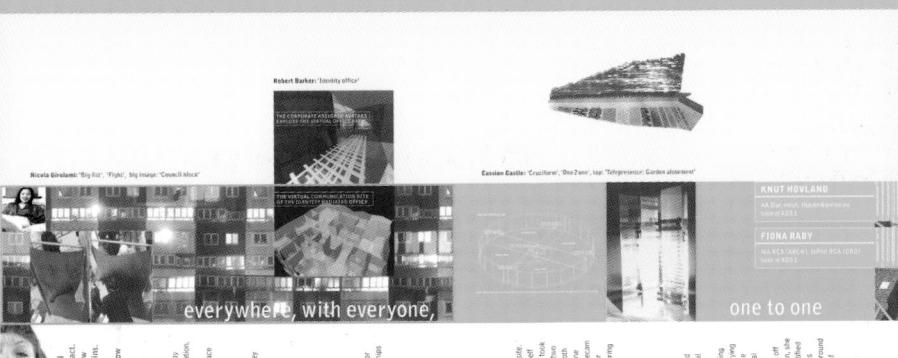

Electronic Legisland, in Secretary and The Call application of the control in application of the Call and Call application of the Call and Call application of the Call and Ca

URBAN LOVE

TRIANGLE:

Three-way Living

'Apartment for "three-way" bring'

The aim of in grouper is to translate the ever flowering winter interests between Yellow incoming interests across the globe with a physical relationship interests across the globe with a physical physical physical squares which we can be outside as the property of the property of the property of the physical squares which would function as a network of the property of the physical squares which would function as an extension of the physical squares which would function as a network of the physical squares which would function as a network of the physical squares which would function as a network of the physical squares which would function as a network of the physical squares which would function as a network of the physical squares which would function as a network of the physical squares which would function as a network of the physical squares which would function as a network of the physical squares which would function as a network of the physical squares which would function as a network of the physical squares which we have a second or the physical squares which we have a second or the physical squares and the physical squares which we have a second or the physical squares are second or the physical squares and the physical squares are second or the physical squares and the physical squares are second or the physical squares and the physical squares are second or the physical squares and the physical squares are second or the physical squares and the physical squares are second or the physical squares and the physical squares are second or the physical squares and the physical squares are second or the physical squares and the physical squares are second or the physical squares and the physical squares are second or the physical squares and the physical squares are second or the phys

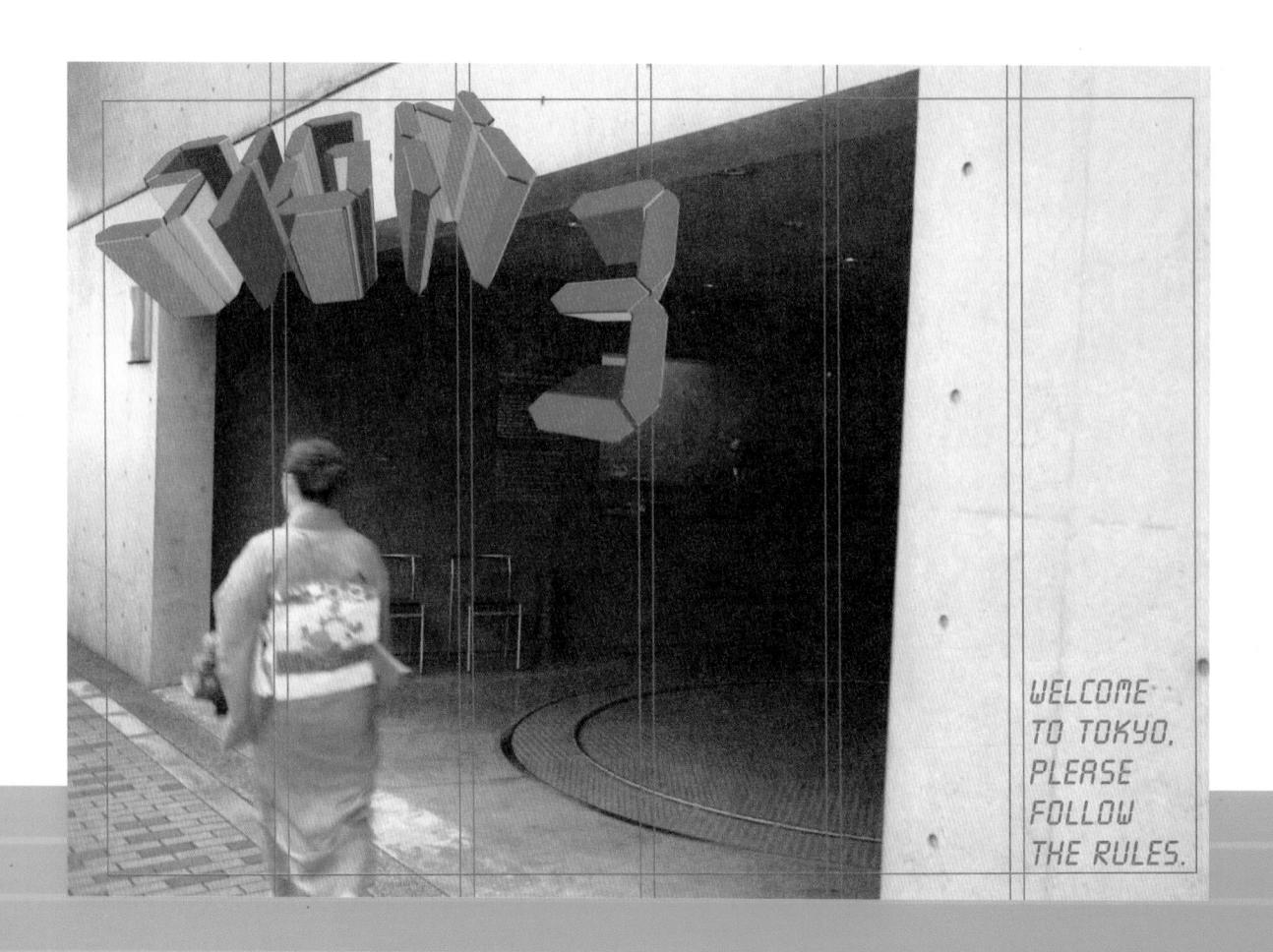

Sign 3, Welcome to Tokyo

This promotional book takes the form of a short trip to Tokyo. At first sight this is an unlikely starting point from which to promote a design company. The informal nature of the photography creates the illusion of familiarity with the circumstance. This is set against the device of a superimposed text grid which refers to the subtitle on the front cover (*left*): Please Follow the Rules. The pictures themselves also reveal the rules and signage of everyday life in Tokyo. Taken as a whole, this distinctive publication explores the possibilities of working imaginatively within a set structure. The highly designed and eccentric page numbers add a quirky and surreal touch.

Special Production Techniques

The book is constructed in the traditional Japanese manner (with spine to the right) so that the sequence of pages runs from right to left.

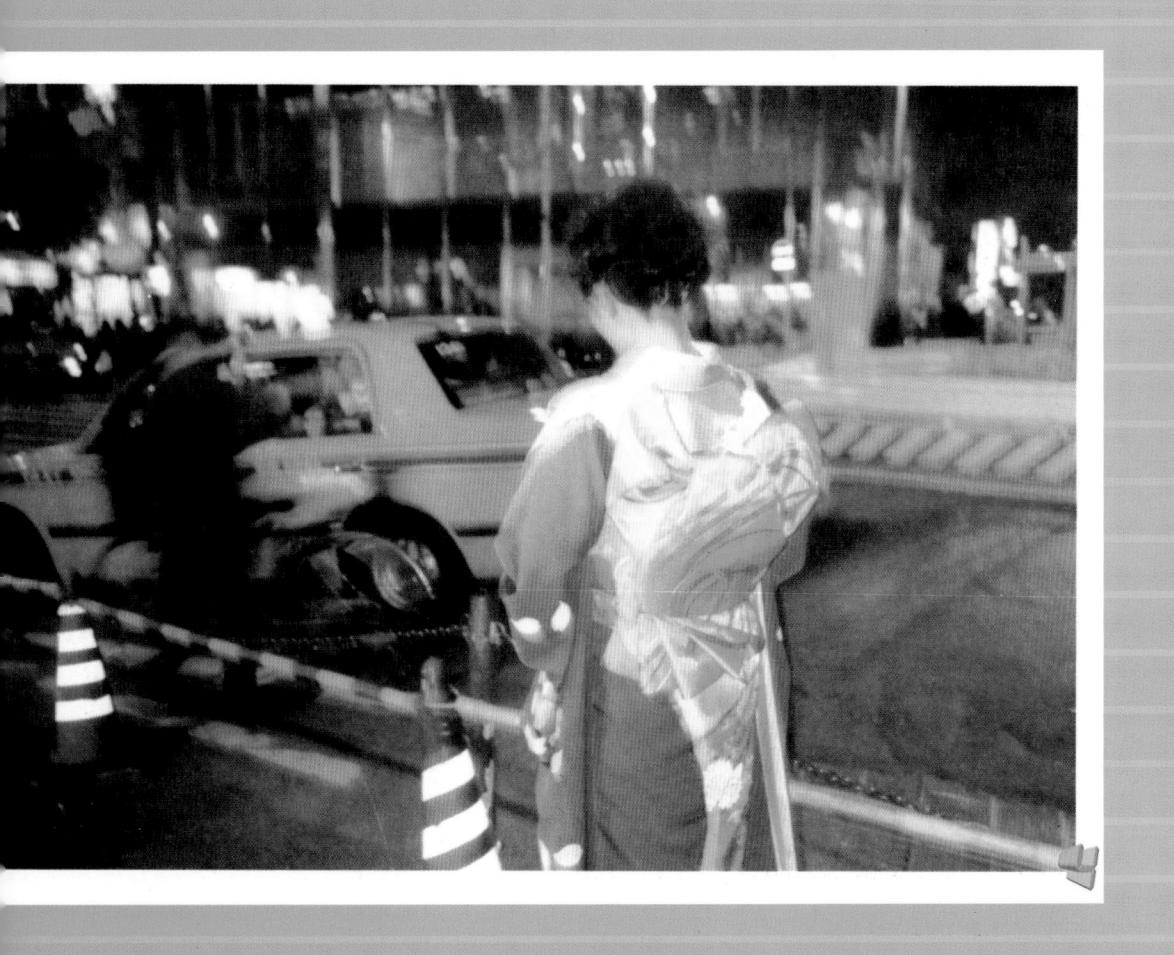

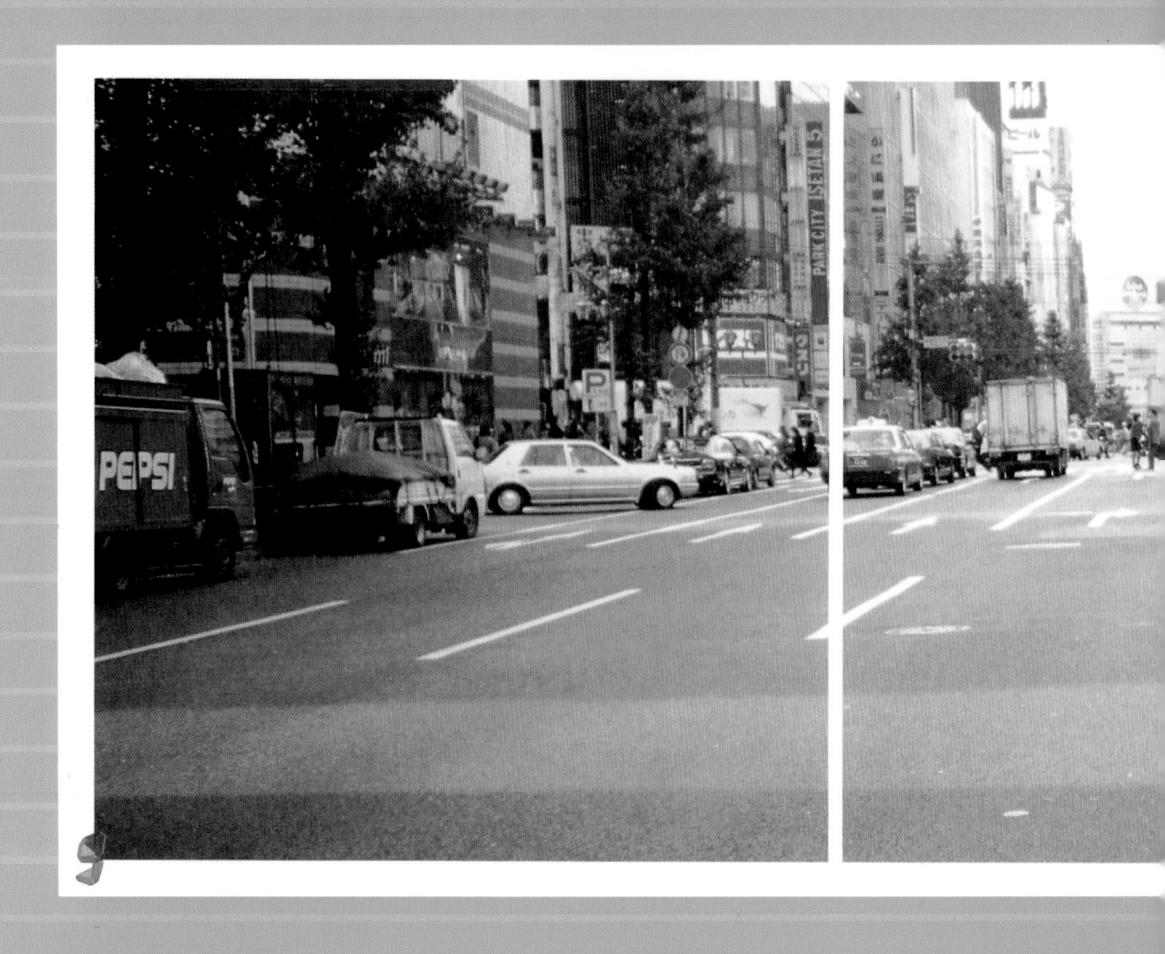

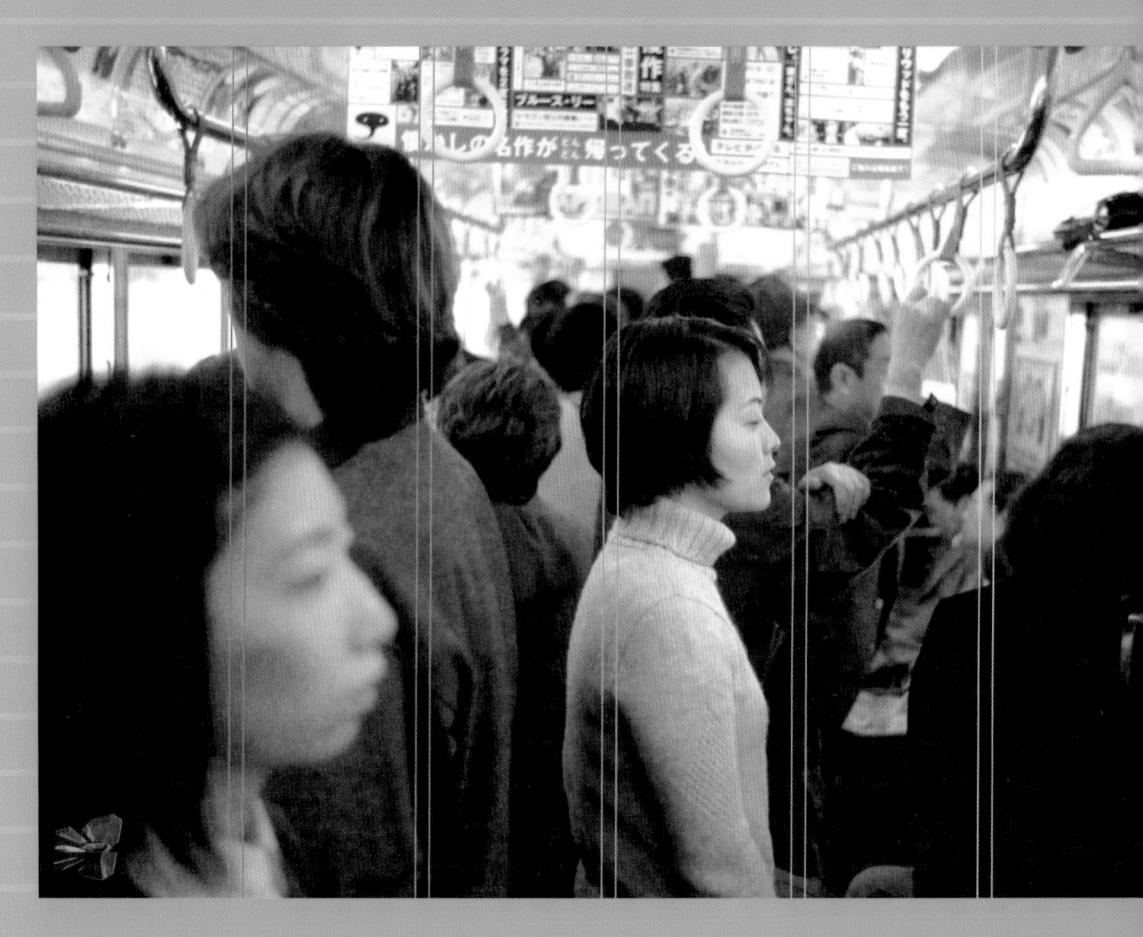

WIE TRANKRA VON "FRNTRSTIC PLASTIC MACHINE" SCHEREN SICH UM KEINE GRENZEN: ENGLISCHE DRUM & BRSS-MAXIS WERDEN IN SCHLRGER VON MARY 5 UND VERGESSENE HITS VON A-HA GEMIXT. UND ALLES TOBT UND TRAZT. OHNE DROGEN UND MIT WENIG ALKOHOL DRUERT JEDE NACHT BIS ZUM HEN MORGEN. UM FÜMF UHR NIMMT DIE U-BAHN DEN BETRIEB WIEDER AUF.

, 21, IST 50 EINER. DER JEDE NACHT DURCHHÄLT UND DOCH JEDEN MORGEN UM ZEHN UHR IM EIMER DER SECOND-HAND-BOUTIQUEN SEIMES VATERS RITT, UM SELTENE LEVIS-JERNS UND ANDERE MODE-RARITÄTEN ZU VERKAUFEN. ER TRÄGT JERNS RUS PAPAS LADEN, EIN HAWAII-HEND ("SEHR GÜNI") UND MIKE-TURNSCHUHE, VON DENEM ER BEHAUPTET, DASS ES SIE NUR EINEN TAG ZU KAUFEN GAB. DIE GELDSCHEINE, DIE ER RUS DER TASCHE ZIEHT, IN FRISCH GEDRUCKT AUS, UND OB NUM DIE TOURISTEN AUS GERNANY DOER OOCH AUS JAMAIKA KOMMEN, DAS IST EGAL. WICHTIG IST IHM NUR, WAS MARKEN SIE TRAGEN. UND DIE KRISE? HITO STUTZT EINEN KLEINEN RUGENBLICK. "WELCHE KRISE?" FRAGT ER SCHLIESSLICH."DAKNE GELD ABER WIRD UYA ZU EINEM TRAURIGEN ORT. EINZIG IM YOYOGI PARK, ABSEITS DER LÄRMENDEN EINKAUFSSTRASSEN, FINDET EIN LEBEN STATT, DAS NICHT IN YEN ESSEM WIRD. DRAG QUEENS STELLEN SICH ZUR SCHAU, SCHULMÄDCHEN FÜNKEN AKROBATISCHE TÄNZE VOR, UND AMATEURBANDS LÄRMEN UM DIE WETTE. PULSIERT DER ENERGIESTROM, DER SHIBUYA DURCHZIEHT, EIN WENIG LANGSAMER.

BÖCKER UND CHRISTOPH DRLLRCH IT ERSCHIENEN IN SPIEGEL KULTUR EXTRR. HEFT 1/1998 **Designer** Antonia Henschel

Art Director Antonia Henschel

Photographers
Antonia Henschel, Ingmar Kurth

Country of Origin Germany

Description of Artwork
A 62-page book, third in a
series promoting the German
design company Sign
Kommunikation GmbH.

Page Dimensions 297 x 210 mm 11³/₄ x 8¹/₄ in

Format Book

DESIGN FOR BUSINESS

Businesses from across the whole commercial spectrum rely on fresh, imaginative design to differentiate themselves from their competitors. The work presented here—calendars, websites, brochures, and catalogs—has been commissioned by companies as diverse as the *International Herald Tribune* and Ultramagic, a Spanish hot-air balloon manufacturer.

BECTION TWO

Designer

Mark Rogerson

Art Director Mark Rogerson

Photographer International Herald Tribune archive

Design Company Mark Rogerson Associates

Country of Origin

Description of ArtworkCalendar for the *International Herald Tribune* newspaper.

Dimensions 180 x 180 mm 7'/* x 7'/* in

Format Calendar

Herald STERNITIONAL Tribune.

PARABUS WIT THE WE THEN AND THE WARRENDER PARE
THE WORLD'S DAILY NEWSPAPER

Hong Kong, Tuesday, July 1, 1997

In a former Colony, the dawn is red. 1000 protesters defy Beijing as it selebrated its resumption of sovereignty over Hong Kong. Martin Lee vowed to remain 'the voice of Hong Kong,' and called on the new rulers to scrap the Beijing appointed legislature.

T:01	W:16	
W:02	T:17	
T:03	F:18	
F:04	S:19	
S:05	5:20	
S:06	M:21	
M:07	T:22	
T:08	W:23	
W:09	T:24	
Γ:10	F;25	
:11	S:26	
S:12	S:27	
3:13	M:28	
M:14	T:29	
1:15		

Chinese New Year (Dragon) Valentine's Day Paranirvana Day

14 15

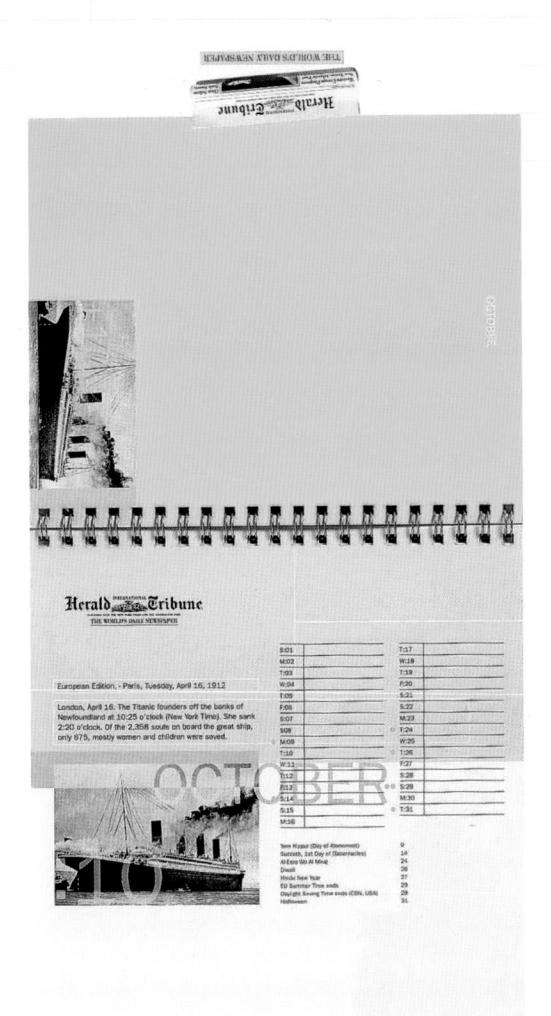

International Herald Tribune 2000 Calendar

This strong design for the *International Herald Tribune*, a traditionally monochrome newspaper, celebrates a century of news reporting by using text quotes and photographs from the paper's archives. The layout is based on a simple structure of four blocks: the large area of yellow; the position of the picture within that color area; the dark gray area on the other side; and the position of the second photographic image. The fixed position of the logo and rolled-up newspaper is orientated for when the calendar is stood up. The well-considered clarity of the typography in a sans serif typeface and the clever way its positioning is varied for each month, makes this apparently simple solution satisfying and fresh for each month of the year.

Welcome to Global.Extra, from BT Worldwide – External Affairs. This site links up BT's Public Relations and Public Affairs communities around the world, including our joint ventures and our global PR agencies. This site will continue to evolve, so please send us your suppositions and contributions to help us keep the site up to date.

NOME NEWS LIBRARY COMMUNIQUÉ ORGANISATION BT'S WORLD PRI ACTIVITIES PA ACTIVITIES

USEFUL SITES
BT INTERNATIONAL LIBRARY COLLECTION
BT PICTURE LIBRARY
HOW TO USE THE LIBRARY
BROWSE THE LIBRARY, SELECT & ORDER PHOTOGRAPHS

BT FACTS
BT & THE ENVIRONMENT
COMMUNICATIONS, RESEARCH & ANALYSIS
PLACES TO VISIT
A SHORT HISTORY OF BT'S WORLD

NHO ARE WE NHAT WE DO ROLLING ISSUE REPORT

VISIT OUR EXTERNAL WEBSITE - CHOICE.COM LIBERALISATION MILESTONES

BT Global Extra Intranet Site

Simply using the logo and web-page title in a set position above the navigation bar, over similarly treated abstract imagery, gives this site a clean, stylish, and consistent appearance. The strong typographic framework provides a corporate look to a site which contains much diverse information. The regularity of the design also makes it easy for users to familiarize themselves with the site layout and enables them to find relevant information quickly.

Designer Mark Rogerson

Art Directors Mark Rogerson, Jonathan Brade

Photographer Jonathan Brade

Design Company Mark Rogerson Associates

Country of Origin

Description of Artwork

Intranet site for British
Telecom Worldwide External
Affairs used by BT's
advertising agencies and
PR companies to source BT
information including the
latest news, logos, corporate
guidelines, and stock
photography.

Dimensions Varies to screen size

Format Website

Designer Martin Brown

Art Directors Jim Sutherland, Pierre Vermeir

Photographer

Phil Starling

Design Company

HGV Design

Country of Origin

Description of Artwork

Spiral-bound direct mail brochure for a rail-based parcel-courier company.

Dimensions (Main Page)

297 X 210 mm 113/4 x 81/4 in

Format

Brochure

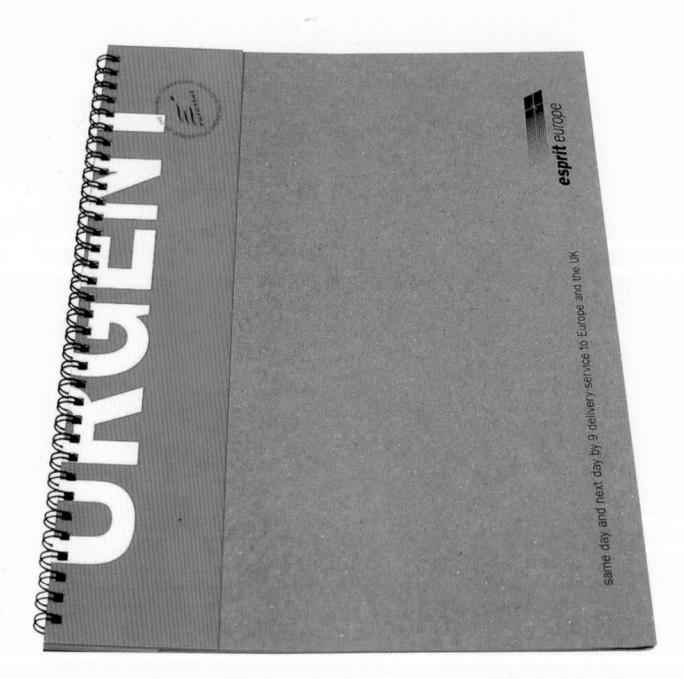

Esprit Europe Brochure

This imaginative brochure combines high-quality photography, railway-inspired graphics, and an ingenious use of spiral binding to produce a very effective promotional publication that works on many different levels. The photography evokes the romance and speed of the train, while the text is presented in ways that directly connect with the graphic devices employed at railroad stations. For example, the clever use of spiral binding and alternate thin 'flip' pages mimics the rollerdeck-style of announcement board used in many station terminuses.

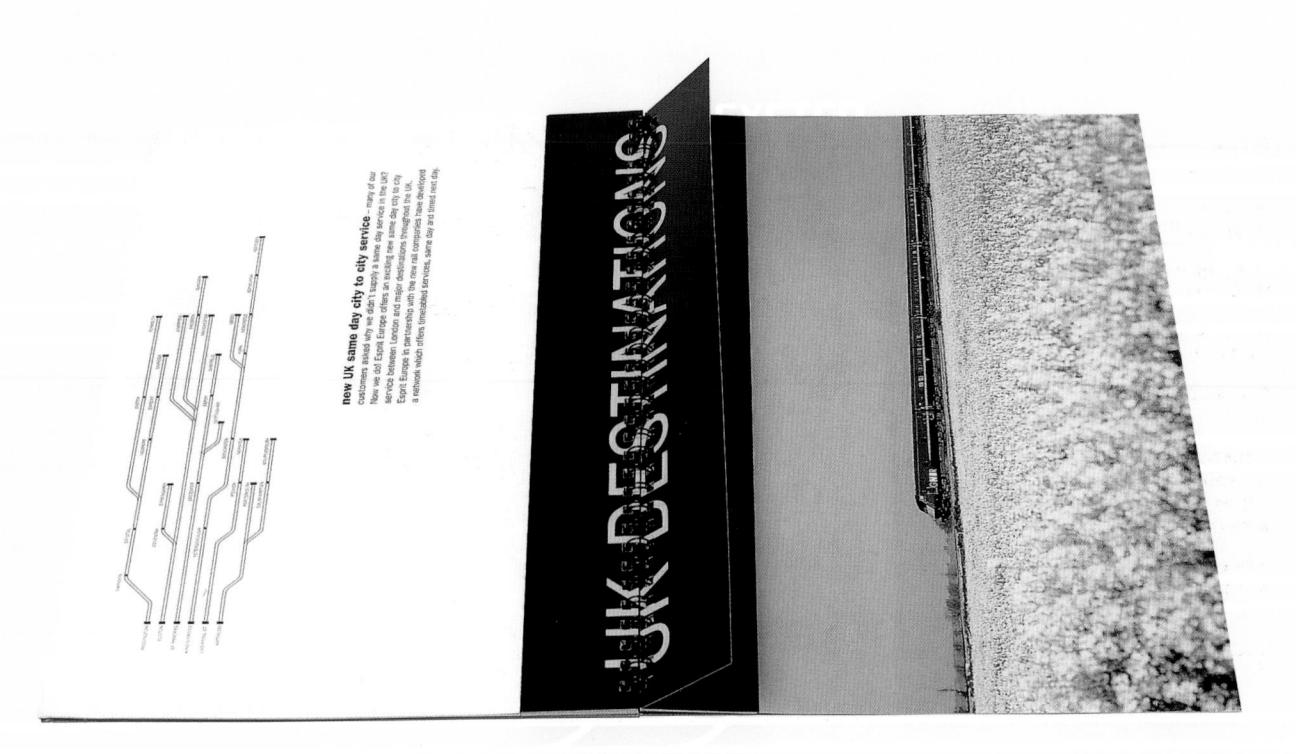

Visual references to the railroad are used to enliven the text. Here, the information is presented in the form of a railroad network diagram.

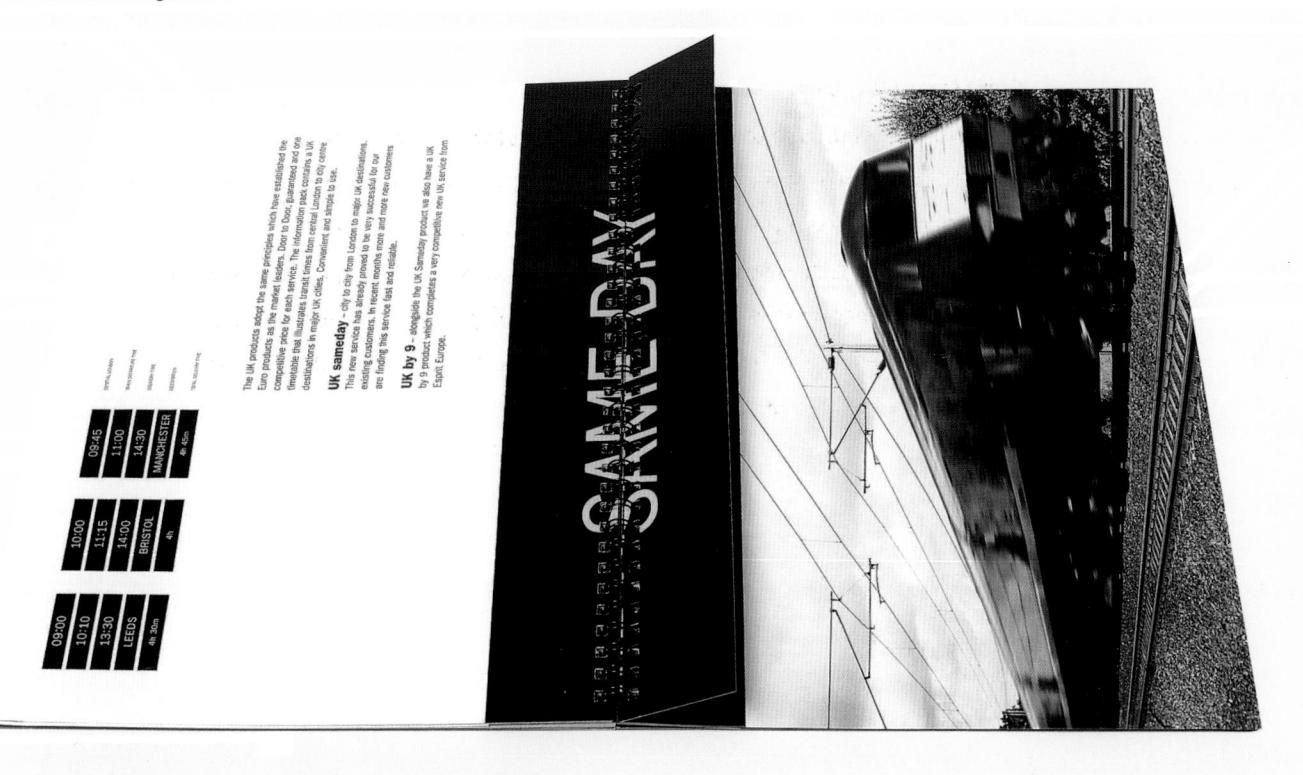

The thin 'flip' page not only allows two different messages to be presented on the same spread, but also involves the reader in flipping the page to find out what is hidden beneath.

Immortality Poster

Created as part of a promotion for paper, the designer has chosen images 'to depict the immortal quality' of the medium. The juxtaposition of images and text draws the reader in and creates a beguiling atmosphere; while the treatment of the typography (different typefaces used in a variety of colors, sizes, and states of legibility) adds texture to the overall composition.

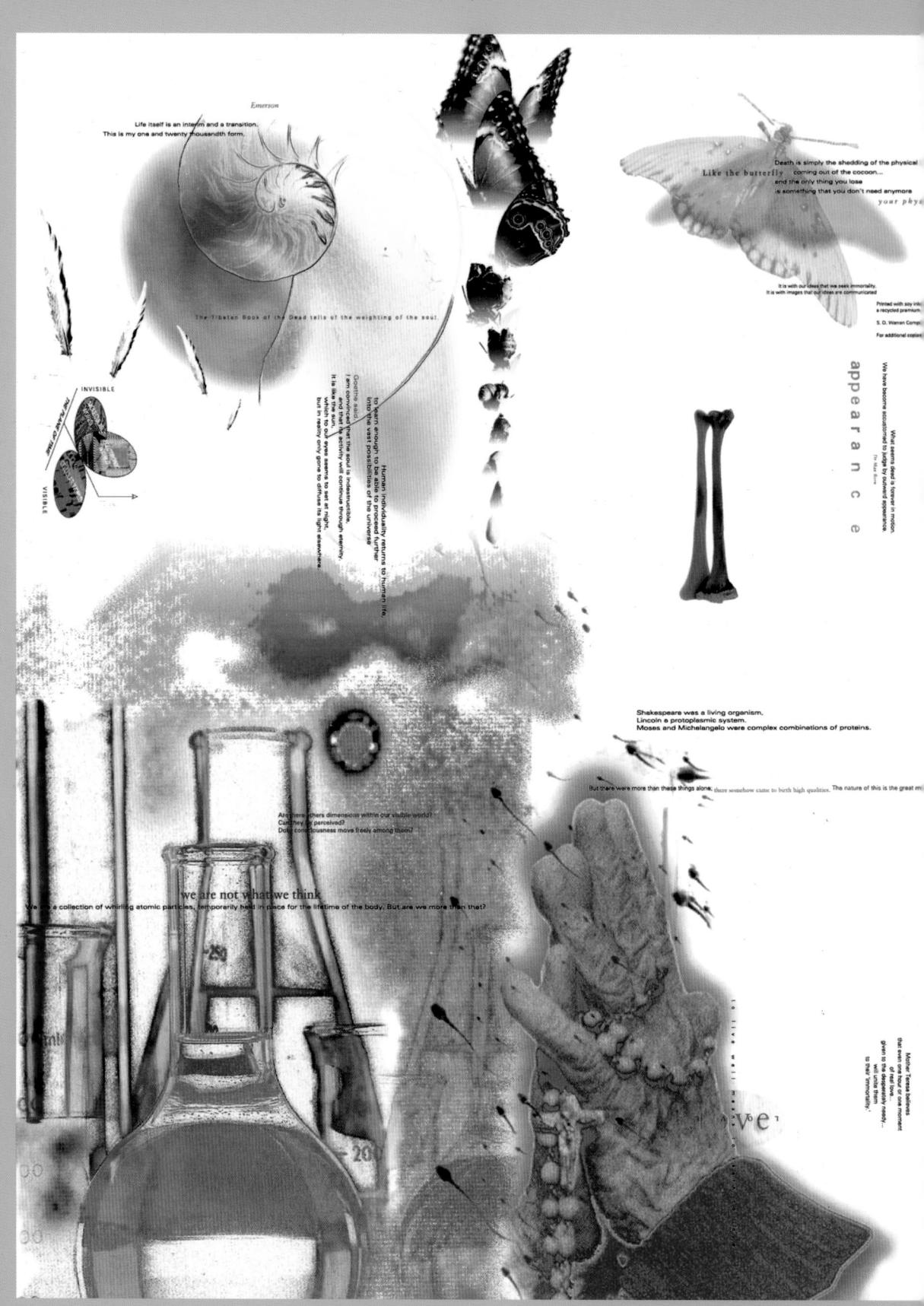

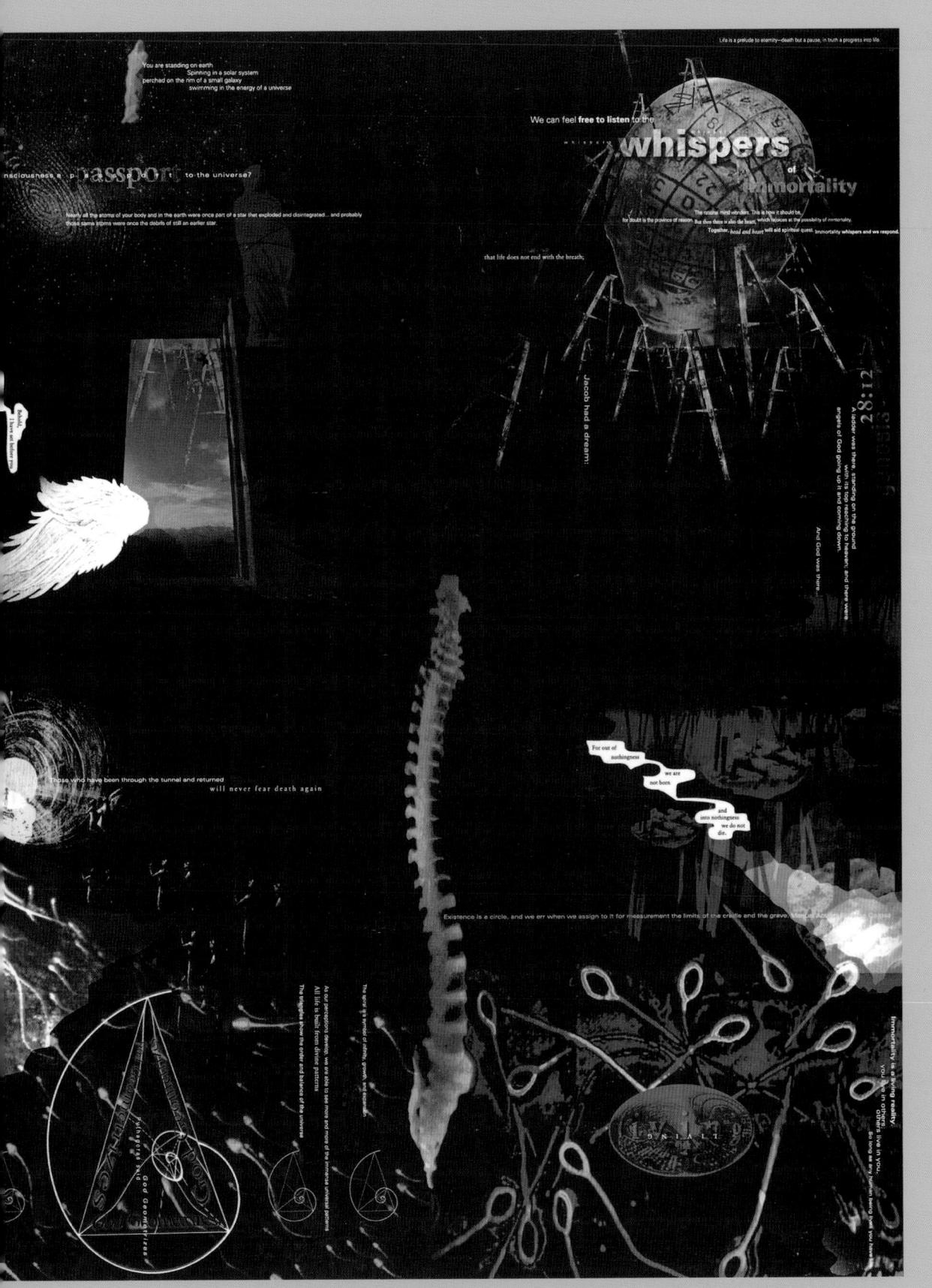

Designer Rafael Esquer

Art Director Rafael Esquer

Instructor Steve Madden

Art College Art Center College of Design

Country of Origin USA

Description of Artwork
Double-sided concept poster
designed to promote the use of paper.

Dimensions 550 x 710 mm 21³/₄ x 28³/₈ in

Format Poster

Ultramagic

Ultra magic

Balloons

熱気球 Heißluftballone

Montgolfières

Globus

Montgolfiera

Balónu

Ballonger Kuumailmapallot

Balões

Ballons **АЭРОСТАТЫ**

Ultramagic

The simple line-and-flat-color cover (*opposite*) gives little away about what to expect inside this multilingual catalog. Once inside, images and text seem to float across the page, creating a sense of space and freedom. The catalog has been used to promote the bespoke nature of balloon construction and to encourage the reader to start imagining their own design by the inclusion of color swatches down the side of one spread (*bottom*, *right*).

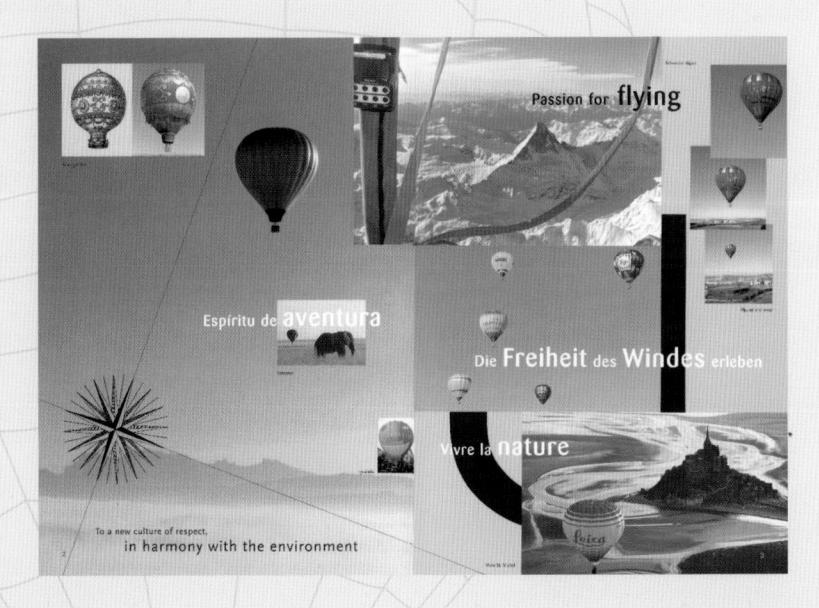

Left: the inclusion of historical imagery sets up a contrast that emphasizes the modern nature of ballooning.

Below: the images of a balloon under construction illustrate the high degree of care and attention to detail offered by the company.

Designer Lluis Jubert

Art Director Ramon Enrich

Illustrations Ultramagic Archive

Photographers
Roger Velazquez and

Design Company Espai Grafic Country of Origin

Description of Artwork Promotional catalog for a balloon factory near Barcelona.

Page Dimensions 210 x 295 mm 81/4 x 115/8 in

Format Catalog

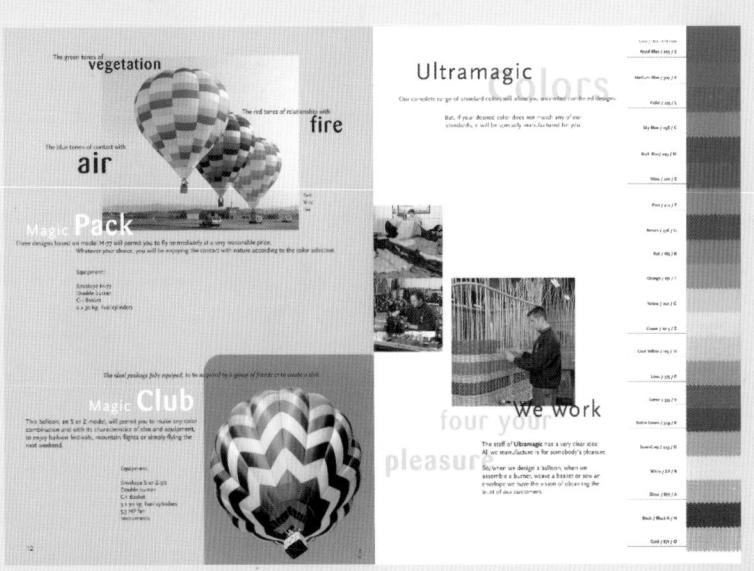

Ocean Pacific

The opening animated sequence (*opposite*) establishes a visual style within which different types of information can be presented while maintaining the overall identity of the company Ocean Pacific. This complex site combines text, still images, and short animations in a highly appealing and accessible format.

Opposite: the motif of rising bubbles, first seen in the opening sequence, is subsequently used as a device to access information. When the cursor is placed over the word LIFESTYLE, bubbles rise from behind it to reveal two options: 'boys' or 'girls.'

Right: two main graphic devices are employed to help separate different types of information—the division of the screen 75:25 (top), and a black rim along the bottom and right-hand side (center and bottom).

Designers

Mark Allen, Adrianne De Loia, Alejandra Jarabo, Chris Martinez

Art Director

Adrianne De Loia

Illustrators

Adrianne De Loia, Alejandra Jarabo

Photographer

Adrianne De Loia

Design Company

Kick Media

Country of Origin

USA

Description of Artwork

Website for Ocean Pacific, showcasing clothing, lifestyles, games, surf pro, and the surf dance.

Dimensions

640 x 480 pixels

Format

Website

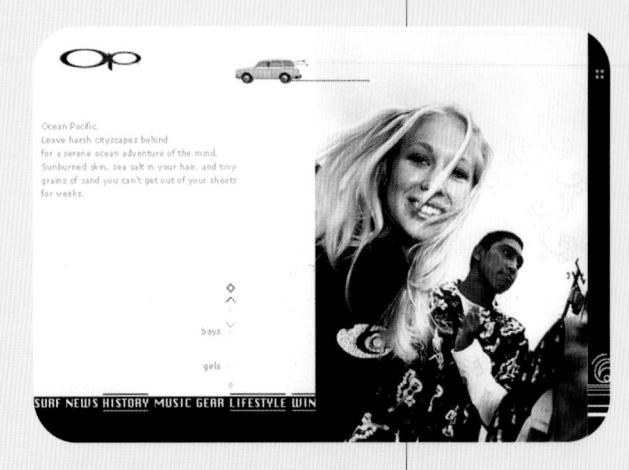

Paperboard international

Groupe Cascades

calendai

calendrier

1999

CALENDARIO

Les Industries Paperboard International Calendar 1999

The brief was to promote the equipment used in the production of paperboard. The designers have taken images which are in themselves descriptive rather than inspirational and have used the design to suggest the advanced nature of the technology. The use of geometric patterns and a consistent style of type and color panels draws together the different qualities of the photographs, presenting them in a fresh and dynamic way.

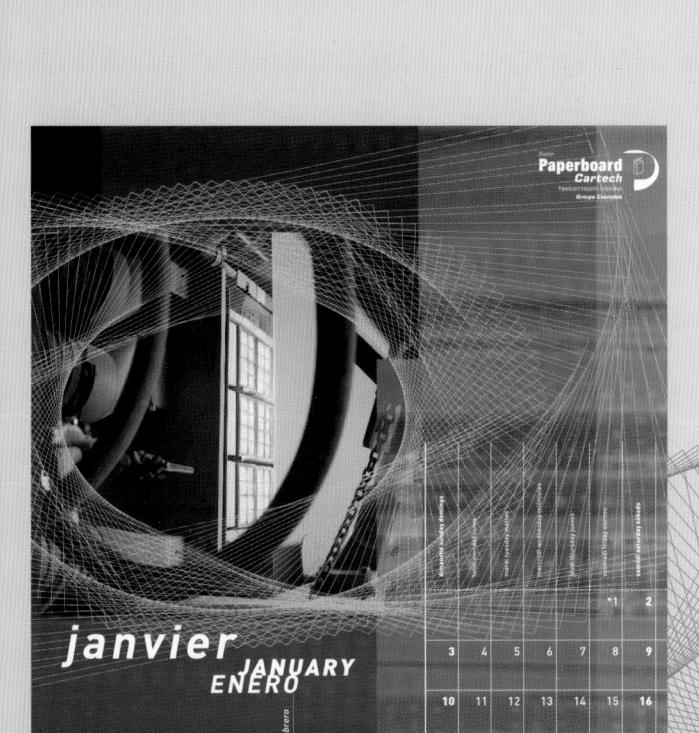

MARZO

Designer Cathoning Patter

Catherine Petter

Creative Directors
Daniel Fortin, George Fok

Art Director Catherine Petter

Illustrator Catherine Petter

Photographer

Jean-François Gratton

Design Company Époxy

Country of Origin Canada

Description of Artwork

Trilingual calendar designed to showcase the high-tech equipment of Les Industries Paperboard International.

Dimensions 406 x 507 mm 16 x 20 in

Format Calendar

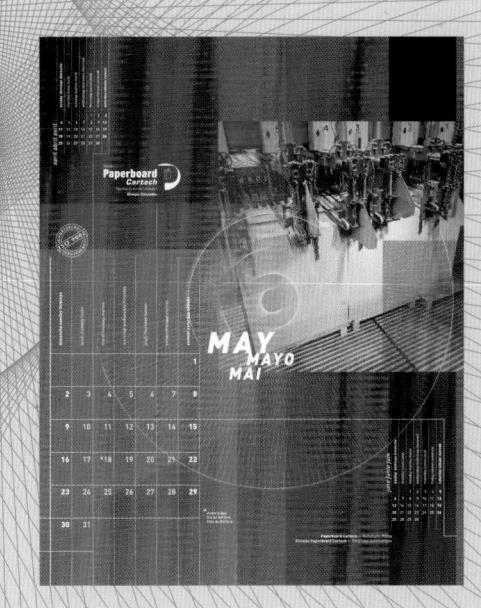

october octobre octubre

	sunday domingo dimanche	monday lunes lundi	tuesday martes mardi	wednesday miércoles mercredi	thursday jueves jeudi	friday viernes vendredi	saturday sábado samedi	
							2	
	3	4	5	6		8	9	
	10	11	12	13		15	16 23	
湯	17	18		20	21	22	23	
	17 24 31	25	26	27	28	29	30	
	31							

NOVEMBER NOVIEMBREN

100 | 10

mber diciembre d

erboard Jonquière — Pulper sion Paperboard Jonquière — Tritura

sunday domingo dimanche	monday tunes tundi	tuesday martes mardi	wednesday miércoles mercredi	thursday jueves jeudi	friday viernes vendredi	saturday sábado samedi
	1	2	3	4	5	6
7	8	9	10	*11	12	13
14	15	16	17	18	19	20
21	22	23	24	25	26	27
28	29	30				

HARRIS

Remembrance Day Jour du souvenir Día del recuerdo

Paperboard Jonquière
mbre november	domingo dimanche sunday	lunes lundi monday	martes mardi tuesday	miércoles mercredi wednesday	jueves jeudi thursday	viernes vendredi friday	sábado samedi saturday
### Doviembre and ###################################	la l			1	2	3	4
	5	6	7	8	9	10	11
	12	13	14	15	16	17	18
	19	20	21	22	23	24	25
	26	27	28	29	30	31	
Topic Condition							

diciembre DÉCEMBRE DECEMBER

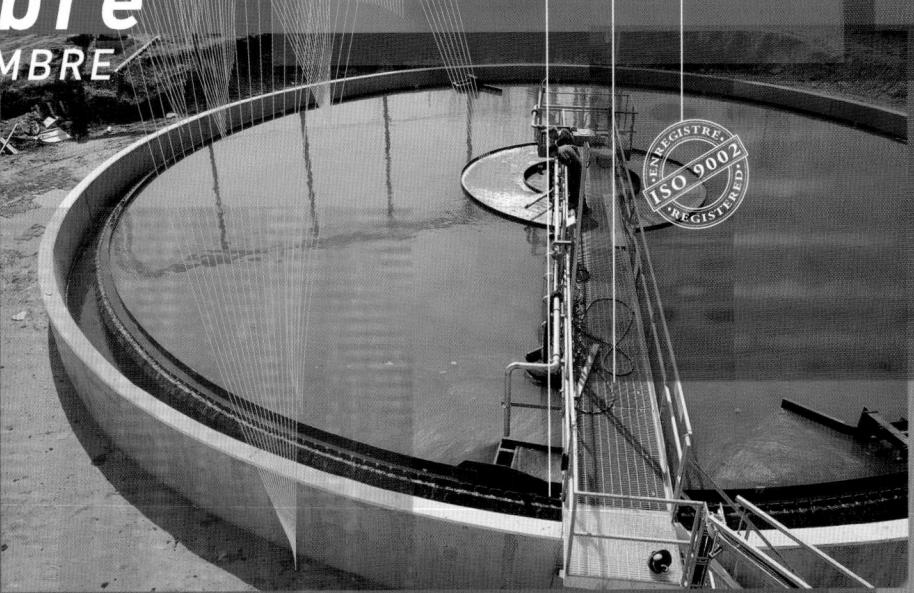

Division Paperboard Jonquière — Traitement des eaux usées Paperboard Jonquière — Waste Water Treatment

DESIGN FOR EDUCATION AND THE ARTS

The pieces shown in this final section are centered around the worlds of education and the arts. Cultural websites, university-faculty brochures, CD packaging, invitations to art exhibitions—a wide range of design projects, demonstrating an equally wide range of approaches and solutions.

ECTION THREE

Archi

manifesto for an architecture beyond building Aaron Betsky + Erik Adigard

manifesto for an architecture beyond building Aaron Bets

Designers

Erik Adigard, Patricia McShane

Art Director

Erik Adigard

Illustrator

Erik Adigard

Design Company

M.A.D.

Country of Origin

USA

Description of Artwork

144-page book that examines possible strategies for living in an electronic age. Text by Aaron Betsky and Erik Adigard.

Page Dimensions

229 x 279 mm 9 x 11 in

Format

Book

Architecture Must Burn

Bold type and simple flat color give the provocative title (*left*) a powerful presence, while the device of turning parts of the title upside-down suggests the subversive and surprising nature of the book's content. The design inside (*see next page*) contrasts the layered styling of the typography with enigmatic imagery—sometimes bold, sometimes complex and abstract—underlying the atmosphere of architectural chaos and 'sprawl' which is the subject of the text.

The central generator of sprawl is the road. Over a quarter of our urbanized areas are covered with collections of empty arteries that represent no more and no less than potential: places always prepared for movement but in themselves no-place. The road always leads somewhere else, carving out a void and eviscerating everything around it. These days we try to contain **h i g h w a y s** with walls, embankments and regulations, turning them into surreally invisible slashes across our land. As soon as the road slows down, it re-enters the fabric of sprawl, eating out more space for itself with intersections and the I-, U- and L-shaped constructions that allow parking in front of stores and businesses. The road, in other words, seeps out to flatten everything around it to make room for the highest value in our society: not freedom or money, but access.

We have long romanticized the road. It in our or We have long romanticized the road. It was the town if the road once disappeared into a met is the way to freedom, the act of moving beyond tar make as soon as it entered through the city gates, to Eden into an untamed nature. The first humans has become the city walls, in the form of beltways that encircle were nomads, and in some ways we memorial-longer a central urban core, only the "strip" the ized their peregrinations in the earliest roads elongation of commercial and sometimes civic devel-(such as the Road of the Kings that traced the "Houston is a city running away from itself, always further Fertile Crescent). The road is also the way to west," says architect and critic Lars Lerup of his own town. On power, the path of conquest that, at crossings, at enclaves or gridded developme the bottom of mountains or at springs, turns into and sheer presence of the road as the most significant aspect of the landscape. We travel from entry to entry, or along what the Romans called the *cardo*, engendering a rhythm of intersections with a monotonous prethe very urban civilization of which we are so dictability. At a smaller scale still, roads turn into the proud. Their needs framed an entire empire by We try to ourb the creation of more roads, blaming not the proliferating crossroads that connected regions, presence but the vehicles that relendessly use them for the corrosion of our landscape. We think that by limiting the blocks, houses and rooms, all making abstract presence of cars, hiding them behind buildings and geometry real.

In the United States, the road embodies our man-road is more essential and can never be margin ifest destiny. It is the line of escape that accom- just becomes the noute of the light-rail system, the void of the modates ever more immigrants in search of a To many, the road is therefore the great destroyer. New Eden. That perfect place is always located the replaces certainty and place with movement and space. Yet somewhere that is not now and here. It is just manifest destiny to keep moving as the new nomads who have beyond the place where the perspectival edges of freed themselves from the constraints of place and history. It the road out of town converge into infinity. It is a change disintegrate all fixed forms into abstraction. The road place of economic and physical escape, along is a collage generator that mixes and matches the real world into a continually changing composition, which we can move into the future and a better leaving us to be the deracinated interpreters who life by gobbling up rocks and trees on the way and make sense of it all. The artery of sprawl might unleash turning them into usable resources.

most of our metrop olises. In many cities, there is no a smaller scale, neighborhoods have disappeared into planned driveways that dominate our houses' front facades. pooling them in parking garages at the periphery of pedestrian zones, we can defeat the road. But the it is also the great fulfillment of modern culture's dream, our is the ultimate modernist space, where movement, speed and us to the wonder of discovery, even as it seems to destroy a

What makes sprawl work are its magnets of meaning: objects and spaces that provide focus in a disparate world. They can be as big as a football stadium or as small as a pair of blue jeans. The "attractors" catch our attention in the field through which we move every day. They also capture our investments of time and money. Their scale, form and composition are both molded by sprawl and give it definition. Attractors make some sort of sense in the realm of sprawl.

Attractors are what stabilize emergent, entropic systems. Since the advent of chaos theory in science, experts in disciplines as far apart as biology and astrophysics have become interested in how smooth, undifferentiated space begins to differentiate itself into a self-forming, or "epigenetic," landscape around one or more centers of attraction. Systems gyrate in wild loops among these attractors, until they fall into repetitive rhythms and finally freeze into place. It is in the tenuous state between chaos and order that the greatest energy exists in a system. In human terms, such a state might be called creativity, which can occur at times of crisis. Sprawl is also such a state. It used to be that cities coalesced around natural features: the places where it was easy to cross a river, a natural harbor, a spring or a high, defensible point. Humans civilized these features with structures of resistance (castles), the domiciles of those who controlled the feature (traders, warlords) and with expressions of wealth extracted from the surrounding countryside and transformed into symbolic artifacts (cathedrals, mosques).

own landscapes, thrusting up sky tack backefice blocks, places of transportation to trave-droping, are severe as undersorable in the control of the control own landscapes, thrusting up sky- kinds: back-office blocks, places of transportation or trans-shipping, and stadie and conve finance, the monuments to our hat move people or material goods. Despite some attempts to make airports into places of ments where movement becomes beauty, the effects of structural publishment on divisit gales are as feeting as the plaines they visible — railroad stations or free-way overpresses — are today's equiv. Noise. On the outside, arports are spiders' webs of termelis, parking parages, service and surger equiva-alent to the river crossing. Mount spaces, ramps and gates that spread out through seas of tarmed. They have no neco Fuji or New York harbor. As capital has been disseminated able form or relationship to Junion experience.

throughout our landscape, new Sade and convertion centure, the third great standards, do. These lar landmarks have appeared. Some sprout up like the pieces of little pieces of little pieces of thousan sprout up like title pieces of little pieces of the pieces of little pieces o city from which they have field, on synature form, but they are all designed by a handful of terms whose privary concern by shopping malls, office compounds and dense housing arrange. These structures are about booth remails and skytoses, not about the communal experience ments. But a strange inversion of takes place: the point of crossing does not lead to a landmark; instead it becomes the empty comments are private to the threshess in a third veneral properties and extension instead it becomes the empty correct properties are private to the terms of the correct properties. The properties are presented to a properties are presented by the properties and the state of the correct ones. Similarly, large buildings no longer focus on a plazar or square, but on an other unpassable barrier. In the strangest speed, of such attractors is that they have, taken, a world of movement.

inonger rocus on a piaza or square, but on an other unpassable barren of movement. The largest structures one finds in such places are even stranger. Like rocused on places of power and replaced them with realms of leisure. The foundation of the stranger could be an external experiment of the stranger could be an external replaced them with realms of leisure. The foundation of the stranger could be an external replaced them with realms of leisure. The foundation of the stranger could be and the pathering around conventionalized violence castles, they have a closed soft of the stranger could be and the pathering around conventionalized control of the stranger could be an external really by phone cords and the suckedifical distinction of the outside, they look out over seas for parking that let people get as acclosed to the keep as possible without having to contend with weather or undesirable sorts. Inside, the existence manners that the structure structures the structure structure structures the structure and dinner structure out the structure of the structure structure structures the structure structure structure structures the structure structure structures the structure structure structure structures are defined outsides the structure structure structure structures structure structure structures structure structures structure structures structure structures str

Simone Cobbold 10 Butts Road, Stanford-Le-Hope, Essex SS17 OJH (01375) 404 287

"Harry" 1997

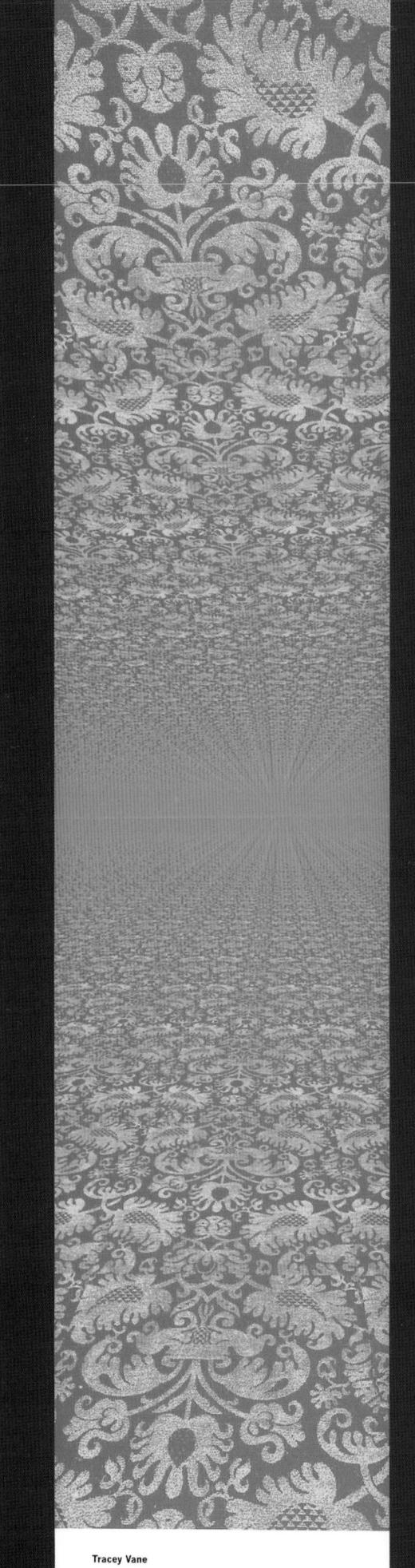

2 May Court, Little Thurrock, Essex RM17 6UB (01375) 384 042

"Damask!" 1998

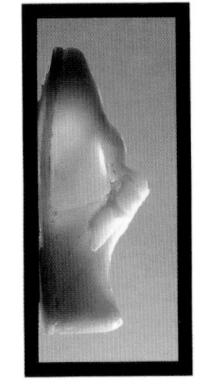

Beverley Holgate

Coggeshall Hall, Coggeshall Road, Kelvedon, Colchester, CO5 9PH

(01376) 570 394

"Untitled" 1998

Stretched

way to display the wide range of work on show. allusion to the relationship between art and commerce, is a striking the best light. The use of the 'check book' format, with its subliminal been individually designed to present the featured artist's work in The layout of each double-page spread in this college catalog has

Damask! utilizes the long format brilliantly to create the illusion of a limitless Second from left: with the gutter as a horizon, the layout for Tracey Vane's

to this spread. between the two pages of Beverley Holgate's Untitled giving a delicate feel the images, the designer has set up an ambiguous, questioning relationship Third from left: by leaving as much blank space as possible between

Designer Gavin Ambrose

Art Director

Gavin Ambrose

Photographer

Design Company Arnold Borgerth

Mono

Country of Origin

Description of Artwork

48-page brochure for the 1998 graduation exhibition of the BA Goldsmiths' College, London. Textiles degree course at

210 x 85 mm Page Dimensions

81/4 x 31/4 in

Brochure

Format

PREMIERE 24 25 26 1998 BITE:98 PHILIP GLASS ROBERT WILSON 瓣 Barbican Centre OBE

BITE:98 YRIL BIRC TAN DUN
DIRECTED BY
PETER
SELLARS TANG THE MEANING OF LIFE - EXPLORED type. A FUSION OF DANCE, BITE:98 IN A DAZZLING TECHNO EVENT

JSIC, LIGHT AND SOUND RENOWNED PIONEERS,

器 Barbican Centre

Box Office 0171 638 8891 ...

Box Office 0171 638 8891 Bigging (Bann)

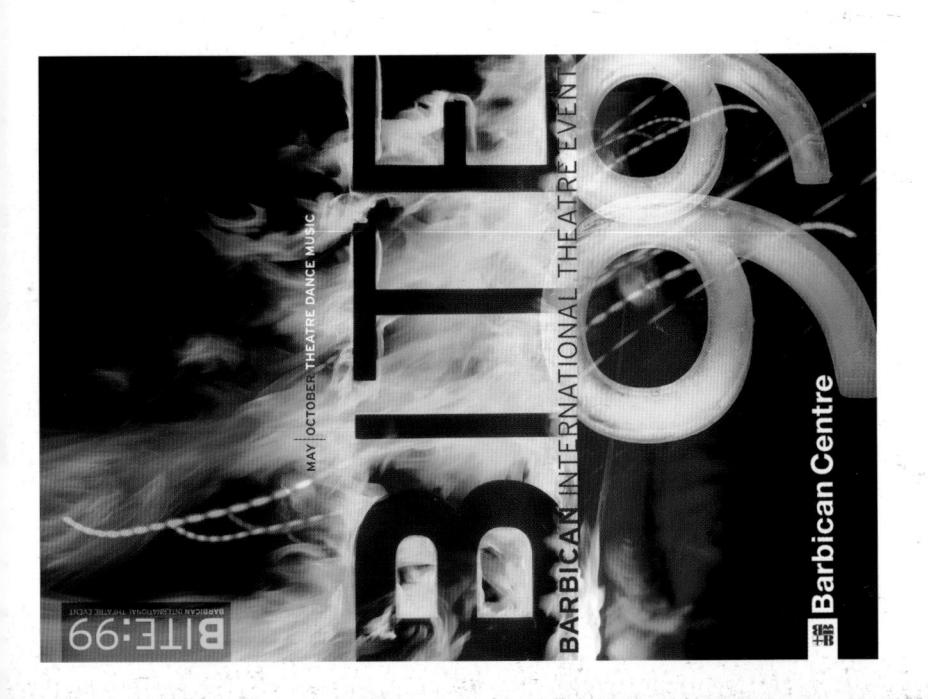

treatment has been carried through to the inside (below) where it is contrasted, very effectively, with the clean, asymmetric typography.

developed to become the central point of the dramatic and surreal imagery used on the cover of the festival brochure (left). This fiery

the BITE umbrella. For the 1999 season, the logotype was further

The diversity of the events within the 1998 season of this international theater festival is reflected in the promotional leaflets (above). One of

Barbican Centre BITE:98 and BITE:99

position. This is enough to indicate that all three events belong under

the few constant elements on them is the festival logotype and its

Designers Why Not Associates

wny not Associates Design Company Why Not Associates

Photographers

Photodisc (BITE:98 Monsters of Grace and Peony Pavilion), E. Valette and Rocco Redondo (BITE:98 GR), Rocco Redondo (BITE:99 Brochure)

Country of Origin

Description of Artwork
Promotional leaflets (opposite
page) and brochure (above and
right) for the Barbican Centre
BITE Festival, 1998 and 1999.

Dimensions

148 x 210 mm 5⁷/8 x 8¹/4 in

Formats Leaflets and brochure

intry of Origin

With a ductr of Oliver Award normatters for List year's groundbreaking auryah assaon, BITE is birk with an other powerful life up of International party many december of command and are carried and offerent countries fillightights include the Blocket Residual in September and 19 plays performe in a sewest by Dublin's exterior and offerent and a solution with Lift Chodon International Festival of Theatre, presenting classic French data and German music theatre. All performances are now on sale as one a warm to care and the some Daves Company

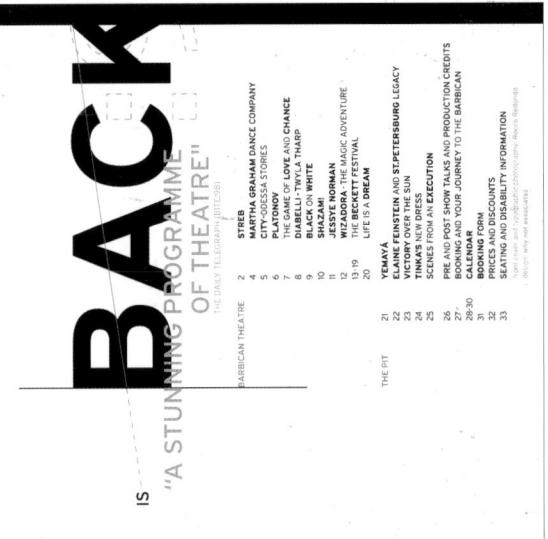

TEATERSALONGEN, HIPP KALENDEGATAN 12

jazzmonitor presenterar

Renegade V

Steve Coleman (AS)

Gary Thon

Ravi Coltrane (TS)

Anthony Tide

Greg Osby (AS)

TORSDAGEN DEN

28 OKTOBE

INSLÄPP 20.00, BILJETTER 140 SKR

Förköp Hipps biljettkassa Kalend

Graphic Identity for Jazzmonitor

Enigmatic photography, bold typography, the controlled use of flat color, and a careful choice of color palette all combine here to produce a very effective and strong visual identity. This solution is flexible and distinctive enough to work at different scales, ranging from a small business card to the size of a poster (*left*). The slightly abstract hard-edged style of imagery adds to the urban mystique of this club event.

Designer Peter Bruhn

Art Director Peter Bruhn

Photographer Peter Bruhn

Design Company Fountain-Bruhn

Country of Origin Sweden

Description of Artwork
Poster (left) and flier
(following spread), as part
of a package including
letherhead, logo, business
card, and labels, for
the ambient club event
Jazzmonitor.

Dimensions
Poster: 500 x 500 mm
19³/₄ x 19³/₄ in
Flier: 286 x 95 mm
11³/₄ x 3³/₄ in

Formats
Poster and flier

MALMO DRAMATISKA T

I HIPPS SALONGER HÖSTEN 1999

TORSDAGAR

Jazzmonitors exklusiva höstkollektion av live M**Y FAVO**L

This dramatic image gives the impression that this club event is not for the uninitiated.

jazzmonitor

Left & below: the consistent use of carefully chosen colors and the repetition of the same photograph on both the poster (see previous spread) and flier (below) set up a series of visual connections that serve to strengthen the Jazzmonitor identity.

TEATERSALONGEN, HIPP KALENDEGATAN 12, MALMÖ.

joy Monitor PRESENTERAR

Renegade Way

Steve Coleman (AS)

Gary Thomas (TS)

he Rick (DR) Ravi Coltrane (TS)

TORSDAGEN DEN

Greg Osby (AS) Anthony Tidd (8

28 OKTOBER

INSLÄPP 20.00. BILJETTER 140 SKF

Förköp Hipps biljettkassa Kalendegatan 2.

Singuhr Klangkunst

The abstract concept of a sound-art gallery is, by its very nature, hard to visualize. Faced with this challenge, the designers chose simplicity and a bold abstract approach to create an intriguing visual analogy for the events at the gallery. The cover typography (opposite) makes clever use of three colors to suggest overlapping circular ripples of spreading sound. Inside, this mental image extends to the display of photographic imagery (below). On the typographic pages (shown on the following spread), the blocks of text have been sculpted to suggest the nature of the aural experience, with curved margins and text blocks 'bouncing' off each other like echoes. The use of monochrome adds a starkness to each composition.

Designers Cyan

Photographer Roland Maerz

Design Company Cyan

Country of Origin Germany

Description of Artwork 120-page catalog documenting the activities of the sound-art gallery Singuhr from 1996–98.

Page Dimensions 200 x 233 mm $7^7/8 \times 9^1/8 \text{ in}$

Format Catalog ben von Jacobis Glocken urteilte dieser, daß die verwendete Legierung nicht für Spielglocken geeignet sei. Gleichzeitig hot er ein neues Carillon an. Im August 1716 starb Weiß und im März 1717 wurde der Niederländer Amoldus Carsseboom als sein Nachfolger eingestellt, allerdings gab es kein vollsteindiges Instrument mehr. Zwei Jahre nach der entäuschenden Einweibung des Carillons schrieb König Friedrich Wilhelm I. u. a. an den Krichenrat der Parochialkirche: Vorneach ihr Such abso gehorsanst zu achten, -- und zwar bey Verliest der von um Stub-Heimiter augewenderen Ginde au seinen habt, daß bisren und der eine Studie der Studie der Studie der Studie der von Um Stub-Heimiter augewenderen Ginde au seinen habt, daß bisren und studie der Automatik beraft habe. 7 die der grötten Glocken hingen in der Mitte und um diese ordneten sich die restlichen Glocken hingen in der Mitte und um diese ordneten sich die restlichen Glocken

Regelmäßige Konzerte erklangen zwischen 1717 und 1782 an drei Tagen in der Woche (Sonntag, Mittwoch und Freitag). Im Sommer von 5-6 Uhr nachmittags, ansonsten von 11-12 Uhr morgens. Von 172-1839 wurde das Carillon reveinal wöchentlich (Sonstag, Mittwoch) ca. eine Stunde gespelt. Zwischen 1839 und 1848 war den Carillonner ubweig Theise nur eine Stunde gespelt. Zwischen 1839 und 1848 und eine Entwicklung mit immer deutlichen eine Stunde gespelt. Zwischen 1839 und 1848 und eine Entwicklung mit immer deutliche senden Bedeutungsvehrust der Carillonkunst in Europa. 1891/28 wurden Turm und Carillon generalüberholt, und der Posten des Carillonnerun blieb unbesetzt. 1829 übernahm füschard Thiele das Amt und übergeb es 1902 seinem Sohn Eugen Thiele Beide spielten zu den Gottes-deutsten und gaben wöchentlich ein habstündiges Sonntagskonzert. Das Repertoire der Konzerte urnfaßte geitliche und weltliche Mussik; größtenteils Bereibrüngen der jeweiligen Carillonnerur für das Instrument. Hauptsächlich Sein 1821 gab es unter Haussik; größtenteils Bereibrüngen der jeweiligen Carillonnerur für das Instrument. Hauptsächlich Sein 1821 gab es unter Haussik größtenteils dem Glottes-dienst und die oggenannen vohreibe auf dem Glottes-dienst und die oggenannen vohreibe auf dem Glottespiele am Mittwoch. Die Mittwochsprogramme enthielten seebs bis vierzehn Stücke, die ein hand ein wiederhehenden Ereignisch en des Jahres und die oggenannen vohreibe auf dem Glottespiele am Mittwoch. Die Mittwochsprogramme enthielten seebs bis vierzehn Stücke, die ein der Hause der Vertrage auf dem Glottespiele am Mittwoch. Die Mittwochsprogramme enthielten seebs bis vierzehn Stünde, die ein der Hause der Werbauder kürzen, auf dem Rochendensteil erklichten in über verhunder kramen, auf einem Notentehenken.

Volleskeder: Blane Luft - Blumenduft Es war ein Klonig in Thule, Mien Veter wer ein Wandersmenn. Zum Beprechtier gehörten ebenfalls einige Märsenke. De Tongeur, Der Hohenführen
ger um 6 Bearbeitungen klassischer Werker Lange auss der Oper Xenzer von Händel, Andarer von
7 ibid. S. 15 Evgl. Heinz Sieper Dig.
Glockenspiel der Evangelischen Parock
Sieper Dig.
Glockenspiel der Evangelischen Parock
siehen zu Berlin Typoskript, 1940 dem
Archiv der Parochialkirche gestiffet S.
Germanne der Sieper Dig.
Sieper Berlin Sieper Berlin Sieper Werten Sieper Berlin Sieper Werten Sieper Berlin Sieper Werten Sieper Berlin Sieper Werten Sieper Berlin Sieper Be

13

tive oder Ergiarung zur traditionellen Präsen¹tationsform von Kunst in Athernativen Vertationsform von Kunst in Athernativen Veröffentlichungen des Institutes für Neue Musik
und Musikerzeibung Darmstadt Bd. 28 hrsg. v.
Johannes Fritsch (Schott) 1998 5.55 56t 1997
hat die Berliner Senatsverwstillung für Wissenschaft, Forschung und Kultur den Begriff Klangkunst als Schwerpunkt in den Katalog ihrer
Förderrichtlinien im Bereich Ernste Musik für die
Sonannen Erisk Musik Frase aufgeschware

I. Es fällt außerordentlich schwer, Klangkunst auf einen bestimmten musikalischen Gattungszusammenhang zu projizieren. Keiner der Gesichtspurkte, die einen Massischen- Gattungszusammenhang konstituieren, macht im Angesicht der vielgestattigen künsterischen Konzepte und Formen, die sich hinter dem Begriff Klangkunst verbergen, eigentlich Sims Besetzung, Text. Fruskion, Aufführungsort ett. Hier scheinen sich sie der Kraft gesetzt. Was Klangkunst ist, —wissen immer nur jene, die eine susschließen, eide bes hausstellungen der eine der Verteilung sich sie der Kraft gesetzt. Was Klangkunst ist, —wissen immer nur jene, die eine susschließen, eide bes hausstellungen der eine der Verteilung von Tantiemen. Ausgenzungen eind möglich, aber, keine Eingerenzun-Franz von Tantiemen. Ausgenzungen eind möglich, aber, keine Eingerenzun-Franz von Tantiemen. Ausgenzungen ein der die mit der der verteilung von Tantiemen. Ausgenzungen ein der Verteilung von Tantiemen. Ausgenzungen ein der Verteilung von Tantiemen. Ausgenzungen ein der Verteilung von Tantiemen. Ausgenzungen der Verteilung von Verteilung von

ist jedoch, ob es mir darum geht, soziale Abläufe zu berücksichtigen, mit einzubinden, abzubilden, zu unterlaufen oder zu stören. Eine gesellschaftliche Einbindung von Kunst erfolgt oft um den Preis ihrer Störqualität. Oft ist die künstlerische Idee im öffentlichen Raum nur in abgeschwichter Form realisierbar. Die Rolle der Klangkunst sehe lech trotzdem als kritischen Kommentar künstlescher Reflesoin innerhalb eines sozialen, state der State

on jemandem in Relation zu den nichtintendierten der Umgebung gebracht werden. John Cage, 1961

Wuzeln hat die temporize Klanginstallation oder Klang-inter-Vention mit ihrem Impetus des Sich-dazwischen-Schaltens oder Sich-Einmischens in gesellschaftliche Zusammenhinge in den Formen der Events, Happenings und Aktionen der Sechziger Jahre. Der Handlungscharster wandte sich damats – abgesehen von der Auflösung des traditionellen Werkbegriffs – gegen das Vernardsten von Kunstverken als Ware auf dem Kunstmarkt. Die dauerhafte inbestiznahme eines Ortes durch eine verärbei programmen in der Verschen der verärbeit der Verschaften von Kunstverken als Ware auf dem Kunstmarkt. Die dauerhafte inbestiznahme eines Ortes durch eine verärbei programmen irritation der alten und zum Einschlefen neuer Hörgewohnheiten führen. Umbrandet von einer permanent sich wandelnden realen Umgebung, könnt tei eigechs bald selbet Gewohnheit werden. Hier stellt sich mir die Frage: Wie lange dauert es, bis eine permanent installter Klangskulptur – auch wenn sie so programmiert ist, daß sie immer wieder anders klingt- im öffentlichen Raum überhoft wird? Im Gegensatz zum Eingespertsein im Konzertsaal kann der Hörer in der Wölnichs der Größtatt, berfreichungen. Fistungen und Kantlen, der Schalten und verschlichen Fallen bei Ströme von Passanten und Verkehr, ihre Verdichtungen. Stuungen und Auflüssungen, ihre Tempt und Zeitnester sind für die Wahrnehmungssituation der Klanginstallation von immenser Bedeutung, Wirds eingebettet in Alltagszusammenhänge, zur musique d ameublement – zum klingenden Großstadmobilier? Arbeit Die Wahrnehmungssituation vor Ort ist von unterschiedlichen Faktoren geprägt: ein bestimmtes Licht, ein besondere Duft oder Geruch, Temperatur und Lufflüchtigkeit, mein eigens Befinden, die Gräussche Bevor ich mich auf die Suche nach einem bestimmen Raum mache, inspiliere ich den Ort und die Menschen. Der architektonische, soziale und akustische Kontext, in den meine Klangswuldt ein die Artun Allverden soll, bildet das wesentliche Ausgangsmaterial für meine Rüngswuldt ein der Artun Allverden soll, bildet des wesentliche Ausgangsm zeln hat die temporäre Klanginstallation oder Klang-Inter-Ve nit ihrem Impetus des Sich-dazwischen-Schaltens oder Sic

17

75

Subcircus-60 Second Love Affair

The packaging for this CD single works simply and effectively. The manipulation of the two photographs to produce large areas of flat, strong background color, which tonally complement the figure, has added to the images' graphic impact. The device of cropping both images through the head of the subject creates a further startling visual link between the two. The computer-till-receipt/neonnewsflash style of the typeface used—Dot Matrix—also gives a subliminal immediacy to the lyrics printed on the sleeve to underline the fleeting nature of the song's theme.

. 3

Designer Rob Chenery

Art Director
Rob O'Connor

Photographer Michele Turriani

Design Company Stylorouge

Country of Origin UK

Description of Artwork Packaging for the CD single of 60 Second Love Affair by Subcircus.

Dimensions 120 x 120 mm 4³/₄ x 4³/₄ in

Format CD single **Designer** Dom Raban

Design Company Eg.G

Country of Origin

Description of Artwork 24-page color brochure overprinted with opaque white ink on 230 micron Colourmaster Grey paper.

Page Dimensions 205 x 205 mm 8 x 8 in

Format Brochure

University of Sheffield School of Architecture

The layout for this brochure has been developed from the proportions of the golden section, an appropriate starting point considering its architectural theme. Blocks of strong color have been used to enliven technical imagery, such as site overview drawings, aerial photographs, and cross-sections. This, combined with the use of white text, gives the work consistency even though the shapes and layouts are irregular.

Special Production Techniques

The brochure has been printed in four colors, overprinted with an opaque white ink that unites the different aspects of the design. This and the subtle contrast of white ink on off-white paper gives this publication a strong visual and tactile presence.

Artur—Forum für Kunst und Kultur (see following spread for description)

Designers Ilja Sallacz, Carina Orschulko (issue 19)

Illustrators

Photographers Bernd Hohlen, Walde (issue 23)

Editor Sonja Hefele Design Company LIQUID Agentur für Gestaltung

Thomas H. Rossma

ountry of Origin ermany

casts a shadow on the page signals one of the

he way the logo

concerns of this issue:
the representation of
three dimensions on
a two-dimensional

decription of Artugal

A quarterly magazine about and a dutture published an southern Germany.
Previous spread: covers files spread: covers files spread: cover and reference and previous spread: cover and cover and previous from issues to me

Page Dimensions
210 x 292 mm
8'/, x 11', in
Opening to a maximum
width of: 840 mm, 33 in

Magazine

Artur - Forum für Kunst und Kultur

No two issues of this magazine are alike; the content, design, number of colors printed, and paper, all change each time.

Sometimes in four-color, sometimes in monochrome, this open-ended brief allows the designer free rein to make each issue as exciting and provocative as possible. It also gives the magazine visual and textural diversity. Set against this freedom is the magazine logo, its constancy identifying the magazine and highlighting the variety in the rest of the publication. Its unusual and obscure shape is strong enough to transcend the subtle changes it undergoes from issue to issue.

surface.

The application of perspective to this type extends the 3D theme

begun with the logo on

the cover.

MILCHSTRASSE —
DAILY SOAP AUS CHILE
La Silla – Der Gipfel der Sternscher.

richten! Selbst der Winseismurk. fehlt.

sich nicht einmal auf den Norizsaft.

the section are sectionally considerable and section are sectionally considerable and sectional are sectional and sectional are sectional are sectional are secretarily considerable. Secretarily secretarily sectional are secretarily sectional are secretarily sectional are sectionaly

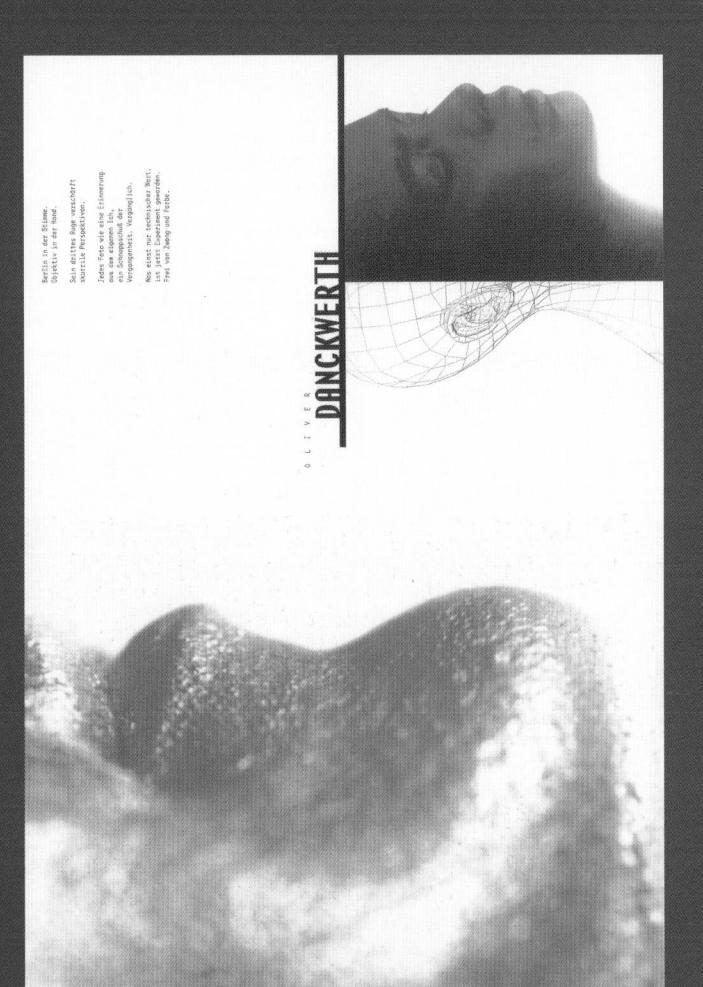

another approach to the way three The use of line drawing to 'map' the human body (head, left and stretching figure, below) shows dimensions can be visualized on the page.

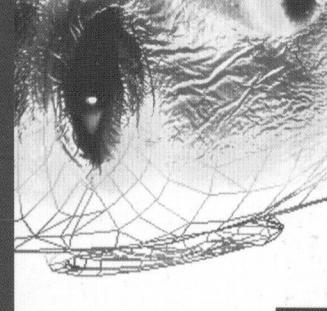

ARGENTUM

LOW-BANDWIDTH: ESPAÑOL | ENGLISH | PORTUGUÊS

HIGH-BANDWIDTH: ESPAÑOL | ENGLISH | PORTUGUÊS

Requerimientos | Requirements | Requisitos PC Explorer 4.0+, PC Navigator 4.0+, Mac Navigator 4.0+ Shockwave 7.0, Flash 4.0, Real Media G2 Player Mejor visualización a 800 x 600 o mayor

UN PROGRAMA DE LA FUNDACIÓN CISNEROS

Orinoco Online

In this website design, the consistent graphic presentation of diverse images and cultures brings them together with a clear and pleasing aesthetic. It succeeds in making relatively obscure information both appealing and accessible. The non-linear structure of the site, with information grouped in constellations rather than hierarchically, is derived from the way in which the indigenous cultures conceptualize the universe. This integrated approach extends to the color palettes and other design elements, all of which were inspired by different aspects of the cultures featured.

The circular navigation graphic is intended to encourage a more intuitive exploration of the site. At first a little unfamiliar, this device mediates the way in which the site is viewed, allowing each visitor to find their own route between the different cultures.

In earlier times, men did not fire. A woman name Kawao u the fire. She would hide it in stomach and would not show anyone, not even her husba When she was alone, Kawao turn herself into a frog, open mouth and spit the fire under cooking pots. When her husi arrived, food was always rea would ask: how did you do it she would answer: I cooked food under the sun. She trici him and he believed her. Wh did not know was that when left, he turned himself into a iaquar

O CULTURE

O OBJECTS IN THE COLLECTION

Designers Rafael Esquer, Mariana Saddakni, Chakaras Johnson

Creative and Art Direction Rafael Esquer

Creative and Project Management Angela Fung

Programmers Harsha Kalidindi, Valerie Valoueva, Stephen Chu

Audio/Video Editor Paul Bozymowski

Executive Producer Hillary Leone

Editorial Director Lelia Delgado

Design Company @radical.media

Country of Origin USA

Description of Artwork

A website (www.orinoco.org) for the Fundación Cisneros to help promote interest, knowledge, and support for the indigenous populations of southern Venezuela.

Dimensions 800 x 550 pixels

Format Website

VENEZUELA

WHAT STORIES WOULD YOU TELL A SMALL CHILD? WHAT STORIES WOULD YOU TELL A PREGNANT WOM WHAT STORIES WOULD YOU TELL A DYING MAN?

(Showtime, 1996)

Born out of Sheffield, an ex-industrial city in the north of England, our work is an attempt to map contemporary experience in a theatre language which both comes from and responds to the times. Central to the work is our the times. Central to the work is our exploration of the struggle for coherence in a life, or in a culture a trying to what we see and vertured to have been life in cities. In clearly, love, fragmentation, the identity, love, fragmentation, the (Pleasure, 1997) need to confess. The theatrical qualities we come back to are And if stories once seemed like those of intimacy under the company to the compan

In thirteen years the ground we have mapped has been shifting constantly, a jumpy the dreams and stories of modern life. The work is amphatically group work dead of night, it's impossible accident, argument and in a dream some person as hifting and the preformance is never and never less than a vital slip of the pieces, a rearrange of the piec

those of intimacy, vulgariny, black to are comedy and gentle comed comedy and gentle optimism. simple things - tray sussential to frame and make sense of the sense of the to frame and make sense of the sense of th In thirteen years the ground world now they can seem like we have mapped has been much more complex and much m

that doesn't have a name.

It is a dream some person and never less users and never less users. It is them in a cloth a magic of ruins. that doesn't have a name. cling to, slips them in a cloth a magic of ruins.

e invite you to this of certain fragments herited - the dreams oad and indifferent ave haunted us at

act of rearrangement
is invite you to this
a trying to make
of certain fragments
wherited - the dreams
bad and indifferent

we're guilty of coldness and spite,
we LAUGHED WHEN WE PROBABLY SHOULD
HAVE CRIED, WE TOLD SOFT STORIES TO
CHILDREN, WE TOLD SOFT STORIES TO ANYONE
That Would Listen, WE WROTE ENDLESS
AND TERRIBLE POEMS ABOUT CEAUCESCU,
WE'RE GUILTY OF FRAUD AND FORGERY,
WE'RE GUILTY OF FRAUD AND FRAUD AND FORGERY,
WE'RE GUILTY WE HAD STREET LUCK, WE LOVED TO GET LOST TOGETHER, OUR MOTTO WAS YES AND NOW AND HERE

(Speak Bitterness, 1995) e you enjoy the work.

@ Tim Etchells 1998

Designer Dom Raban

Photographer Hugo Glendinning

Design Company Eg.G

Country of Origin

Description of Artwork 12-page mono brochure supplied with 6 do-ityourself color stickers.

Page Dimensions 105 x 148 mm 41/4 x 63/4 in

Format Brochure

Forced Entertainment

This witty and imaginative retrospective brochure for an innovative theater company succeeds in both entertaining and intriguing, all within a tight budget. A spirit of experimentation is encouraged through the use of cost-effective one-color printing combined with the inclusion of six colored stickers for the reader to add to the design. The do-it-yourself nature of the brochure makes it a memorable publication.

At first glance deceptively simple, the logotype is in fact composed of various typefaces.

Network Gallery

The distinctive logotype allows the designer to present many of the different visual aspects of the gallery on each card while maintaining a sense of continuity. The success of this strategy can be seen, in particular, in the fifth card (*below*) where a strikingly different approach to the photography and a change in format have been successfully accommodated. All these two-color cards effectively and economically promote the gallery and reflect the fact that it shows a wide range of work.

Designer Brad Bartlett

Art Director Brad Bartlett

Photographer Brad Bartlett

Brad Bartlett

Art College Cranbrook Academy of Art

Country of Origin

Description of Artwork Series of cards to announce the opening of the Network Gallery, Cranbrook Academy of Art.

Dimensions
Phases 1–4 (opposite):
254 x 101 mm
10 x 4 in
Phase 1 (right):

Phase 5 (*right*): 140 x 197 mm 5¹/₂ x 7³/₄ in

Format Cards

DesignerDanielle Foushee

Art Director
Danielle Foushee

Country of OriginUSA

Description of Artwork
A series of Family Gallery
Guides for the Museum of

Contemporary Art, Los Angeles.

Page Dimensions

254 x 305 mm 10 x 12 in

Format Museum Gallery Guide

Vestigial Appendage, 1962 Oil on canvas, 72×93.5 in. The Museum of Contemporary Art, Los Angeles The Panza Collection

Where did he get his ideas for this painting?

ROSENQUIST

orn 1933 in Grand Rapids, North Dakota Lives in New York City

MOCA Family Gallery Guides

The bold setting of each artist's work and the accompanying typography against a white ground draws together image and text in this distinctive series. An uncomplicated device, but it allows the designers to sustain a stylish solution throughout a large number of titles. The skill in creating eye-catching typography out of a small amount of information and subtle color combinations shows that often simple solutions are the most flexible.

Below and opposite: printing type in colors drawn from the artwork places the emphasis on the artist, rather than the design, and gives each guide an individual feel.

WHAT MAKES THIS The Museum of Contemporary Art, Los Angeles Gift of Marcia Simon Weisman Jass

A WORK OF ART

Map, 1962 Encaustic and collage on canvas, 60 x 93 in.

Jasper JOH

born 1930 in Augusta, Georgia lives in New York City

Haarlem Goes Missing

The style of illustration, the simple integration of typography and images, and the physical construction of this joyous project all imbue it with immense charm. The pages can be viewed as a sequence of double-page spreads or, as the book concertinas out into a long frieze, as a series of connected images on a single surface charting the character's progress through the story. Apparently a children's story, it is also a witty allegory for adults.

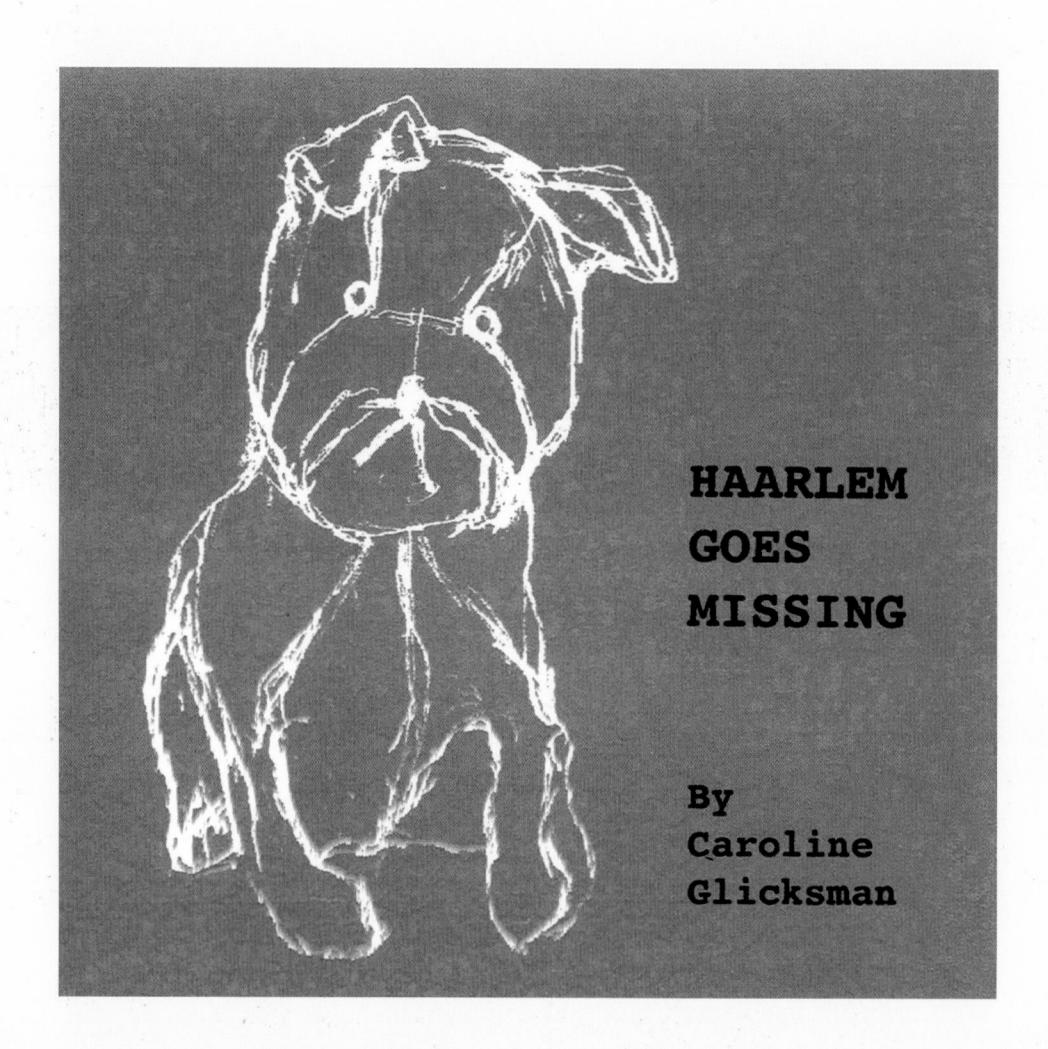

Special Production Techniques

Silkscreen printing, as used in this work, involves the application of different colored inks which build up, layer by layer, into the complete image. The inks may be opaque or translucent, allowing the colors beneath to show through.
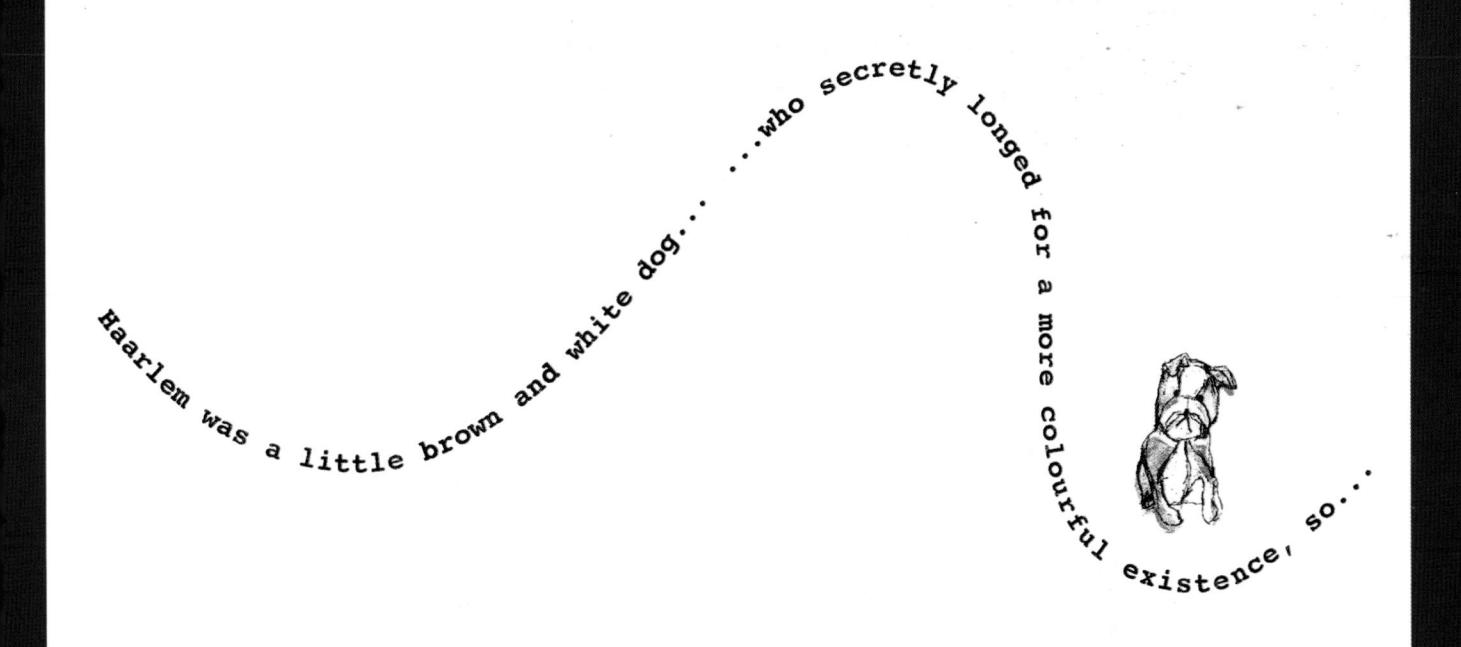

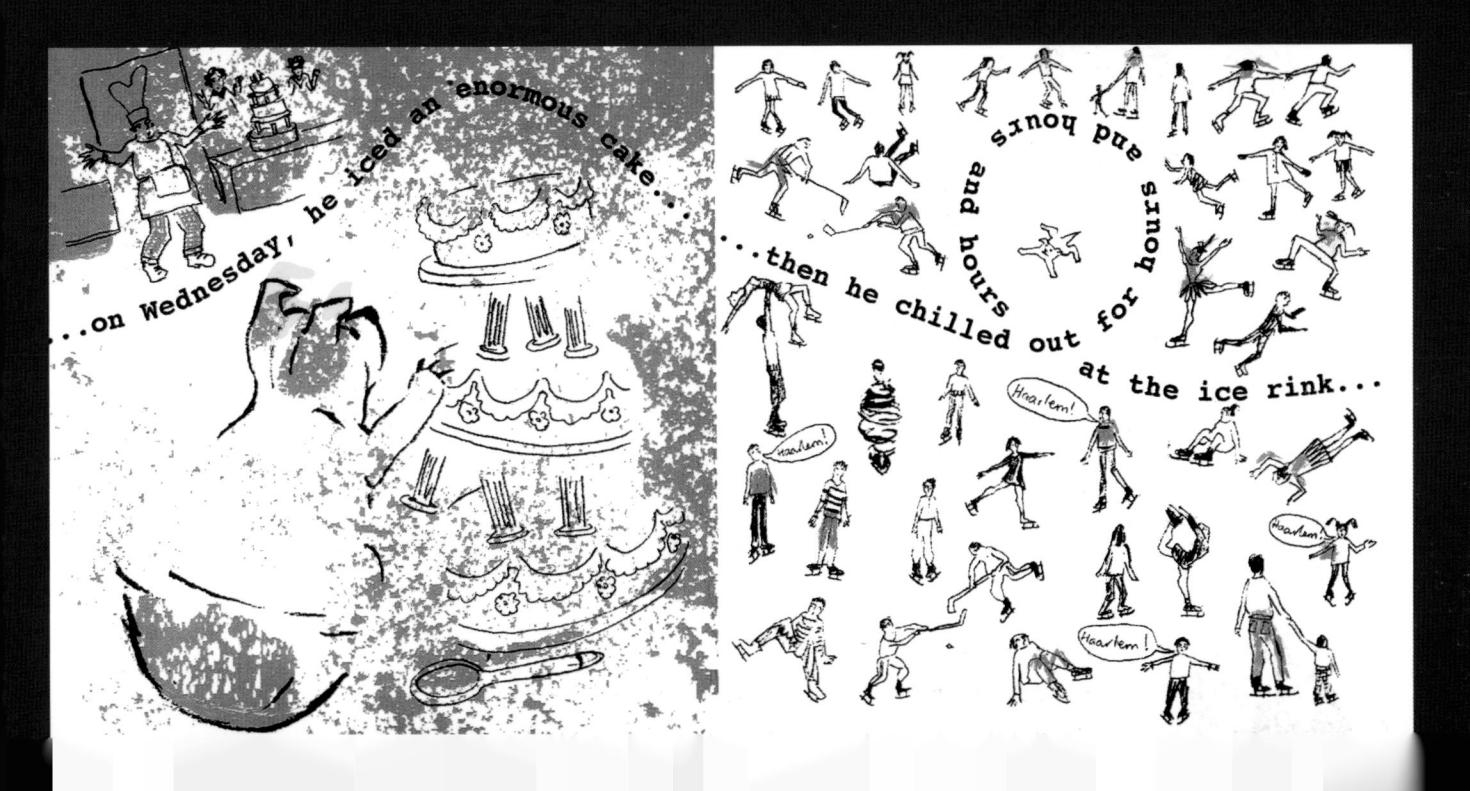

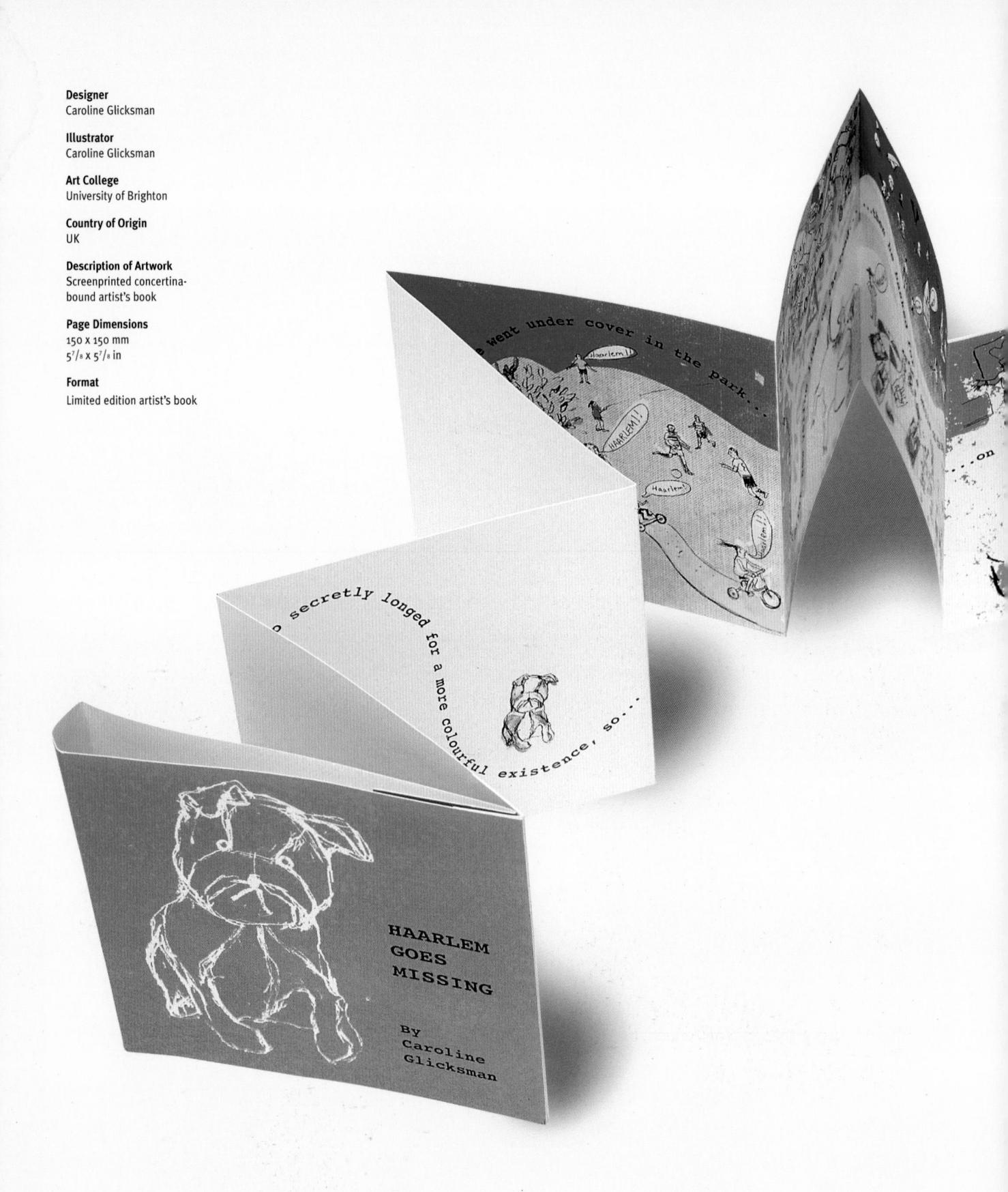

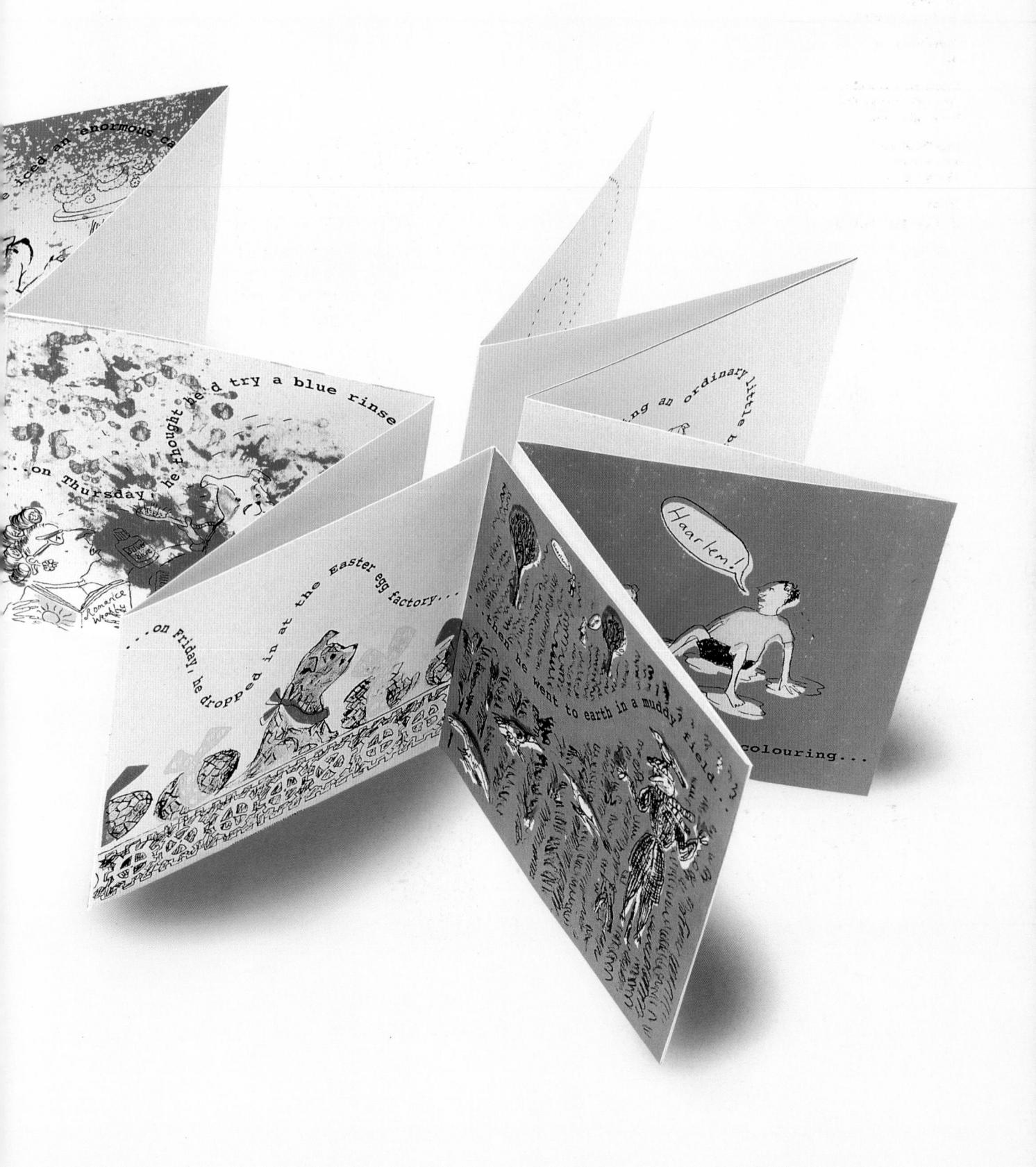

SSI laries em ie, Ronald Designer

Sibylle Hagmann

Art Director Sibylle Hagmann

Design Company TypoStudio

Country of Origin USA

Description of Artwork Catalog and invitation for a fine-art exhibition entitled 'Crossing Boundaries.' The invitation includes the program of events scheduled during the show.

Page Dimensions

Catalog: 216 x 241 mm $8^1/8 \times 9^1/2$ in Invitation: 142 x 159 mm $5^5/8 \times 6^1/4$ in

Formats

Catalog and invitation

Crossing Boundaries Jamex and Einar de la Torre Steven La Ponsie, Ronald Gonzalez Crossing Boundaries

Crossing Boundaries

The bold use of a slab serif typeface combined with subtle color fades around the edges of the catalog cover (*opposite*) and on the front of the invitation (*left*) clearly identifies this event—a simple and effective solution. The use of faded color is picked up on the inside of the invitation (*below*), in which the unusual and irregular positioning of the text in and over the edges of the white cutouts brings a distinctive quality to the list of exhibition talks and workshops.

Special Production Techniques

The design of the invitation has been achieved with minimal use of color: the outside is printed using three colors and the inside two.

Tuesdays at Fisher

A weekly program of dialogue, workshops, and perforPer program information or to RSVP, please call (213)

Admission is free. tion or to RSVP, please call (213) 740-5537 November 23 Dr. Max F. Schulz leads a Curator's Walkthrough of the exhibition. February 15 February 22
Mixed media artist Miquizilicoati conducts a gallery walkthrough exploring the cultural significance of iconography in selected works. USC Fisher Gallery cordially invites you to the opening reception and special programs for Wake Up Call!

Thursday, December 2, 1999, 6:30 pm.

The Gin D. Wong Conference Center (Harris Hall Room 101) December 21 Holiday Open House. Enjoy refreshments and good cheer Peatured artists Jamex and Einar de la Torre discuss the effect their Mexican/American cross-cultural experience has had on their art, the advantages of collaborating, and the shock of having their work destroyed by a religious realor. Crossing Boundaries: Jamex and Einar de la Torre, Steven La Ponsie, and **Ronald Gonzalez** Moderated by Richard Meyer, Assistant Professor of Contemporary. Art, University of Southern California. November 18, 1999 - February 26, 2000 Families at Fisher Saturday, December 11, 1999, 12 noon Opening Reception Tuesday, November 16, 1999 5 pm - 7 pm Bring the entire family for an afternoon of fun! Activities include sculpture-themed art workshops, live music, storytelling, facepainting, tours of the RSVP requested (213) 740-4561.

Designer Christina Glahr

Art Director Simon Schmidt

Illustrator Christina Glahr

Photographer Frank Voth

Design Company Lorem Ipsum, Büro Für Konzeption & Gestaltung Country of Origin Germany

Description of Artwork Brochure to promote surfing at Klitmoeller Beach on the North Sea coast of Denmark.

Page Dimensions 250 x 200 mm 9⁷/₈ x 7⁷/₈ in

Format Brochure

Klitmoeller Brochure

Although this evocative brochure, with its 'weathered' colors and rounded 'surfer' typography, alludes to the attractions of the beach in a rather abstract and oblique way, it is nonetheless quite clear. The text, which includes quotes from individual surfers and well-known pop songs, is sized and positioned to encourage closer scrutiny. Among the more obvious pictures, such as surfers on the water or a board strapped to the top of a van, there is an unexpected image with two animals (*opposite*, *top*) which immediately draws the viewer's attention.

The horizon is a key feature of this design. The photographic horizon is reinforced by a long line of text and the silhouette of a lone surfer looking out to sea, which align to create an alluring atmosphere.

of the sea and I smile.
thing I miss, nothing I
lousy of, just living.

0

1 I was looking there, prodise, lace to live. is what we found

onything else in the world. If you don't know it, you won't miss it. But if ot exist without. It's the simplicity of total freedom.

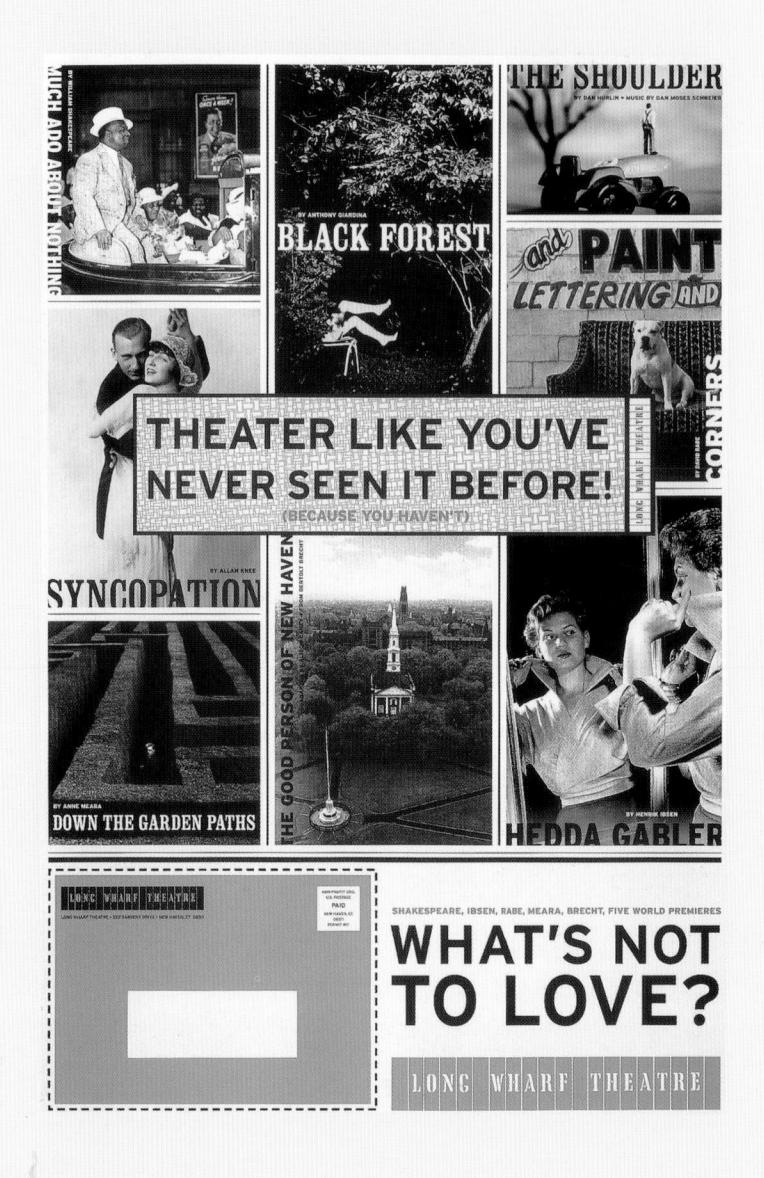

Long Wharf Theatre

To represent eight different elements (plays, in this case) in one piece is always difficult. However, an interesting and pleasing unity has been achieved by the clever use of duotone images (*above*). A different typeface or type size has been adopted for each play and this device has been repeated on the back (*opposite*) to help segregate a mass of information: individual production notes, special ticket deals, an introduction by the Artistic Director, a seating plan, and booking form. The mix-and-match approach to the typography and the use of a limited color palette gives this side the attractive period feel of a page of old advertisements.

Dear Friends.

MUCH ADO ABOUT NOTHING

SYNCOPATION

5 WORLD PREMIERES, 3 WORLD-CLASS SHOWS MAINSTAGE #5

DOWN THE GARDEN PATHS

"If Long Wharf was brave and prophetic in lavishing WIT with a world-class premiere - a

memorable reopening of Stage II - it is now positively heroic."

BLACK FOREST

"There's a new electricity emanating from New Haven's Long Wharf Theatre since Doug Hughes became artistic director two years ago. You can feel it in the lobby before the show even begins."

THE GOOD PERSON OF NEW HAVEN

ONE UTTERLY ORIGINAL MUSICAL

THE SHOULDER

STAGE II BI

CORNERS 🌞

HEDDA GABLER

STAGE II M3

FOR SUBSCRIBERS ONLY:

- Priority Seating
- Free ticket exchanges with 48 hours advance notice 8 Play Subs Only Free ticket exchange anytime before curtain
- Discounts on all additional ticket purchases
- Pabulous restaurant and retail discounts

 Discounts at other regional and national theatres

 The Loading Bock newsletter by mail

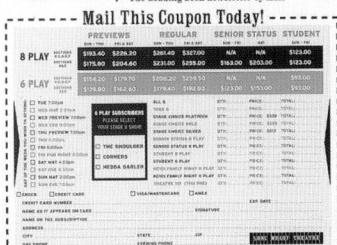

Designer Sandra Planeta

Art Director Drew Hodges

Design Company Spot Design

Country of Origin USA

Description of Artwork

A direct mailout program and booking form for the Long Wharf Theatre's 1999/2000 season.

Page Dimensions

152 X 204 mm 6 x 8 in

Format

Direct mailout

PACKAGE DESCRIPTIONS:

on the interest term.

STAGE CHOICE CARD

STAGE CHOICE CARD

White has been been price to the interest term. In the control of secretary straight that describing we will add applied to find and straight that the ARTHONION of the North Terminated \$3.00.

—TALEBACK TUSSBAY
—SENDAY STMPOSIUM —SENDAY STMPOSIUM — SENDAY STMPOSIUM — S

SUBSCRIBE BY PHONE (800) 782-8497 OR (203) 787-4282

Blag-The Book

and reassess the intention and meaning of the book. Printed selection of subjects. The bewildering range in the style of images, along with the title, provokes the reader to assess a collage of verbal explanations and imagery on a diverse This high-end fashion and style book treats the reader to stock, the whole book can be seen to be questioning the on matt paper, in contrast to the usual glossy magazine fashion-magazine-as-artifact status quo.

Designers Yacht Associates and friends Mark Thomson (departures

Photographers spread)

S. Edwards (cover), Red James Wallace (departures spread) (Japanese spread), Barnaby

Design Company Yacht Associates

Country of Origin

Description of Artwork

162-page book

245 x 303 mm 95/8 x 12 in

Page Dimensions

Format Book

304 • 2688		1863 79	62 • 441	962	1966 •	110 10
5 - 5	- 11 -	61 +	4 + 12 -	- 16 -	9 +	1 -
治 第 133 135 136 137 136 137 136 137 136 137 137 137 137 137 137 137 137	147 •	マトC 日セン 3050 2 ジテレビ TOT	31. 1524 2 - 13 - 0 トステム	903	アルブス電 E 1330 30 - ドイオニア E 2530	三 228 12 + 三 変車 510 •12
9 + 4	- 9-	4 +	8 + 30		10 -	20 -
印 419 321 3 - 13 フレ 590 - 333 31 - 27	- 5 +	富士字 新日報 4700 2 20 ◆ コニカ 川 銀 437 2	39 • 991 ·	NEC 1449 富士通 1890	3040 +	川崎重 277・2 8・4 5川島 伊藤 200
1.700 第4人 1.700 390 21 章 東 大食 東 レ 330 4 4	2665 •	音生学 NKA 1410	17 1840 4 - 3	神 第5 215 松 2160	マクセル 2423 横河 ^本 740	日産自 442。 1442。 1442。 東エ 73460 年 1
サヒ クラレ 1139 2 + 13 リン 旭 化成	- 305	東燃素	金 614 614 マ 住友重機 6302 102 103 103 103 103 103 103 103 103	- 1036 ·	デンソー 2415 45 = アマダムトレ	本田技 住2 4610 • 島津製 三

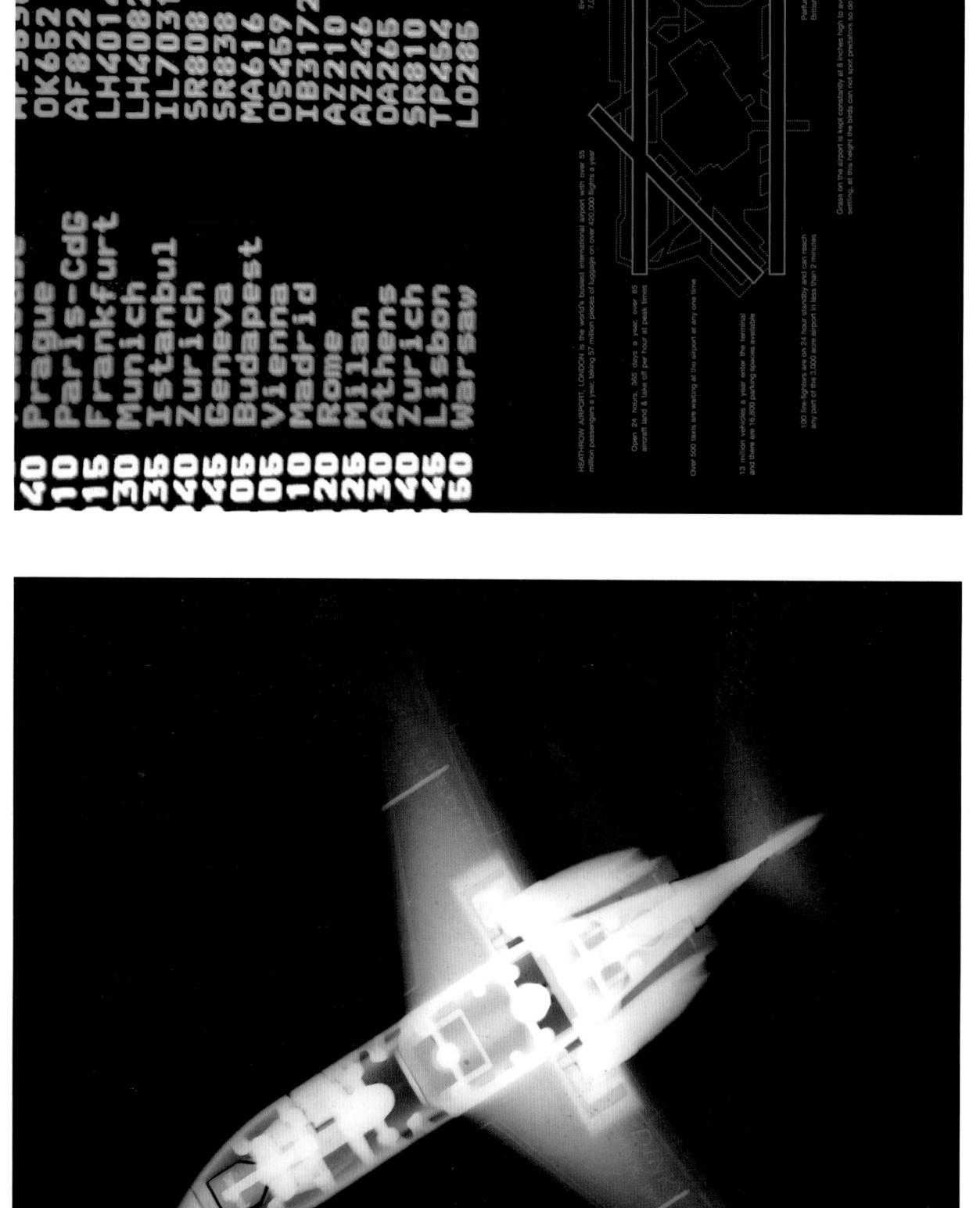

0K652 AF822 LH4014 LH4082 IL7031 SR838 MA616 05459 183172 AZ210 AZ210 AZ210 TP456

BAŞTAN AŞAĞI YEPYENİ NESNELER

Küçük filolar, çağrılmış-arzulanmış, içlerinde taşıyarak Dünyanın ortasında bir Schuylkill'den çıkageldi

Dost gölgelerini, onun tanıdığı, herbiri getiriyordu yaptığını, onun inandığı sudan ve arzudan,

Ustalar, işlev neymiş bilmeyen, bilmek de istemeyen. Yerkürenin ortasında yaşayan, yarı insan

Kanolarının küreklerini çeke çeke, binlerce binlerce. Bu adamcıklar zamanın pasıyla pas yeşili

Öyle biçimlerdeydiler ki, öyle derde deva biçimler, Görünce bildi onların ince niyetini,

Koskoca bir halkın, yaşlanmış düşüne düşüne... Anladı ki bu biçimler tam tamına biçimleriydi

Tinicum'ın altında ya da küçük Cohansey'nin. Yatmış yıllanıyorlar belki de onların ataları

Wallace Stevens

Seçilmiş Şiirler. Faber & Faber: Londra, 1965. (Çev: Fatih Özgüven - Nihal Koldaş)

25 Worlds, 1996-1997. Watercolor on paper. 17.8 x 12.4 cm. Courtesy Studio Guenzani, Milan.

66 - MANISHA PAREKH 1964 UTTARSANDA (GUJARAT), HİNDİSTAN BÖĞUMLU. YENİ DELHİ'DE YAŞIYDA.

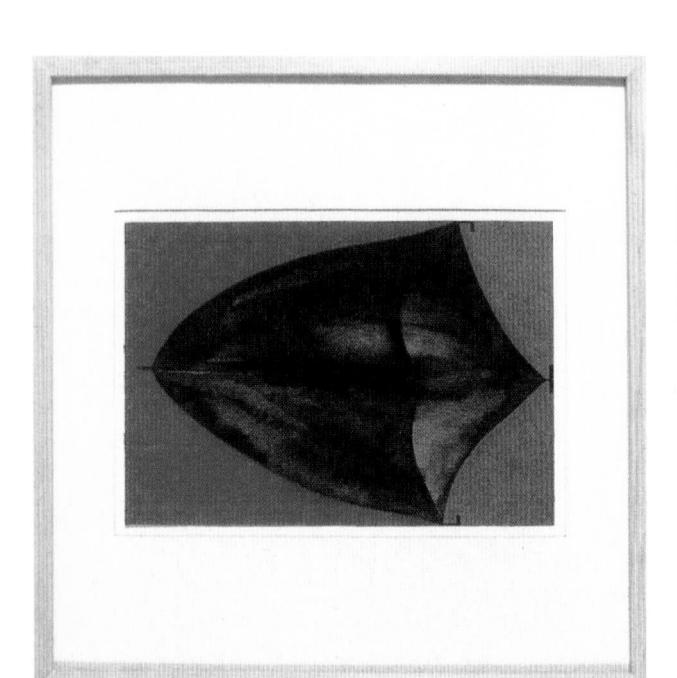

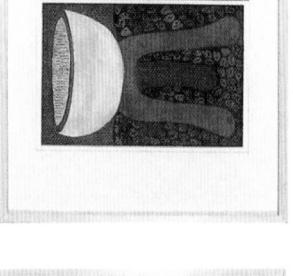

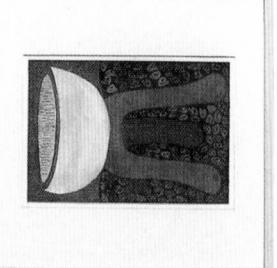

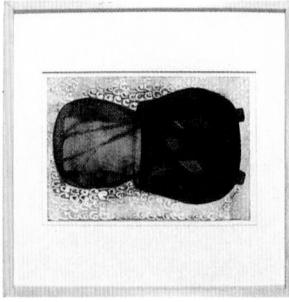

ា

64 - MUTLU CERKEZ

U overture curtain opera 0

6th International Istanbul Biennial

Gülizar Çepoğlu, Aysun Pelvan

Gülizar Çepoğlu Art Director

Photographers

Various

Gülizar Çepoğlu Graphic Design Co. **Design Company**

folio number and the artist's name. The first page of each section

a 'running footer' at the base of each page which includes the

address. Once established, such a layout allows framed images

has a small photograph of the artist, their year of birth, and

displayed as if in a gallery (opposite page) to sit comfortably

alongside a more conceptual text-based work (right).

these layouts, the designers have used the consistent device of

the artworks without compromising the design itself. To anchor When presenting the work of artists, the layout needs to serve

Country of Origin

fine-art festival. The first of two International Istanbul Biennial 276-page book for the 6th **Description of Artwork** for each Biennial.

Page Dimensions 165 x 235 mm 6¹/₂ x 9¹/₄ in

123

Designers Brad Bartlett, Danielle Foushee

Art Directors Brad Bartlett, Danielle Foushee

Photographer Brad Bartlett (cover)

Art College Cranbrook Academy of Art

Country of Origin USA

Description of Artwork 144-page book documenting the work of 71 artists graduating from the Cranbrook Academy of Art.

Dimensions

241 x 165 mm 9¹/₂ x 6¹/₂ in

Format

Book

Cranbrook Graduate Book

The unsettling undercurrent generated by the ambiguously threatening image (*opposite*, *bottom*) contrasts with the clean typography of the word 'Cranbrook' to produce an arresting four-color cover. The inside spreads are economically monochrome yet nonetheless convey the individuality of each student's work.

Below and bottom: the freedom of composition in the first spread is a long way from the subtle formality of the squared-up images of flamingoes in the spread below it. This indicates that when a structure is needed it is there, and when it is less important it need not be imposed.

7a 77 | joshmark

Designers

Dom Raban, Pat Walker

Illustrators

Dom Raban, Pat Walker, Andrew Wilson

Photographer Mark Harvey

Design Company

Eg.G

Country of Origin UK

Description of Artwork Promotional brochure for the 'Year of the Artist'—the UK's largest ever nationwide arts festival.

Page Dimensions

210 X 297 mm 81/4 x 113/4 in Opening to a maximum width of: 940 mm, 37 in

Format

Brochure

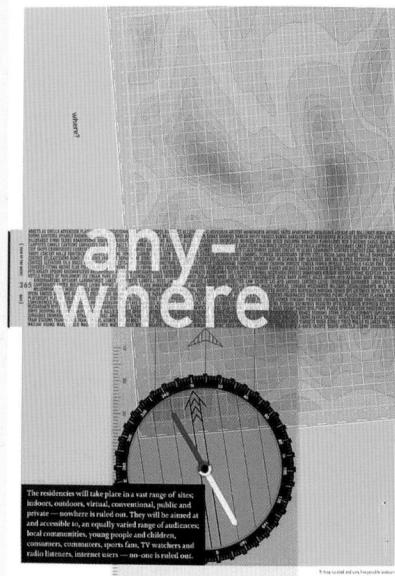

Year of the Artist

Based on the numerical sequence 1 (year), 4 (seasons), 12 (months), 52 (weeks), etc., this brochure is designed to promote the accessibility of contemporary art. Its visual appeal is enhanced by the use of vibrant colors indicating the different sections (*opposite*, *top right*) and the use of familiar imagery, such as the pull-out street scene. The accessible 'hands-on' nature of the project is shown by the inclusion of a do-it-yourself street cut-out kit (*bottom*).

Special Production Techniques

The use of fold-out pages has allowed the designers to create long landscape images which stretch the limitations of the brochure format and communicate the breadth of this arts festival.

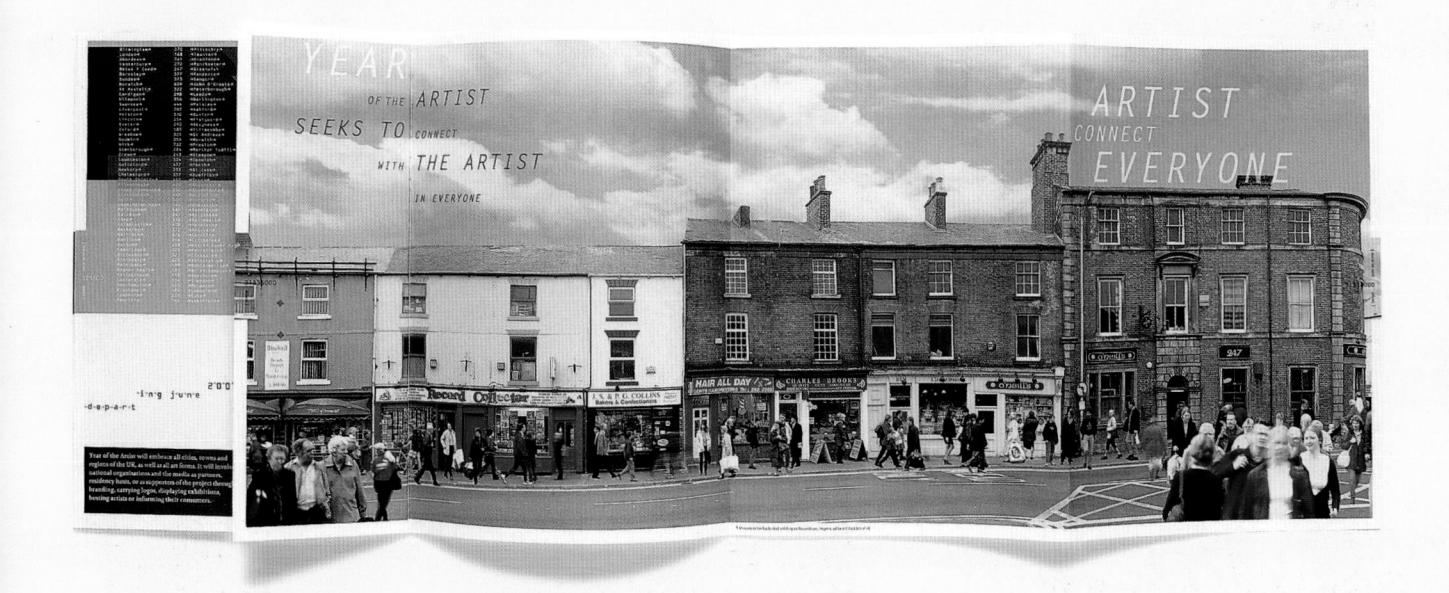

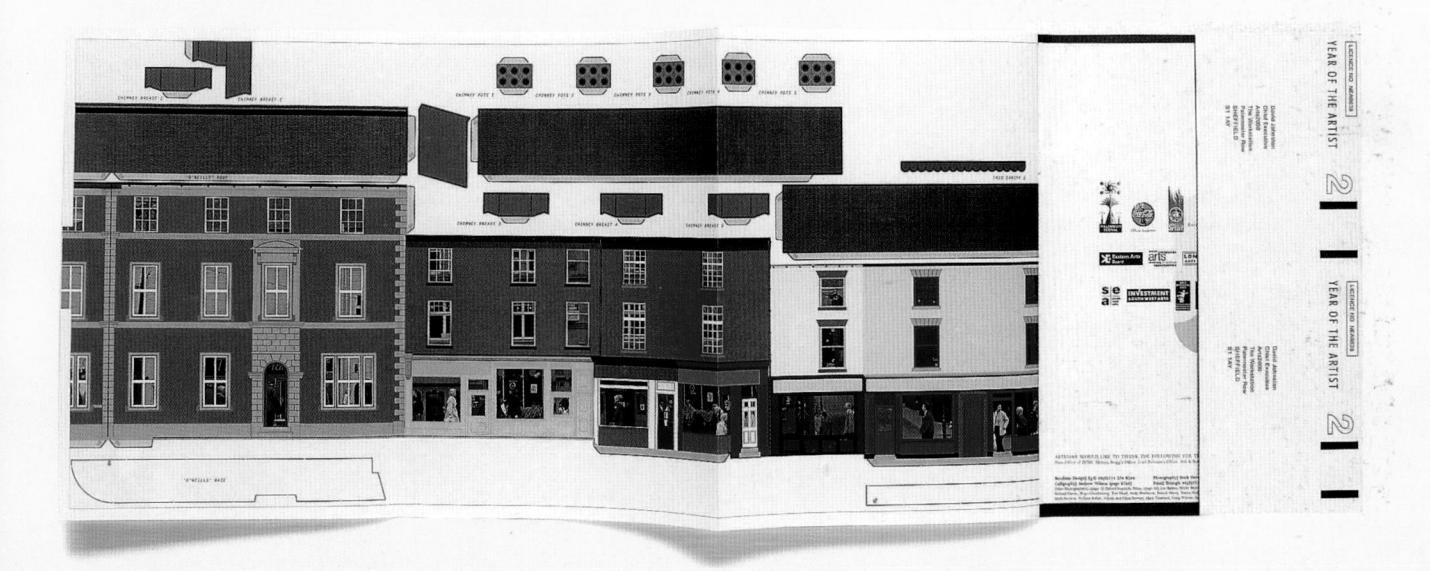

Designer Bob Aufuldish

Art Director

Bob Aufuldish

Photographer

Douglas Sandberg

Hybrid Tool Designer Karl Weiser

Design Company Aufuldish & Warinner

Country of Origin

USA

Description of Artwork

A series of three postcards sent to alumni of the California College of Arts and Crafts to solicit donations to a scholarship fund.

Dimensions

152 X 229 mm 6 x 9 in

Format

Postcards

CCAC Scholarship Program

Here, direct and apparently simple imagery is used to make the complex and intangible theme of scholarship immediately accessible. The clarity and unity of the images is enhanced through the use of only two colors—black and metallic silver—and the recurring textile backdrop. The photograph on each card is subtly suggestive of a different process associated with learning—original and unexpected ideas (*left*), individual expression (*center*), and the receiving and understanding of information (*right*). These are reinforced through the use of the abstract, white, central graphic which is itself encapsulated and 'processed' within a variety of parentheses.

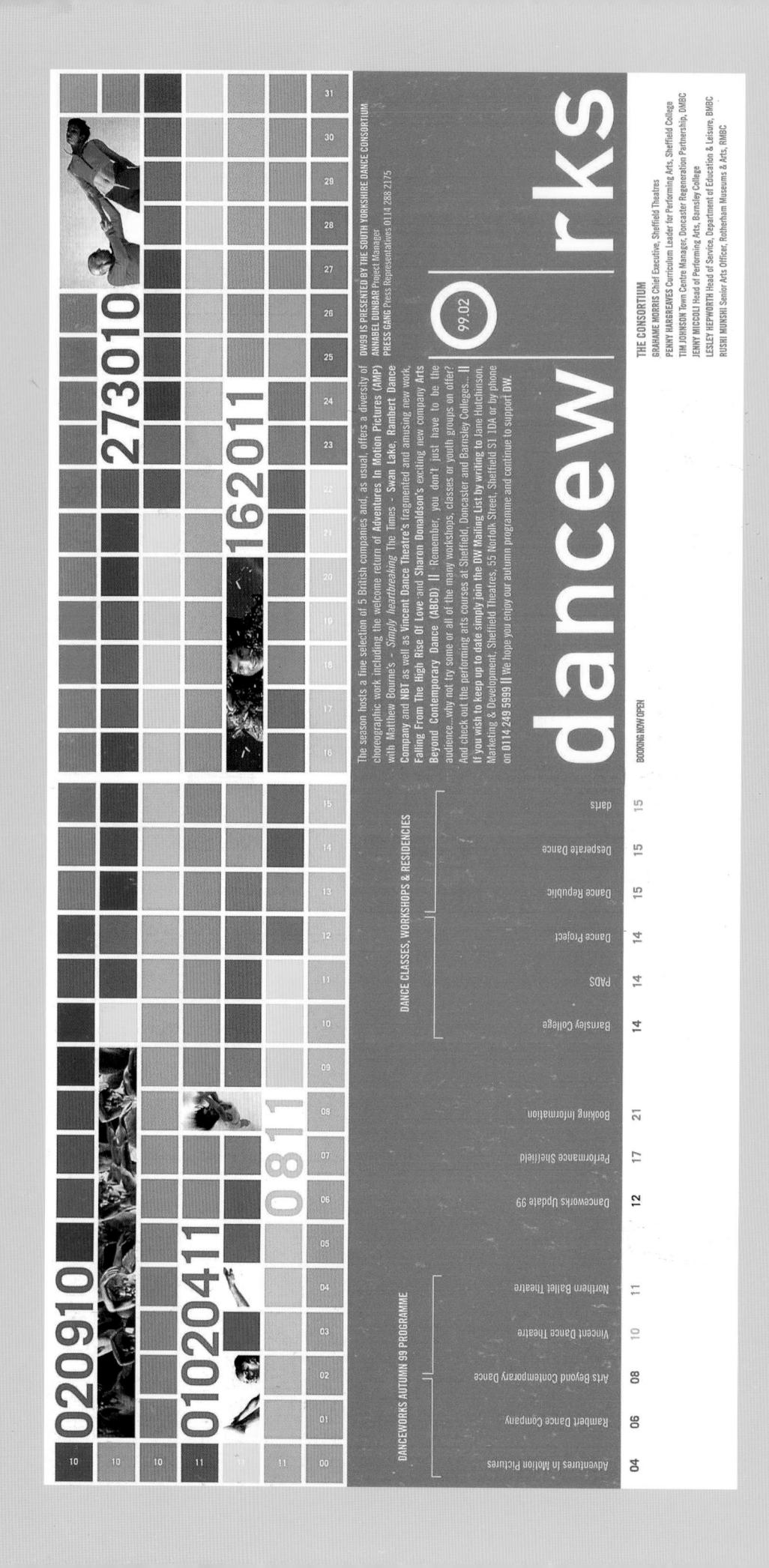

Designers Dom Raban, Pat Walker **Photographers** Various

Description of Artwork

24-page brochure for the South Yorkshire Dance Consortium. Second in an annual series of three. Page Dimensions 205 x 205 mm 8 x 8 in

Design Company Eg.G

Format Brochure

Country of Origin UK

Danceworks

A powerful 'logo' (above), strong use of a colored grid (above and opposite), and consistent application of typeface and typesize have all been used to erect a framework within which the designers have then been able to play fast and loose with individual images. This approach allows a squared-up layout (right, top) to sit comfortably next to a free-flowing spread featuring cutouts (right), in which the typography reflects the motion in the leaping figure.

Special Production Techniques

The curved text (right) was produced with the use of two design programs: QuarkXPress and Illustrator

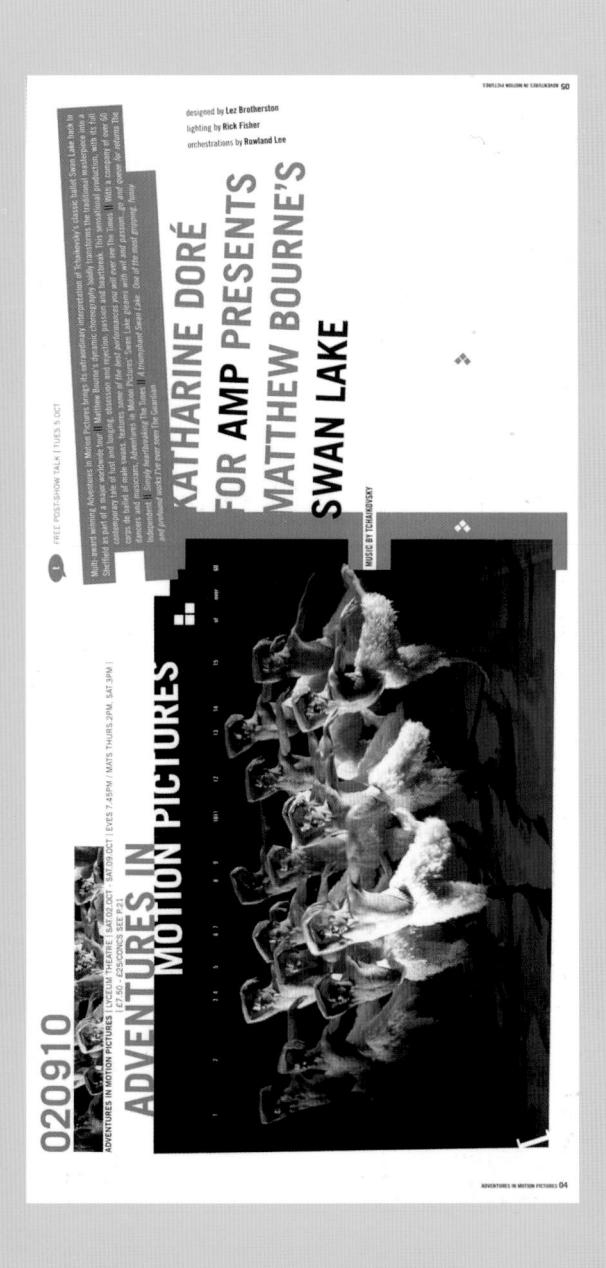

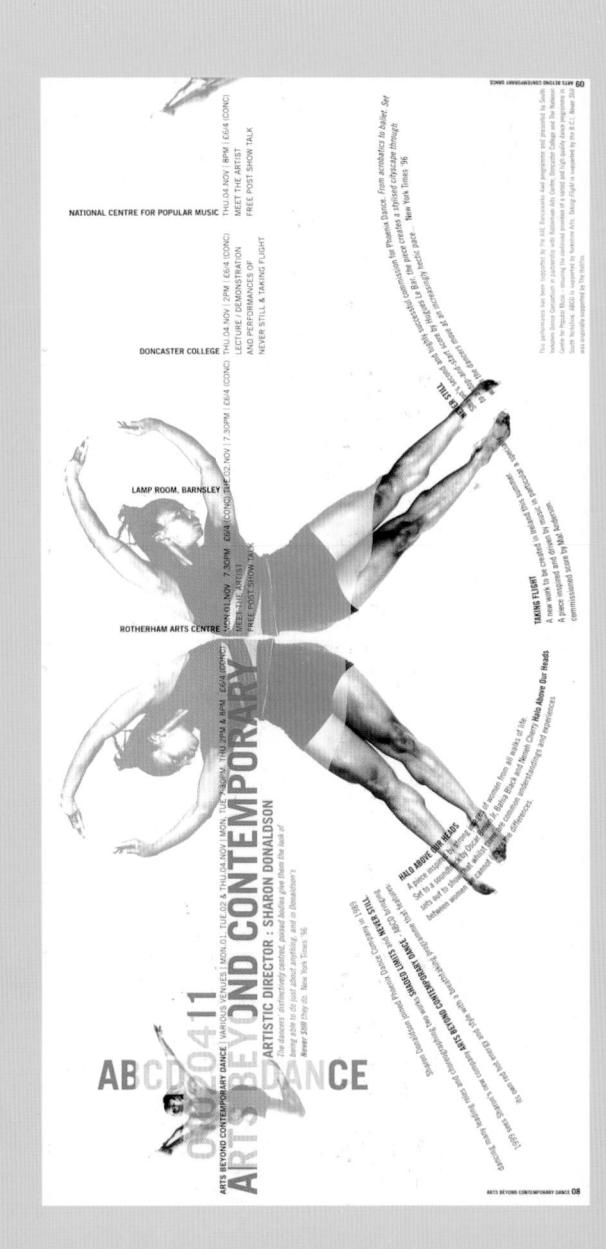

Unless otherwise noted, all CCAC Institute programs—exhibitions,

opening receptions, film screenings, and lectures are free and open to the public. For more information, call 415.551.9210.

SEARCHLIGHT: CONSCIOUSNESS AT THE MILLENNIUM

September 25-December 11, 1999

Logan Galleries and Carroll Weisel Hall

1111 Eighth Street, San Francisco Montgomery Campus

7–9 pm, featuring a special guest appearance Opening reception: Friday, September 24, by Deep Blue Ir.

Diana Thater, Bill Viola, Gillian Wearing, and La Martin, Yoko Ono, Adrian Piper, Ad Reinhardt, consciousness has evolved as one of the most than thirty artists including Louise Bourgeois, international contemporary art to reveal how Douglas Gordon, Rodney Graham, Gary Hill, Robert Irwin, Iñigo Manglano-Oralle, Agnes exhibition includes over fifty works by more compelling artistic themes of our time. The Theresa Hak Kyung Cha, Stan Douglas, This exhibition surveys thirty years of Monte Young and Marian Zazeela.

Hours: Monday, Wednesday, Thursday, Friday, and Saturday 11 am-5 pm Tuesday 11 am-9 pm; closed Sunday. Holiday closure: November 25-28

NRLFRANCOSRAMS:

SEARCHLIGHT: CONSCIOUSNESS

programs take place in Timken Lecture Hall on CCAC's Montgomery Campus in San Francisco. AT THE MILLENNIUM PROGRAMS For more information, call the CCAC Institute Unless otherwise indicated, all Searchlight

SEARCHLIGHT LECTURE SERIES Artist Talk: Jörg Herold

at 415.5519210.

Fuesday, September 7, 7:30 pm

documenta X (1997), the Venice Biennale (1990 and 1995), Prospect 93, and the Eighth Biennale marks the first time his work has been shown in installation Körper im Körper, 1989, featured film, 1987. Herold's work has been featured in In this Searchlight pre-opening talk, German of Sydney (1992). The Searchlight exhibition in the Searchlight exhibition. The talk will be followed by a screening of some of the artist's conceptual artist and filmmaker Jörg Herold 1969-1988, Beiwerk, 1985, and Der Wurstwill discuss his work, including the video early film works including Sportfest 69,

Artist Talk: Stuart Sherman

and discuss his unique approach to language, Performer, video artist, and filmmaker Stuart time, and mind. Sherman's films and videos Sherman will screen a selection of his works nous han factured in factions in Darlin No Tuesday, September 21, 7:30 pm

SEARCHLIGHT FILM SERIES

Seven evenings of experimental film explore the was organized by Steve Anker, Irina Leimbacher, time-based medium of film. Presented by the San Francisco Cinemathèque, this film series nature of conscious experience through the and David Sherman.

Dawning of Awareness

Tuesday, October 5, 7:30 pm

b/w, sound, 21 minutes; Zorns Lemma, 1970, These films trace a journey from the origins of Müller, Super-8mm, color, sound, 16 minutes; silent, 27.5 minutes; Peggy and Fred in Hell: Scenes from Under Childhood: Section No. 3, 1970, by Stan Brakhage, 16 mm, color consciousness through the development of Prologue, 1985, by Leslie Thornton, 16mm, Films include Epilogue, 1987, by Matthias by Hollis Frampton, 16mm, color, sound, language to the social order of adulthood 60 minutes.

Flows of Perception

structural possibilities of cinema. Films include Think, 1992, by Scott Stark, Super-8mm, color. This program explores the phenomenology of Lumiere Brothers/Ken Jacobs, 16mm, b/w and 1975-1998, by Guy Sherwin; 16mm, b/w, sound sound, 15 minutes; S:TREAM:S:S:ECTION:S: color, sound, 9 minutes; Short Film Series. Gehr, 16mm, color, 23 minutes; Glass, 1998, by Leighton Pierce, 16mm, color, sound, 7 minutes; 3.95 Untitled, 1995, by Brian Frye, Super-8mm, color, sound, 7 minutes; Openi 15 minutes; Serene Velocity, 1970, by Ernie 1997B (Departure), 1997, by Steve Polta, 16mm, b/w, silent, 3 minutes; Don't Even ECTION:S:S:ECTIONED, 1968-71, by Paul the 19th Century: 1896, 1896/1991, by the mind through the experiential and Tuesday, October 19, 7:30 pm

Sharits, 16mm, color, sound, 42 minutes. In Search of Sense and Sequence

The creation/discovery/imposition of order and Blackie, 1998, by Jeanne Finley and John Muse, Test, 1996, by Kerry Laitala, 16mm, b/w, silent, Gordon, 16mm, color, sound, 10 minutes: The color, sound, 17 minutes; The Adventures of video, color, sound, 9 minutes; Poetic Justice, 31.5 minutes; Anatomy of Melancholy, 1999, meaning is a ubiquitous urge of conscious life. by Brian Frye, 16mm, b/w, sound, 12 minutes; 1972, by Hollis Frampton, 16mm, b/w, silent, The films in this program endeavor to make Amateurist, 1998, by Miranda July, video, some "sense" of experience. Films include I'll Walk with God, 1994, by Scott Stark, 3 minutes; An Algorithm, 1977, by Bette Fuesday, October 26, 7:30 pm

Gillian Wearing, 2 into 1, 1997

calitoraia

Special Events.

Exhibitions.

Lectures. and Symposia

> October 2-November 24, 1999 INTERWEAVINGS Oliver Art Center

Designer Bob Aufuldish Art Director

hotographer

USA

Design Company Aufuldish & Warinner

Country of Origin

Description of Artwork A fold-out announcement of

> semester 1999. Page Dimensions 152 X 229 mm

6×9 in

Format

Self-mailing announcement

A fold-out announcement of the public program offered by the California College of Art the California College the fall and Crafts during the fall

and embroidery. Among the featured artists are Opening reception: Friday, October 1, 6–8 pm Rinder, Interweavings presents works made Guillerminot, Mona Hatoum, Fabrice Hybert. through collaborations among contemporary classic French crafts of lacemaking, tapestry, international artists and practitioners of the Organized by Yves Sabourin and Lawrence Ghada Amer, John Armleder, Marie-Ange 5212 Broadway, Oakland

Annette Messager, and Jean-Michel Othoniel Oliver Art Center, Oakland campus

Saturday 11 am—5 pm Wednesday 11am—9 pm; closed Hours: Monday, Tuesday, Thursday, Friday, and Sunday. Holiday closure: November 25-28

B X R L I G B R O G R A M S

INTERWEAVINGS LECTURE SERIES

Unless otherwise indicated, all Interweavings Oakland campus. For more information, call programs take place in Nahl Hall on CCAC's the CCAC Institute at 415.551.9210.

Lecture: Yves Sabourin Friday, October 1, 8 pm

Interweavings curator Yves Sabourin discusses

16mm, color, sound, 8 minutes.

CCAC Public Programs, Fall 1999

The striking juxtaposition of natural and urban images on the cover draws attention to the experimental and conceptual nature of many of the films and events offered in the program. The clear typography on the inside, with the second color printed beneath the black text, reflects the preoccupations of many of the talks which have to do with contextualism and the overlaying of meanings.

Special Production Techniques

Two-color printing (pale green and black) has been used to good effect to add a subtle depth to the duotone images on the front cover and for the overlaying of text on the inside.

Artist Talk: Johan Creten and Mylène Salvador Artist Johan Creten and lacemaker Mylène Salvador discuss their collaboration. Wednesday, November 3, 7:30 pm

Contemporary Art. It is made possible by the support of the Free Philippe Favier, Les Milles et une Nui Services; Étant donnés: The French American Endowment for Ministry of Foreign Affairs through AFFA and French Cultural avings is part of Côte Ouest: A Season of French

Contemporary Art; and Tom and Jan Boyce.

CCAC Textile Department, 5275 Broadway, Oakland Sylvie Deschamps presents an embroidery information, call the Textile Department at Artist Sylvie Skinazi and lacemaker Brigitte demonstration and workshop. For more Lefebvre discuss their collaboration.

Demonstration: Sylvie Deschamps Wednesday, October 20, 7:30 pm 510.597.3703.

View, 1992, by Peter Tscherkassky, 16mm, b/w, 16mm, color, silent, 12 minutes; The Five Bad Sirius Remembered, 1959, by Stan Brakhage Elements, 1997, by Mark LaPore, 16mm, b/w, sound, 33 minutes; Parallel Space: Inter-Paris, 1918, director unknown, 16mm, b/w, silent, 4 minutes; Magenta, 1997, by Luis Recoder, 16mm, color, sound, 9.5 minutes; Luther Price, Super-8mm, color, sound, 25 sound, 18 minutes; Mother, 1988-98, by minutes; Time Being, 1991, by Gunvor Nelson, 16mm, b/w, silent, 8 minutes.

Contested Personas

Artist Jean-Michel Othoniel and embroiden

Wednesday, October 27, 7:30 pm

and Sylvie Lezziero

Artist Talk: Jean-Michel Othoniel

Sylvie Lezziero discuss their collaboration

This program examines several sites of struggle others. Films include Smoke, 1995-96, by Pelle Perfect Film, 1986, by Ken Jacobs, b/w, sound Epileptic Seizure Comparison, 1976, by Paul and affirmation in the power plays inherent in Lowe, Super-8mm, color, sound, 24 minutes; Spirit (by Kelly Gabron), 1992, by Cauleen 23 minutes; Les maîtres fous, 1955, by Jean Mute, 1991, by Greta Snider, 16mm, color, sound, 14 minutes; Chronicles of a Lying the socio-historical awareness of self and Smith, 16mm, color, sound, 5.5 minutes; Rouch, 16mm, color, sound, 36 minutes; Sharits, 16mm, color, sound, 30 minutes. uesday, November 9, 7:30 pm

Tuesday, November 23, 7:30 pm Conscious Spaces

sound, 14 minutes; News from Home, 1976 through their existence in time. Films include 16mm, color, sound, 45 minutes; Paris and These films explore space and architecture Athens, 1994, by Lynn Kirby, video, color, by Chantal Akerman, 16mm, color, sound, Wavelength, 1966-67, by Michael Snow

90 minutes.

ness first-hand as the audience drifts in and out Bring your sleeping bag and mat to an overnight embodies the paradoxes of film and conscious of consciousness. Doughnuts served at 6 am. Friday, December 3, through Saturday, December Sleep, 1963, by Andy Warhol, 16mm, b/w, screening of Andy Warhol's Sleep, which 12 am-6 am Oliver Art Center, Oakland silent, 321 minutes. Sleep-Over

Support for Searchlight: Consciousness at the Millennium has and Celeste Meier; Nancy and Steven H. Oliver; Susan and Richard and William Timken; Rena Bransten; Gloria Brown Brobeck; Alfred Watkins; The Good Guys!; Norma Schlesinger; Byron Meyer; and and Eunice Childs; Carla Emil and Richard Silverstein; Anthony been provided by the National Endowment for the Arts; Judith Paul and Elizabeth Wilsor

Agency; LEF Foundation; Clinton Walker Foundation; Gyöngy Laky; The CCAC Institute programs are made possible through the gener ous support of Mrs. Paul L. Wattis; The James Irvine Foundation; Endowment for the Arts; Grants for the Arts/San Francisco Hotel Tax Fund; Lannan Foundation; California Arts Council, a State Pro Helvetica, Arts Council of Switzerland; Tecoah and Thomas Ann Hatch/California Tamarack Foundation; The National Bruce; and members of the CCAC Institute Council.

numbers listed with each event to confirm dates, Events are subject to change. Please call phone times, and locations.

5212 Broadway (off Clifton) Oakland 94618 (510) 594-3600

CCAC's Oakland Campus

1111 Eighth Street (near Wisconsin and 16th streets) ccAc's San Francisco Campus San Francisco, CA 94107 (415) 703-9500

Wednesday, October 13, 7:30 pm

struction of a Face, Red Cross Worker,

London-based artist Martin Creed will make his Creed's work has been featured in the Eleventh Biennale of Sydney (1998) and in exhibitions at Toronto. Creed also plays in the band Owada first West Coast appearance, discussing his dryly humorous approach to conceptual art. Cabinet Gallery, London; Gavin Brown's Enterprise, New York; and Art Metropole,

Ken Jacobs: From Muybridge to Brooklyn Bridge Tuesday, October 12, 7:30 pm Pacific Film Archive Theater

Films that Tell Time: The Paradoxes of the Ken Jacobs in one of his legendary live Nervous hot-wired to the screen," says Tom Gunning in movement out of stillness, to synthesize space operates his analytic projectors, he also hooks Our basic ability to perceive figure and ground into our most primal processes of perception and time are played with, as though we were 2575 Bancroft Way, Berkeley (New Location!) The Pacific Film Archive presents filmmaker System Performances. "Jacobs not only Cinema of Ken Jacobs.

Symposium: The Art of Consciousness General Admission \$6

Advance reservations are strongly recommended; Saturday, October 30, 1-9 pm call 415.551.9202.

This special program includes a series of and linguistics, UC Berkeley; Alva Noë,

Cruz; Pauline Oliveros, experimental musician Vilayanur Ramachandran, director of the Brain understanding of consciousness. Speakers are manifold ways in which art contributes to the George Lakoff, professor of cognitive science interdisciplinary presentations exploring the assistant professor of philosophy, UC Santa professor of Indo-Tibetan Buddhist studies, psychology, UC Berkeley; Lawrence Rinder, and Perception Laboratory, UC San Diego; Searchlight curator; Robert Thurman, Eleanor Rosch, professor of cognitive

Columbia University; and Bill Viola, artist Artist Talk: Gary Hill

performance. A recent winner of the prestigious Gary Hill will discuss his early video work Why Wonderland and a "metalogue" from Gregor Mind, are woven together in a mind-bending America's most highly regarded video artists. Do Things Get in a Muddle? (Come on Petunia), 1984, in which two texts, Alice in MacArthur Fellowship, Gary Hill is one of Bateson's Steps Toward an Ecology of Tuesday, November 30, 7:30 pm

fuesday, December 7, 7:30 pm Artist Talk: Stan Douglas

appearance, Douglas will discuss how his works the Arts, New York; The Renaissance Society at His work has been shown at the Dia Center for compelling twist to conventional narrative and Contemporary Art, London; and the Art Gallery have investigated aspects of consciousness. the University of Chicago; the Institute of documentary forms. In this rare Bay Area Stan Douglas's film installations lend a

Del 18 de desembre de

Galeria 22, Sant Josep, 22, 08700 Igualada,

Ramon Enrich

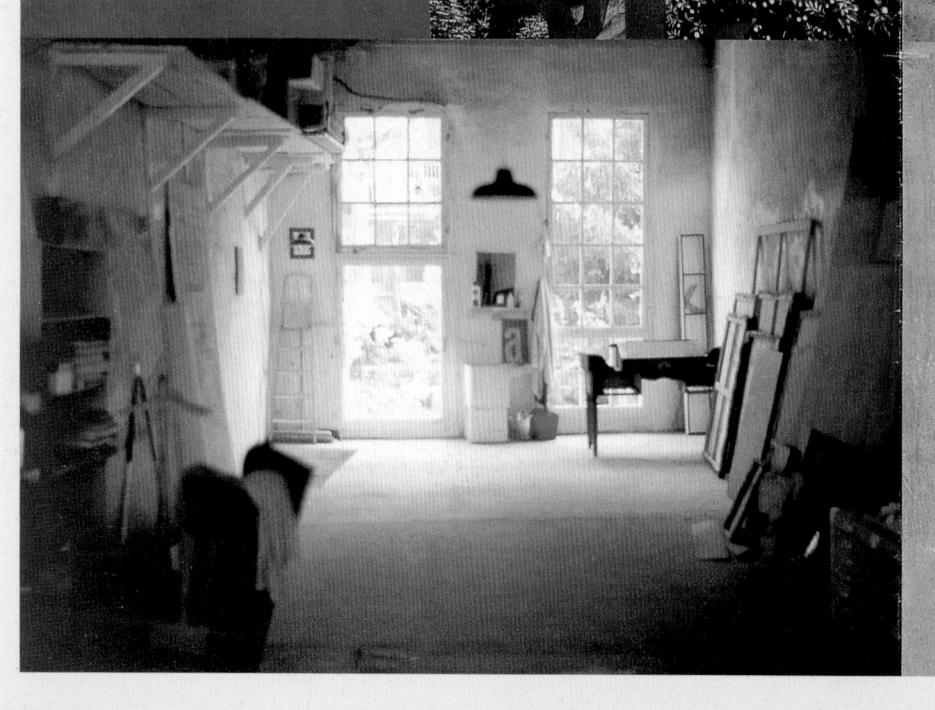

Galeria 22 i Ramon Enrich tenen el plaer de convidar-vos a la inauguració de l'exposició, que tindrà lloc el proper divendres dia 18 de desèmbre de 1998 a les 20 h.

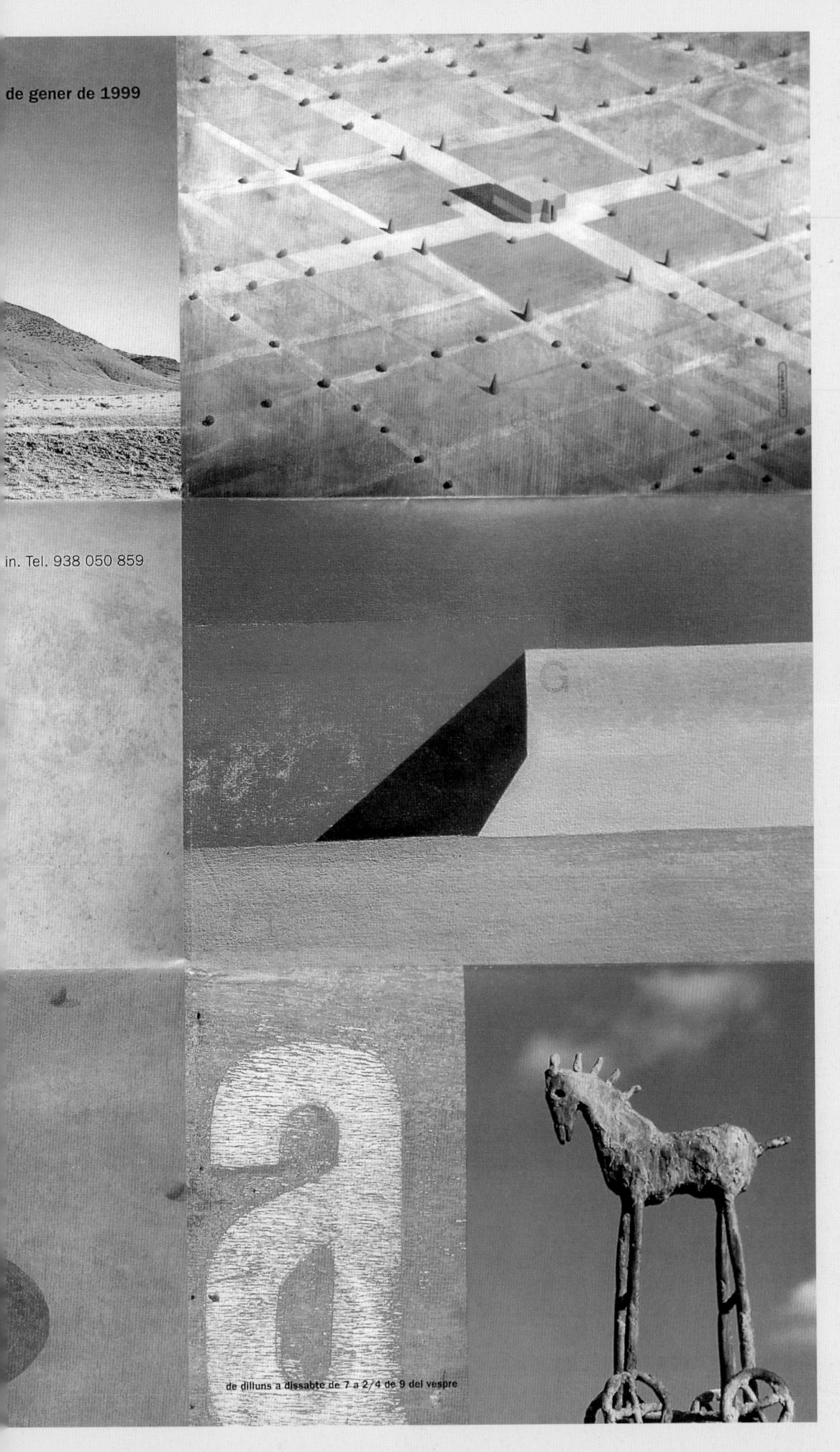

Galeria 22

Whether spread out as a poster (left), or folded to one ninth of its size to make an invitation, this eye-catching design gives a strong sense of the artist's preoccupations. The juxtaposition of rich imagery-photograph next to painting and close-up next to long-shot—reveals a concern with the geometric structure of images. This is something seen in the paintings themselves which, grouped together in this way, also show the extent to which the colors of landscape and sky have influenced the artist's color palette.

Designer Lluis Jubert

Art Director

Ramon Enrich

Illustrator Ramon Enrich

Photographer Ramon Enrich

Design Company Espai Grafic

Country of Origin Spain

Description of Artwork

An invitation to an exhibition at a Barcelona art gallery, which can be unfolded to make a poster.

Dimensions

210 x 150 mm 8¹/₄ x 5⁷/₈ in (folded) 630 x 450 mm 24³/₄ x 17³/₄ in (unfolded)

Format Invitation/Poster

Shift! Doubletake

The originality of the initial idea (see jacket text, above left) and the intriguing nature of this international photographic project have been borne out by the resulting imagery. The layout of the spreads reflects the atmosphere of the double-exposed pictures and, critically, does not intrude upon them. This work stands for itself.

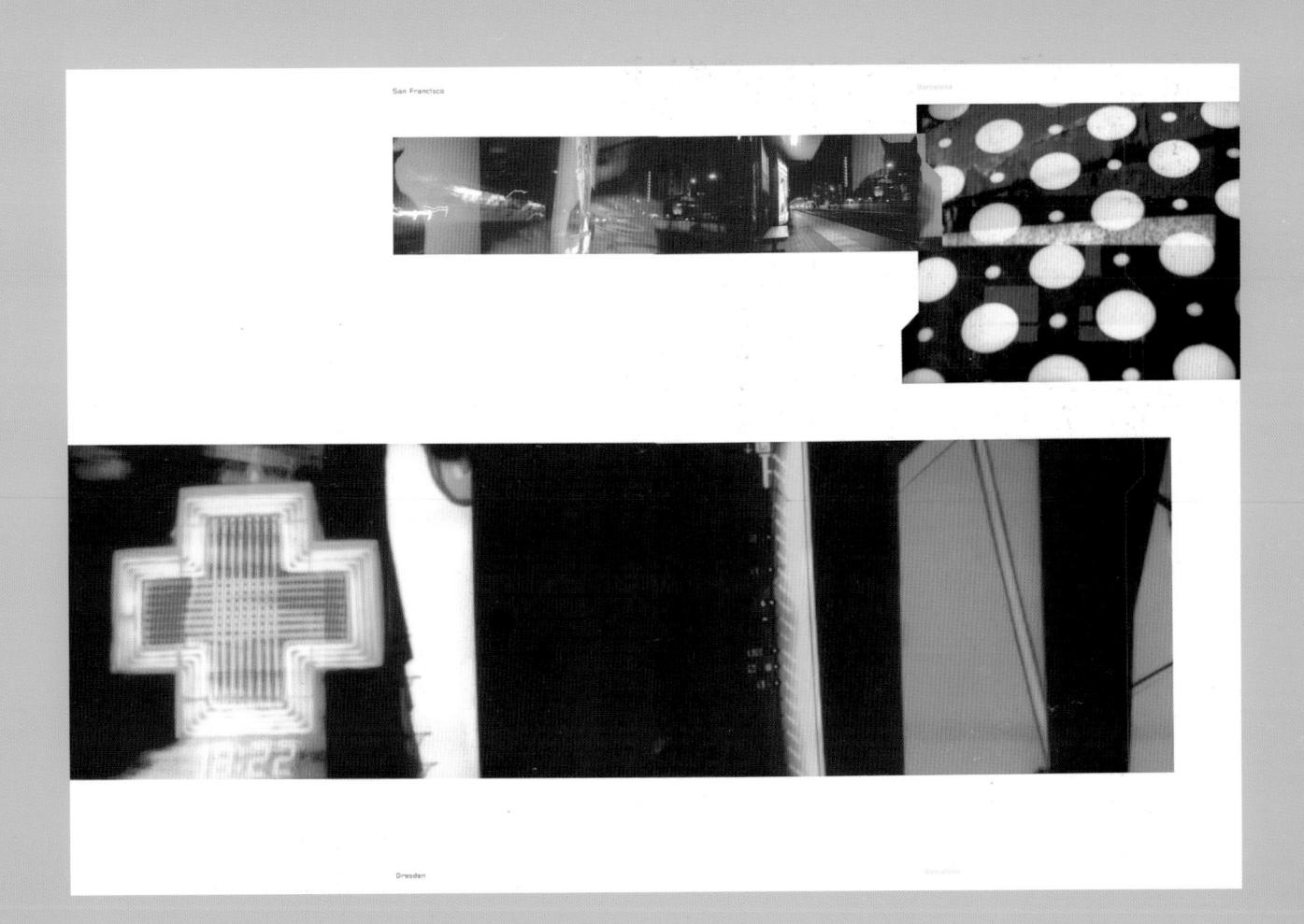

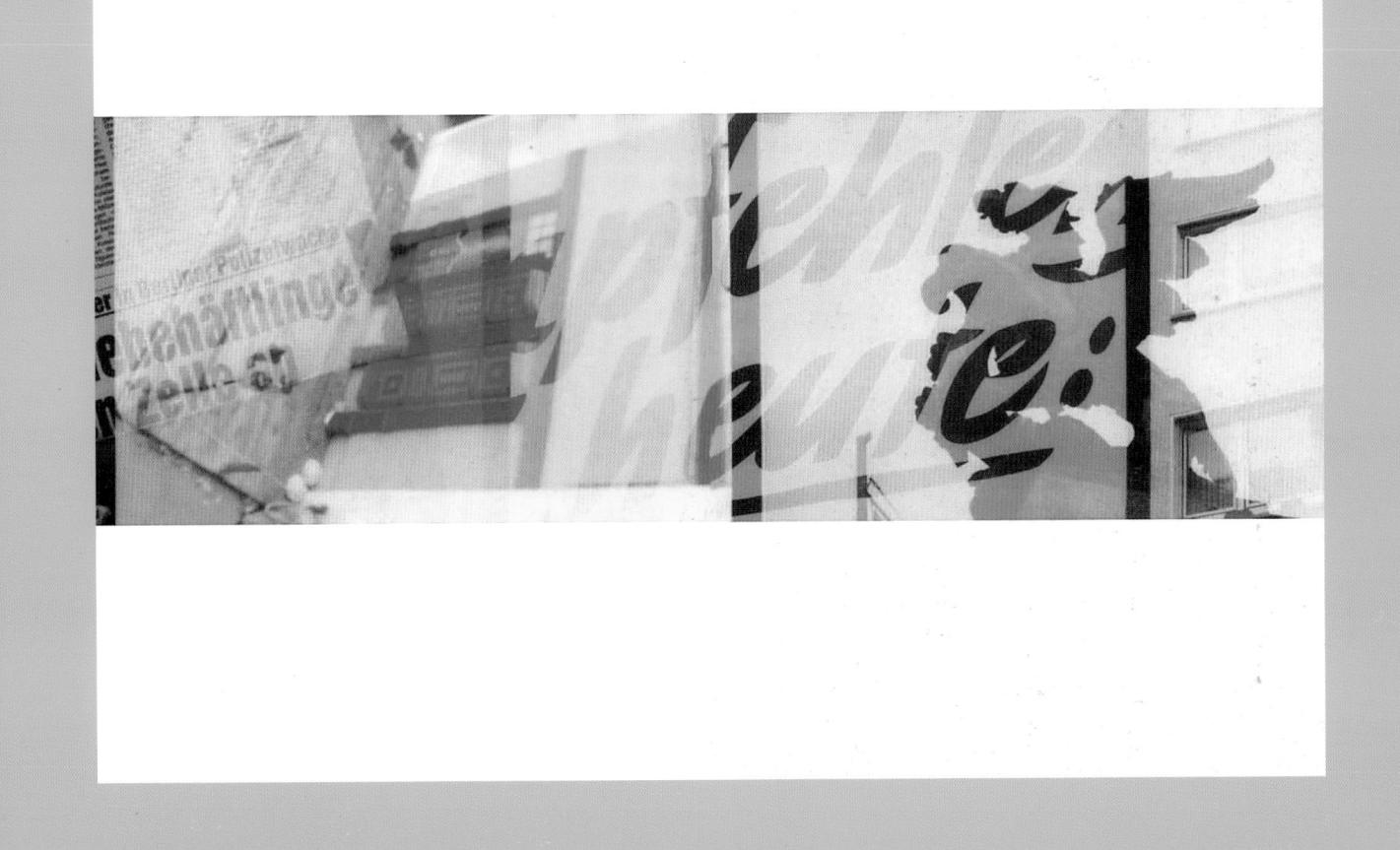

Stuttgart

Concept

Anja Lutz, Christian Küsters

Designers

Anja Lutz, Christian Küsters, Julia Guther

Art Director

Anja Lutz

Photographers

Previous spread, right-hand page: Amy Auerbach and Tobias Melzer (top, center), Sergi and Lydia Carzola (center and top, right), Corinna Gab and Rudi Feuser (bottom). This spread: Anja Osterwauder and Oliver Krimmel.

Design Company

Shift!

Country of Origin Germany

Description of Artwork

160-page book documenting a photography project involving double-exposed images from around the world. Introduction by Liz Farrelly and short stories by Judith Hermann and Gregor Sander.

Page Dimensions

225 x 168 mm 8⁷/₈ x 6⁵/₈ in

Format

Book

ADOBE ILLUSTRATOR

A popular graphic/illustration manipulation program used by many designers for both printed and electronic publication.

ADOBE PHOTOSHOP

The industry-standard image manipulation program used to prepare images for publication.

CMYK (COLOR PRINTING)

The printing of pages in full color through the application of four separate colors in succession: Cyan (blue), Magenta (pink), Yellow, and K (black). K is used for black, because using B could cause confusion between blue and black. It is possible to combine different types of color printing on the same sheet of paper by, for example, using four colors on one side and a single color on the reverse. This is referred to as 'four-back-one' printing. If this technique is used to produce a book then when the printed sheet, or signature, is folded the four- and one-color pages appear alternately throughout the publication.

CAP HEIGHT

The measuremant from the baseline to the top of a capital letter.

DUOTONE

The process by which the complete range of tones, from light to dark, is represented using two colors. Often, one of these two colors is black, but any two printer's inks can be used.

FOLIO

The page number in a book.

GUTTER

The line running along the center of a book where the pages are bound together. Gutter can also be used to refer to the space between two columns of type.

LEADING

The amount of space, measured from baseline to baseline, between two or more lines of type.

LITHOGRAPHIC PRINTING

The most common form of commercial printing process in which the text/image is first etched onto a metal plate. This plate is often curved and fits onto a fast-rotating drum. Ink is applied to the plate which is then pressed against a second rotating drum, usually covered in a rubber blanket, onto which the inked image is transferred. This second drum is then rolled over a sheet of paper printing the image onto the paper. This process is technically called Offset Lithographic Printing because the text/image is not printed directly but first 'offset' onto an intermediate surface before finally being printed onto the paper.

OVERPRINTING

The printing of one color on top of another.

PIXEL

The basic unit that makes up an image viewed on a TV or computer monitor. The ultimate size of an electronic image when viewed on a screen depends on its dimensions in pixels and the resolution of the screen. The higher the resolution of the screen, the smaller—and the more clearly defined—the image will appear.

POINT SIZE

In typography, still the most common unit of measurement used to denote the size of a typeface. There are approximately 72 points to the inch.

QUARK XPRESS

A page-layout computer program used in the production of all types of design.

REVERSE OUT/KNOCK OUT

In printing, the technique of creating text/

outline/image by taking away the color from a particular area to allow the paper beneath, or another ink/inks, to show through without overprinting.

SERIF

In typography, a serif typeface is characterized by additional strokes at the extremities of each character. A typeface that lacks this is referred to as sans serif. Baskerville is an example of a serif face; Univers is a sans-serif face.

SIGNATURE

Books are often produced by printing a number of pages (usually 4, 8, 16, or 32) onto a single sheet of paper. Each of these sheets is then folded to form a section of the book. These sections are known as signatures.

SILK-SCREEN PRINTING

A method of printing in which the ink is forced through a mesh made from fine material (originally silk) onto the surface to be printed. It is often used in poster printing.

TYPEFACE

The style or design of the type.

X-HEIGHT

The measurement from the baseline to the top of a lower-case letter.

A
ADIGARD, ERIK 76–9
AGRAPHE 20, 144
ALLEN, MARK 14, 68
AMBROSE, GAVIN 80
ART CENTER COLLEGE OF DESIGN 64
@RADICAL.MEDIA 100
AUFULDISH, BOB 128, 132
AUFULDISH & WARINNER 128, 132

B
BARIL, POL 40
BARTLETT, BRAD 104, 124
BEAUFONTS 18
BRAVENEC, DAVE 14
BROWN, MARTIN 62
BRUHN, PETER 84-7

C
CAYLOR, MARK 30
CEPOGLU, GULIZAR 122
CHENERY, ROB 92
CRANBROOK ACADEMY OF ART 104, 124
CRANE, ROB 32
CYAN 88–91

D DE LOIA, ADRIANNE 14, 68 DULUDE, DENIS 40

E
EASTWOOD, JOSEPH 42
EG.G 94, 102, 126, 130
ENVISION+ 44-51
EPOXY 70-73
ESPAI GRAFIC 66, 134
ESQUER, RAFAEL 64, 100

F FILIFOX 26–9 FOUNTAIN-BRUHN 84–7 FOUSHEE, DANIELLE 106, 124 FUEL 22–5

G GARSIDE, SEEL 18 GEHLHAAR, JENS 22-5, 36-9 GLAHR, CHRISTINA 114
GLICKSMAN, CAROLINE 108–11
GRAPHIC HAVOC AVISUALAGENCY 16
GULIZAR CEPOGLU GRAPHIC DESIGN
CO. 122
GUTHER, JULIA 136–9

H HAGMANN, SIBYLLE 112 HAND, DAVID 18 HENSCHEL, ANTONIA 52–5 HGV DESIGN 62 HITCH 18

J JARABO, ALEJANDRA 68 JOHNSON, CHAKARAS 100 JUBERT, LLUIS 66, 134

K KICK MEDIA 14, 68 KO CREATION 40 KUSTERS, CHRISTIAN 136-9

L LIQUID AGENTUR FUR GESTALTUNG 96–9 LLENADO, ARMANDO 14 LOREM IPSUM 114 LUTZ, ANJA 136–9

M
M.A.D. 76–9
MARK ROGERSON ASSOCIATES 34, 58–61
MARTINEZ, CHRIS 14, 68
MCSHANE, PATRICIA 76–9
MILDENBERGER, ESTHER 44–51
MITCHELL, IAN 18
MONO 80

O ORSCHULKO, CARINA 96–9

P PELVAN, AYSUN 122 PETTER, CATHERINE 70–73 PLANETA, SANDRA 116 R RABAN, DOM 94, 102, 126, 130 RED DESIGN 10–13 ROGERSON, MARK 34, 58–61 ROYAL COLLEGE OF ART 44–51

S
SADDAKNI, MARIANA 100
SALLACZ, ILJA 96–9
SATELLITE 32
SAVOIR, PHILIPPE 26–9
SHIFT! 136–9
SPOT DESIGN 116
STYLOROUGE 30, 92
SWITZER, BRIAN 44–51

T TYPOSTUDIO 112

U UNIVERSITY OF BRIGHTON 108–11 UNIVERSITY OF SALFORD 42

WALKER, PAT 126, 130 WHY NOT ASSOCIATES 82

YACHT ASSOCIATES 118-21 YATES, MARTIN 32

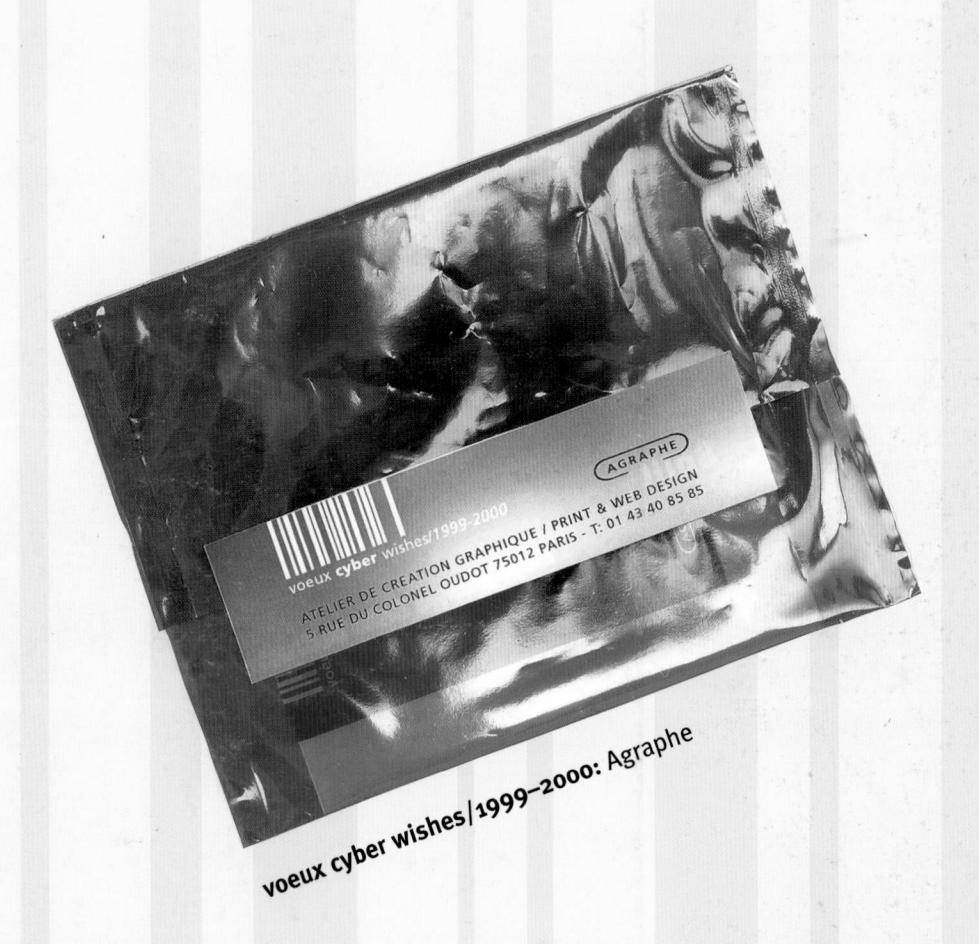